Scandals, Vandals, and Da Vincis

A Gallery of
Remarkable Art Tales

Scandals,
Vandals, and
Da Vincis

HARVEY RACHLIN

Originally published in the United States by Penguin Books.

First published in Great Britain in 2007 by
Robson Books
10 Southcombe Street
London
W14 0RA

An imprint of Anova Books Company Ltd.

Copyright © Harvey Rachlin, 2007

Designed by Paula Szafranski.

The moral right of the author has been asserted.

ISBN 9781861058782

10 9 8 7 6 5 4 3 2 1

A CIP catalogue record for this book is available from the British Library.

Printed and bound by Creative Print and Design (Wales), Ebbw Vale.

This book can be ordered direct from the publisher.
Contact the marketing department, but try your bookshop first.

www.anovabooks.com

For Marla and Glenn

ACKNOWLEDGMENTS

For me, the past is an obsession. What could be more compelling than the dramas, romances, and adventures of the human race through the millennia? Stepping into the past, whether via the written word or in my own reveries, leaves me in raptures.

Beginning with my book *Lucy's Bones, Sacred Stones, and Einstein's Brain,* I have tried to package the past in fun and unique ways. With this present endeavor, I owe a great debt to many people.

For their kind help, I want to express my very special gratitude to Jean Walsh, Kelvingrove Art Gallery and Museum; Verena Borgmann and Dr. Dorothee Hansen, Kunsthalle Bremen; Hilary Folwell Krueger, Washington Crossing Historic Park; Leonardo expert Dr. Pascal Brioist; Helen Smailes, National Galleries of Scotland; Cecilia Wertheimer, Bureau of Engraving and Printing of the U.S. Department of the Treasury; Jodie Waldron, Lefevre Fine Art; and Quentin Buvelot, Mauritshuis.

Generous assistance was also provided by Jane Smith Whannel, Glasgow Museums; Arnaud Glize, Château du Clos Lucé; Robyn Fleming, Thomas J. Watson Library, Metropolitan Museum of Art; Lydia S. Tederick, The White House Curator's Office; Anne Halpern, National Gallery of Art,

Washington, D.C.; Mariette Halkema, Mauritshuis; Dr. Patricia de Montfort, University of Glasgow; Taco Dibbets and Jonathan Bikker, Rijksmuseum; Dr. Robert Shoemaker, University of Sheffield; Dr. Sharon Flescher, International Foundation for Art Research; Pierre Paillot and Xavier Popineau, Météo-France Bibliothèque; Robert L. Giannini III and Coxley Toogood, Independence National Historical Park; Kim Feinknopf-Dorrian, Ohio Historical Society; Michelle Harvey, The Museum of Modern Art, New York City; Shona Corner, National Galleries of Scotland; Tracey Walker, Manchester Art Gallery; Laura Valentine, Royal Academy of Arts; and Harmony Haskins, The White House Historical Association.

I always received quick, courteous, and bountiful help from staff members at the Museum of Fine Arts, Boston. I would particularly like to thank Deanna M. Griffin, Brooks Rich, Kate Silverman, and Danielle Archibald Kachapis.

A wonderful (and anonymous) Discalced Carmelite nun in Spain sent me, in response to one of my inquiries, a long, informative, and warm handwritten letter about Saint John of the Cross and his famous drawing of Christ being crucified. Ignacio Alberto Jiménez Muñoz of the Avila Chamber of Commerce and Industry in Spain kindly forwarded my request for information to her at the Monastery of the Incarnation.

Art historian Dr. David R. Meschutt, in a long telephone conversation, gave me a comprehensive overview of the story behind Benjamin Wilson's portrait of Benjamin Franklin. Dr. Meschutt, a brilliant young scholar who could not have been more generous with his knowledge and time, sadly passed away while this book was being written.

Valerie-Ann Lutz at the American Philosophical Society provided me with valuable research materials and also went to great lengths to find an eighteenth-century magazine picture for a chapter on a Gainsborough painting that unfortunately did not make it into the book.

Manhattanville College, where I teach as an adjunct in the music department, enriches my life in many ways. Dr. Carmelo P. Comberiati, the

chairman of the music department, graciously facilitated assistance for various of my research needs. Dr. Gillian Greenhill Hannum, Dr. Lisa M. Rafanelli, Kathryn DiBernardo, and Patricia Walker were all very helpful. Professor Alessandra Hart painstakingly translated for me a lengthy excerpt in Renaissance-era Italian for a Jacob van Ruisdael painting that I was not able to include in the book. Dr. Anthony La Magra made it all possible for me before moving on to well-deserved retirement.

I am grateful to the entire Manhattanville College library staff, all of whom are courteous, knowledgeable, and helpful; but I must single out one individual for her invaluable assistance: Susan Majdak, who heads the interlibrary loan area. It was vital to my research to peruse old and rare materials, and Susan quickly and diligently made everything I requested available to me. She played an integral part in the research of this book, and my gratitude to her is enormous.

For their support and encouragement I want to thank Mina Shuman, John Ulatowski, Barbara Magor, Evelyn Zerner, Jeff Burke, Jesse Berensci, Jon Keith, M. William Phelps, Elyssa Strug, and Lauren Goldwert.

My wife, Marla, and my son, Glenn, to whom I have dedicated this book, bore with infinite patience my endless series of absences, as well as my preoccupation with one or another art story when I happened to be around. They will always have my boundless gratitude.

The great lyricist Sammy Cahn famously asked about songs, "What comes first, the words or the music?" Often writing under contract, his answer was, "The telephone call." Similarly, I inquire, "What comes first, the writing of the book, or the dream of seeing my work in print?" Taking a cue from the maestro, I would update his response to say "The e-mail." In that regard, I owe a tremendous debt to my agent, Patty Moosbrugger, who does everything a great agent is supposed to do (and occasionally sends some lovely e-mails). Her enthusiasm has always been a source of great inspiration.

I was fortunate to have not one but two superb editors at Penguin. Caroline White acquired the book and was helpful in shaping it in so many

ways. She was a great joy to work with, and I shall always be grateful to her. Caroline retired but left me in the most capable hands I could ever have imagined, those of Brett Kelly. Brett is a genuinely caring editor whose keen editorial suggestions improved the book enormously. She brought this book to fruition, and I cannot lavish enough praise on her. I would also like to thank editor Karen Anderson, who attentively shepherded this book through its final stages.

My last acknowledgment cannot be overstated. My wonderful friend Judy Stein read the manuscript and served as editor, adviser, critic, troubleshooter, counselor, and guru. My debt to Judy is incalculable; I could not have written this book without her. She is a brilliant and extraordinary person, and only space limits the praise she rightfully deserves.

Finally, I would like to pay homage to the past. Without it, not only would we not have all our great paintings and their wonderful stories, but none of us would be here to appreciate them!

CONTENTS

�

INTRODUCTION

✥

Whaﾑt is the story of a painting?

The connoisseur of art may reel off with dazzling perspicacity a litany of details related to the work's light, color, imagery, and texture, followed by erudite discourses on the painting's meaning, psychology, narrative, and mood. Such analyses are impressive and edifying and cannot help but make us more appreciative of the genius, talent, and precision that often go into making a work of art. But what is the tale—or tales—behind the work?

One of the great joys of art is learning the stories of paintings, but there may be a myriad of enthralling yarns associated with a work of art, some of which are known while others remain hidden. Long ago, as a delicate canvas was carefully carried out of the master's Renaissance workshop and hauled on a cart over mountains and valleys to a royal patron in a foreign land, what thrilling escapades did it have on its journey? While a magnificent portrait adorned a stately wall in the castle of a wealthy noble family for generations, through famines and wars, floods and plagues, personal crises and festive events, what comforts did it bring, or what thoughts did it provoke? When an icon of the Virgin was displayed in a Byzantine church in a town under

siege by foreign invaders, how did the faithful in their worst moments of fear and desperation come to venerate it?

Were these stories recorded by witnesses? Were they handed down orally, only to be forgotten a generation or two later? Or did the protagonists just keep the stories to themselves, not thinking they would be of interest to posterity?

The possibilities for stories about just a single painting are seemingly endless, and in contemplating the peregrinations of old masterpieces or even the personal associations of more recent works, we may conjure up romantic visions of adventure and passion. It is left to the storyteller to dig deep into the history of a painting and come up with true tales that, even though they may be but a single slice of the painting's history, nevertheless illuminate some aspect of the work.

Art stories are almost a genre unto themselves, in which the painting is actually subservient to the story. Does it matter how a painting uses symmetry or perspective or spacing, or whether it is naturalistic or abstract? The art expert's sagacious commentary on composition, technique, and aesthetics is rarely germane. When the story of a painting is inspiring and memorable, the artwork is magically transformed into something more than an image celebrated for its mastery of artistic elements. In the viewer's mind, the work of art becomes even more vibrant, more splendid, more mythical, and more remarkable.

WITHIN THE CONFINES of a single frame, a painting opens a window on a world of tales, from anecdotes, to parables, to allegories, to epics. In these tales may be real-life casts of characters who are colorful and engaging, including—besides the great artists themselves—kings, queens, wealthy patrons, celebrated historical figures, soldiers, spies, marauders, art sleuths, and even the mentally deranged. Each comes alive within the subtext of the brushstrokes, and a single painting can have a multitude of such stories.

Are these tales simply stories for the sake of entertainment, or are there particular reasons we should pay attention to them? Are there useful insights we can gain from the stories, and if so, how do we know what to look for?

Inherent in stories are themes. A theme represents a particular point of interest about a work of art, such as what unconventional route an artist chose to paint a picture, how a commissioned portrait served the aims of its sitter, how a painting was used as a political tool, how a painting affected its owner's emotional well-being. A theme helps clarify the purpose, point, and redeeming value of a story, and its focus serves to highlight just one of the painting's many tales.

This is a book of stories about famous paintings. Each of the stories has a theme, which is presented at the opening of the chapter before the narrative begins. Stories are often told only for the sake of diversion, but stories that elucidate themes carry universal meaning.

The themes here are about art, human nature, and their varied interactions. Some themes generate a sweeping story, others take a narrower angle, spotlighting a telling detail.

The stories behind paintings are often overlooked or not widely known, which is regrettable, because the stories may be as compelling as the works of art themselves. Some stories remain obscure because people have typically remembered a famous incident connected to a painting and have come to regard it as *the* story of that painting. But that is not always the best, or only, approach. There are grand stories and there are little stories. The latter are sometimes the most revealing.

Intriguing stories can be found, for example, in a remark somebody made about a painting, a myth that became attached to a painting, the effect a canvas had on someone associated with it, or the ironic role a work of art played in the artist's life. These accounts are not usually in the repertoire of tales the art experts relate about paintings, yet they may be absorbing and edifying parables that tell us something revealing.

That paintings make for gripping narratives should come as no surprise, since intrinsic to these works are certain elements that, separately or together, are the basis for spinning an effective yarn—namely, the painting's subject, provenance, and artist.

A subject, whether real or fictional or both, may be explored not just for its meaning but for why it was chosen. What could be more captivating than a painting based on genuine people and events that coalesced in some dramatic, heartrending, or poignant way and inspired their portrayal on canvas? A painting of an imagined scene with fictional characters, on the other hand, leads the viewer to discover or speculate about the incidents or impulses that drove the artist to create it.

The history of ownership, or provenance, of a painting, particularly an older one, often includes a rich cast of characters who make their entrances only well after the painting's creation. How the lives of people years, decades, or even centuries removed from the artist and subject became intertwined with the work can be the stuff of engrossing sagas. A person who inherits, acquires, or covets a painting may bring a new personality to the work itself and may even supersede the artist and subject as the focal point of its lore.

A painting's story may also integrate the background and psychological complexities of the painter and probe the artist's motivation to put brush to canvas. To each work of art the painter brings not just a unique artistic imagination but a lifetime of interactions that resulted in the artist's being who he or she is. Central to these interactions are stories that shed light on the created work.

For all the inspiration and imagination that infuse a work of art, it may truly only come alive when the tale behind it resonates in the mind of the beholder. As artistically impressive as a painting may be, it is often the backstory that makes it remarkable in human terms. A horrifying painting of a boy being attacked by a shark is titillating, but if the picture is based on a real-life attack whose gruesome details you know, the picture becomes more fearsome. A portrait of a beautiful, stunningly dressed young woman

may be pleasant to look at, but when you know the tragic tale of the subject's life, her likeness takes on a whole new dimension. Even a painting that looks as if the artist flung a pot of paint against its canvas may take on fresh life when details of its sensational history become known.

A range of stories is presented in this book, including some old favorites whose details may be unfamiliar to new generations, as well as novel approaches to well-known paintings. Omitted from the selection are accounts that seemingly have no elements which illuminate the human condition (at least to this author). Tales of garden-variety theft or the serendipitous discovery of a valuable painting have been excluded; while they may be charming or colorful, they lack the substance that is the point of the book.

The story behind a painting transcends the work's aesthetic qualities and offers a redemptive message, which may be the fundamental significance of art. It's about us and our neighbors and humankind as a whole, a reflection of where we've been and where we're heading, who we are and how we relate to this world. It's about love and hate and desire and greed, about sensuality and tolerance and hope and faith. Joy, rage, compassion, contempt, boldness, conviction, and courage—art is all these things, and more.

Art is about life, and ultimately the stories behind it are not art stories but human stories.

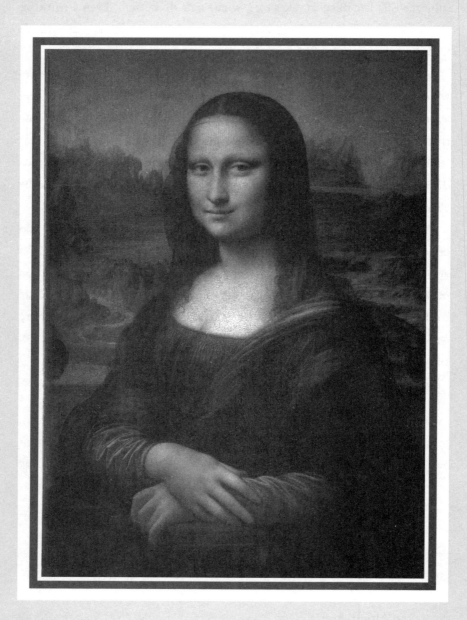

Mona Lisa

(1503–06)

Leonardo da Vinci

⊹

Some paintings are steeped in mystery. Leonardo da Vinci's *Mona Lisa* is perhaps the most famous example.

Indeed, the most prominent features of the long history of *Mona Lisa* are its enigmas: When exactly was the portrait taken out of Leonardo's native country? Did Leonardo really paint the unsigned work? Was its subject a real woman, or a composite drawn from the artist's imagination—or could the inscrutable figure perhaps have been the artist himself? And then there is the most famous mystery of all: What is the meaning of the subject's smile? This last mystery may never be solved, but we may be forgiven for wondering whether, following her early-twentieth-century escapades, Mona Lisa finally had something to smile about.

———————

IN THE EARLY fall of 1516, before the winter snowfall, or perhaps in the spring of 1517, a small party of men set out on a journey from Italy. The artist Leonardo da Vinci, accompanied by two of his students, was headed across the Alps to France by the invitation of the King. Like his predecessor Louis XII, Francis I was an ardent admirer of the artist—Leonardo's *Last Supper* at the monastery of Santa Maria delle Grazie in Milan was a favorite

of both men—and the king had made an attractive offer of a château and a pension to the venerable old master. Now in his sixty-fourth year, Leonardo felt compelled to accept it. With his recent wretched experience at Rome, where the pope had behaved most uncordially toward him, Leonardo was not unhappy to return to the service of the French, who had been excellent patrons over the years.

The men continued to central France, carrying with them precious cargo—paintings, documents, and other possessions of the master that over time would become revered treasures of art history.

The journey may have taken as long as a few months. By late spring, Leonardo and his disciples Francesco Melzi and Gian Giacomo Caprotti were settled in at their destination, a manor house at Cloux in the Loire Valley, a neighborly distance from the king's Château d'Amboise.

Francis, the twenty-two-year-old new king, fresh on the heels of the great victory at Marignano, in which he had seized back Milan, had a deep respect for Italian culture and was beginning to build a collection of art for his court. Leonardo's talents were well known. Over the years he had demonstrated genius in science, mechanical engineering, painting, architecture, and sculpture. At Cloux, Leonardo's function was to be a celebrated guest at the king's disposal for intellectual intercourse, but he would also advise the French king in matters such as architecture and canal planning.

One day in October 1517, Leonardo received a visit from Cardinal Luigi of Aragona. The cardinal had stopped at Amboise while traveling in France and wished to greet his esteemed Italian compatriot. Accompanying the cardinal on his visit to Cloux was his secretary, Antonio de Beatis, who took diligent notes of the meeting. Leonardo, the ecclesiastical scribe wrote, showed his visitors three pictures: *St. John the Baptist, Virgin and Child with St. Anne,* and a "portrait of a certain Florentine lady." This last picture was probably the one that came to be known as *Mona Lisa.*

According to the sixteenth-century art historian Giorgio Vasari, it was for Francesco del Giocondo that Leonardo had painted the portrait of Lisa

Gherardini, his wife. The exact purpose of the Giocondo commission—if in fact Vasari was correct—is not known, but as commissions were sometimes given in honor of personal occurrences, it could have been to celebrate the birth of a child. The portrait of Madonna Lisa, or Mona Lisa for short, was painted in Florence between 1503 and 1506.

Why did Leonardo have in his possession in France in 1517 the painting commissioned by Mona Lisa's husband, Giocondo, at least a decade earlier? According to Vasari, after working on it for four years, Leonardo "finally left it unfinished." Why did Leonardo not complete the painting after such a long period and turn it over to the Giocondo family? Portions of the landscape still awaited final touches. Did Leonardo not complete the portrait simply because he did not wish to part with it? What did it mean to him?

Vasari, a perspicacious and skillful biographer who gathered information for his life histories by meticulously combing through documents, anecdotes, and oral histories, almost certainly never saw Leonardo's portrait. But he wrote that whoever wished to see how far art could imitate nature might "do so to perfection in this head, because we have here all the details painted with great subtlety."

The portrait of Mona Lisa, or La Gioconda, shows a young woman seated on a chair before a landscape background. By most accounts, the sitter was about twenty-four years old when Leonardo began to immortalize her image. The woman's body, voluptuous and buxom, is turned to her left, but her face looks almost directly to the front. She is wearing a pleated gown with long silk sleeves, and a shawl is draped over her shoulders. Her dark hair is parted in the middle; ringlets fall over the sides of her face to her shoulders. A thin veil covers her hair. Her left arm rests gracefully on the chair arm, the fingers curled around the end, and her right hand covers her left wrist.

Mona Lisa is seated before a country landscape that can be seen at close range below her chin, while in the upper part of the painting, it extends far into the distance. The background is not merely a picturesque visual

accompaniment but may be considered part of the essence of the portrait, as it can be interpreted to have symbolic meaning.

In contrast to Mona Lisa's soft and pleasant demeanor, the countryside is rugged and ominous; yet, like the sitter, it is sturdy and mysterious. The landscape to the left shows a serpentine road that seems to have no beginning and no end, and across from it on the right is a bridge that runs over a dry riverbed. The far terrain consists of mountains with chaotic, jagged peaks jutting into a misty greenish sky.

From copies of *Mona Lisa,* it is apparent that the painting was originally larger than we have come to know it. At some point, perhaps in the early seventeenth century, columns on both sides of the portrait were clipped off, possibly because these parts of the painting had been damaged.

The viewer's attention is naturally drawn to the sliver of a smile on Mona Lisa's serenely indecipherable face. Her lips arc upward ever so slightly at the corners, as if defying the viewer to read her mind. She flirts, yet she is restrained. Something is on her mind, yet she is mute. She glows, yet she is subdued. Her being is opaque, a human Sphinx inviting the viewer to unravel her mystery, all the while apparently enjoying the perplexity she inspires. No matter how long the viewer stares at her, tries to get to know her, the camaraderie she seems to encourage remains distant. Over time, many of the best minds in art have tried to penetrate the enigma of Mona Lisa's smile, but with no success. Did Mona Lisa actually smile when she sat for Leonardo? Or did the painter add this feature for his own reasons? Was Leonardo saying something about himself, rather than Mona Lisa, with her expressive eyes and mouth? Was he attempting to embody in this single portrait the ineffable quality of the human female?

Mona Lisa smiles, but was she a happy individual? Among the very few facts known about her is that four years before she sat for Leonardo, she had tragically lost a young daughter. Her husband, a wealthy merchant, was two decades older and had lost two previous wives.

Leonardo endowed his sitter's eyes with a hint of a sparkle, just as he crafted her lips with the suggestion of smile. But the artistry of her eyes is transcendent. No matter where in front of the painting you stand, her gaze seems magically to meet yours. She is frozen on canvas, yet life emanates from her visage.

"Mona Lisa was very beautiful," enthused Vasari, who also reported that "to keep her from that look of melancholy so common in portraits," Leonardo took the precaution during the sitting of engaging musicians to perform or witty people to jest in her presence, so that she might continue to be cheerful. "This picture of Leonardo's," Vasari continued, "has so pleasing an expression and a smile so sweet that one must think it rather divine than human. It has ever been esteemed a wonderful work, an exact appearance of life itself."

Leonardo never wrote about Mona Lisa. Is it possible that the portrait was painted by somebody else? Historians through time have agreed that Leonardo was the painter. Is it possible that the sitter was not Mona Lisa, the wife of Giocondo, but another woman?

Making the matter even more complicated is a statement written by Cardinal Luigi's secretary, Antonio de Beatis. In reference to the portrait of a "certain Florentine lady," de Beatis wrote that the work was "painted from life, at the instance of the late Magnifico Giuliano de' Medici." Was *Mona Lisa* not commissioned by the model's husband? Could the "Florentine lady" seen by de Beatis have been one of the mistresses of the pope's brother, Giuliano de' Medici?

It has been suggested that while de Beatis provided an invaluable account of his visit to the Cloux palace, he sometimes got his information wrong, as he reported Leonardo a half-decade older than he actually was at the time, and likewise made an error in his statement on the commission of the portrait, perhaps owing to some bit of confusion on his part.

By some accounts Leonardo's portrait was purchased before he died by Francis for the sum of four thousand livres; by others, Leonardo's heir, Melzi,

gave it to the king in recognition of Francis's patronage of Leonardo. In any case, Vasari, who didn't begin writing *The Lives of the Painters, Sculptors and Architects* until 1546, when Cardinal Farnese asked him to compile a catalog of artists and their work (the first edition appeared in 1550, the second, almost completely revised, came out in 1568), reported of the *Mona Lisa* portrait, "This work is now in the possession of Francis, King of France, at Fountainebleau," where the king had a residence. Francis was a collector of art and possessed works by many masters; near his death in 1547, his vision for a repository for the royal collection began to take shape as the building of the Louvre commenced.

Over the years, Leonardo's portrait of the Florentine lady with the veil was shuttled around, from Amboise and Fontainebleau to the Louvre and the palaces at Versailles, the Tuileries, and Luxembourg; in the second half of the nineteenth century it returned permanently to the Louvre. Throughout its history, *Mona Lisa* was recognized as a great portrait. Raphael sketched variations of it not long after Leonardo began to paint it, and at the dawn of the nineteenth century Napoleon took it to hang in his bedroom at the Palais des Tuileries. Leonardo certainly felt his portrait of Mona Lisa was quite special, as he may have had it in his possession for up to sixteen years, if he in fact began it in 1503 and held on to it until his death in 1519. Had the painting remained in the painter's homeland, it very well might have been purloined by Napoleon's raiders, who spirited away many treasured artworks and artifacts from Italy, including a number of Leonardo's manuscripts.

With precious few paintings by Leonardo having endured over time, the survival of *Mona Lisa* is something of a cultural miracle. From its Renaissance journey over Italian and French roads to its exhibition to the masses in modern times, the great painting avoided such calamities as fire, war, natural disaster, and madmen, not to mention the depredations of well-intentioned meddlers who, in attempting to restore the painting's original hues with varnish, obscured them even further. Instead of becoming a lost work of art mentioned in passing in history books and biographies of the

master, *Mona Lisa*'s fame as the greatest painting of all time began to spread in the nineteenth century. Generation after generation of people on every continent knew of Leonardo's painting of the lady with the mysterious smile. As the twentieth century dawned, *Mona Lisa* had become a matchless treasure. Having serendipitously endured over time, this artistic icon was entrusted to the solicitous safekeeping of the modern wardens of the masterworks of the past.

FOUR CENTURIES AFTER his death, the spirit of Leonardo hovered in the Salon Carré of the Louvre Museum in Paris, where his beloved *Mona Lisa* was displayed. Visitors from all over the world came by ship, train, and motor vehicle to gaze at the famous picture that was as much a part of the history books as revolutions and wars, remarkable discoveries and landmark scientific theories, eminent leaders and notorious villains, momentous explorations and major social issues. In this majestic gallery of the Louvre were the sublime works of many other masters, but so legendary was Leonardo that *Mona Lisa* was indubitably its most famous denizen.

Tuesday, the twenty-second of August, 1911, promised to be like any other day at the fabled art museum. It was the start of a new week, as the museum was closed to the public on Mondays, a day designated for maintenance, cleaning, and the preparation of exhibitions.

In the morning, a French artist, Louis Béroud, who painted grand scenes from the Louvre, noticed with frustration that *Mona Lisa* was not in its place. To one side of the vacant spot on the wall hung Correggio's *Mystic Marriage of St. Catherine,* to the other Titian's *Allegory of Alfonso d'Avalos.* But the da Vinci space was not filled as usual by the charming Florentine lady; there was nothing there but the vacant wall, from which a set of picture holders protruded. Béroud summoned a guard.

At first, the guard was not concerned. The official photographer, he assumed, had probably taken the painting to his studio, as some of the museum's important pieces were being photographed. It was unimaginable

that *Mona Lisa* could be purloined from the Louvre. It was true that theft and vandalism had been recent concerns at the museum; some works of art had been appropriated, sometimes without the losses being immediately made known. Damage to paintings was an even greater worry, but that was being addressed by a rather new—and controversial—museum policy of enclosing some of the more important paintings in glass.

But *Mona Lisa* was a force of nature as steady as night and day, as the seasons of the year, as the wind and the rain. No, the guard was certain the museum photographer had simply brought it to his studio on Monday when the museum was closed and had been negligent about returning it. The guard regretted the inconvenience, especially with the summer tourists who would be flocking to the museum anxious to see the portrait, but surely it would soon be returned to its customary place.

As time passed, Béroud grew increasingly impatient. He again summoned the guard, who this time checked with the photographer. No, the photographer had not removed the picture. Well, then, where could it be? The authorities were notified, and soon plainclothes detectives were discreetly searching for the portrait. By about three o'clock that afternoon, when it failed to turn up, the museum was ordered closed. A small army of sleuths now began to scour the huge museum for the world's most valuable painting.

The detectives made a discovery: *Mona Lisa*'s frame and the glass pane used to protect it had been discarded on a staircase. But the painting itself was nowhere to be found. Any last hope that the immortal painting had simply been misplaced vanished.

The theft of any painting at the Louvre would be cause for alarm, but the burglarizing of *Mona Lisa* bordered on a national crisis. Even though the painting came from Italy, it was as much a part of French culture as any of its great landmarks. Such an icon was this work of art that it would be an irretrievable loss, and not just for the Louvre, not even just for France, but for the world.

The police began to formulate theories. The most plausible was that the thief or thieves had hid in a room of the museum after it had closed two days earlier, on Sunday, August 20; and then the next morning, Monday, when the museum was closed, the culprit or culprits dressed themselves in workmen's clothes and, unnoticed, spirited the painting from the museum. Based on an account of a worker who passed through the Salon Carré when the museum was closed, *Mona Lisa* was probably stolen between 7:00 and 8:30 A.M. on Monday.

How the world's most famous painting could have been removed without its being detected was puzzling, but even more perplexing was why anyone would steal it. It was too famous to be put on the black market; *Mona Lisa* could never be sold without inviting trouble.

At five o'clock on the afternoon of August 22, Louvre officials announced publicly that *La Joconde,* as the French called the portrait of La Gioconda, had been stolen the previous day. The reaction from the local press was instant and vociferous: Stories ranted about the unlikelihood of such an event and about the incompetence of the Louvre. The theft became the lead headline in newspapers around the world.

Police interrogated all the employees of the Louvre, from custodians to curators. Even employees of independent contractors were interviewed. Jean Guiffrey, an assistant conservator, advised the police to look closely at the glaziers involved in the making of frames and glass coverings for the museum's most vulnerable items.

Leads and clues turned up: a readable fingerprint obtained from the discarded glass pane that had covered *La Joconde;* a series of letters addressed to "Mona Lisa" at the museum over the past twelve months; a man spotted at the railroad station on the morning of the theft carrying a portrait-sized object covered by a blanket, who boarded a train bound for Bordeaux; someone seen on Monday, the day the museum was closed, discarding into a gully a knob that belonged to one of the doors at the Louvre. Special government agents

around the world searched steamers as they arrived in ports, customs agents were put on alert, detectives trailed suspicious art dealers.

In a Paris newspaper article in late August, the avant-garde poet Guillaume Apollinaire criticized the Louvre guards and the museum's security measures. A couple of weeks later, in early September, Paris police arrested Apollinaire, not for the theft of *Mona Lisa* but for his association with Géry Pieret, who had served as his assistant and who was now missing. Pieret, a Belgian, had a few years earlier begun stealing Iberian busts from the Louvre, which he gave or sold to friends, one of whom was Pablo Picasso. Through the *Paris-Journal,* Pieret exposed the lax security at the Louvre by selling a stolen piece to the newspaper (he was promised anonymity), which reported his sensational criminal exploits. So flagrant did the plunderer's acts become that when he planned to visit the museum, he would ask his friends if there was anything he could get them. Picasso, who secretly returned to the *Paris-Journal* the pieces he had acquired, was interrogated by police but not charged. Apollinaire was eventually released.

Like the impenetrable enigma of Mona Lisa's smile, the whereabouts of the "Florentine lady" resisted discovery. How could the job have been executed so perfectly? Many of the best minds in the police community applied themselves to this caper but could not figure it out. Could *Mona Lisa* have been lost forever?

One year passed, then another. New leads emerged, but still the famous picture—if it still existed—was as untraceable as it had been when it had first disappeared.

The case was as murky as *Mona Lisa*'s gloomy mountain air. Would it ever be solved? Perhaps its course would be like the road behind La Gioconda, one that zigzags along with no end in sight.

At the end of November 1913, when hope for *Mona Lisa* had largely been abandoned, the lost painting no longer preoccupied the newspapers, and tensions of a world war were brewing, an antiques dealer from Florence named Alfredo Geri received a strange letter. The sender said that he had in

his possession the stolen *Mona Lisa* and that he wished it to be returned to Italy as restitution for Napoleon's looting of art and objects from his native country. The writer signed the letter "Leonard."

At first Geri thought his correspondent was just another prankster or crackpot, but he also realized that with the enormous difficulties of selling the picture, the thief might now be desperate. What was there to lose in responding to the letter?

Geri first contacted the head of the Uffizi Gallery, Professor Giovanni Poggi, who advised him to write back and say he was interested in purchasing the painting but would have to examine it first to make sure it was the authentic painting and not a fake, and that only then could he set a price. Geri exchanged letters with "Leonard" with the aim of setting up a meeting; "Leonard" requested it be in Paris, while Geri wanted it in Italy. But on the tenth of December, "Leonard" showed up unexpectedly at Geri's art shop.

The two arranged a meeting for the following day; Geri insisted that the art expert Giovanni Poggi participate. In the afternoon the three gathered in "Leonard's" room at the Hotel Tripoli-Italia. "Leonard" bolted the door shut and then took a trunk out from under his bed. He unlocked it and withdrew a pile of objects. The trunk appeared to be empty, but it had a false bottom. As Geri and Poggi looked on, the man then lifted the false bottom and withdrew a painting wrapped in cloth. The two tried to contain their excitement as "Leonard" carefully removed the painting from its shroud. After a preliminary inspection, Poggi said it would need to be examined further, and the three men proceeded with the painting to the Uffizi. A special committee of professional art experts gave the painting a detailed analysis. The portrait had on its back the identifying marks of the Louvre. It was indeed the stolen da Vinci. The men told "Leonard" that they would get in touch with him about the ransom, but shortly thereafter the Florence police, tipped off by Poggi, came to arrest him.

The arrested man was Vincenzo Perugia, a carpenter born in 1881 who had moved to France from his native Italy and had worked for an indepen-

dent company hired by the Louvre to build glass containers for some of its more famous paintings to protect against vandalism. He claimed he had stolen *Mona Lisa* as retribution for Napoleon's having pilfered works of art from his homeland, and he wanted to return the painting to the country to which it rightfully belonged.

Perugia, who had found Geri, the antiques dealer, in Florence from advertisements he had placed in local papers asking to buy objects of art, said he had acted alone. Henri Drioux, the head of the investigation, believed this to be true. The painting was small enough that if it was detached from its frame, it could be carried a short distance by one man. But Perugia, who had taken sole credit for the theft, perhaps because he viewed it as a heroic act, eventually implicated two others in the crime. On December 21, 1913, Paris police arrested three more people in connection with the theft: two brothers, Michele and Vincente Lancelotti, and a girlfriend of one of the brothers. Perugia said the brothers—who had hidden in an equipment room of the Louvre with him after it had closed and who had served as lookouts the following morning while he removed the painting from the wall—had harbored the painting, and that they had also helped construct the trunk in which it had been sequestered.

Meanwhile, public excitement about the recovery of *La Gioconda,* as Leonardo's portrait was called in Italy, was running high. French authorities approved plans to exhibit it in Italy. Leonardo's painting was shown at the Uffizi Gallery in Florence on December 14, 1913. The painting was next displayed in Rome, and then in Milan. Carabinieri—Italian soldiers— escorted the portrait on its rail trips. Wherever it was exhibited, people turned out in droves to see it.

Now it was time for Leonardo's portrait to be returned to France. It was packed securely and prepared for transport. Dignitaries and police accompanied the portrait in its journey by railway carriage, which arrived in Paris on the afternoon of December 31, 1913. In just days it would hang

again in the Louvre before an adoring public, two years and four months since it last had done so.

At his trial, Perugia made himself out to be a patriot of Italy, but prosecutors maintained he stole the painting purely to profit from his misdeed. Geri claimed Perugia wanted money for *Mona Lisa,* which Perugia vehemently denied. But Perugia's defense garnered much sympathy from his countrymen, who saw him as a kind of folk hero. In the end he was found guilty of stealing the painting but received a light sentence of twelve months and fifteen days. This term itself was reduced, and with the amount of time he had already spent in jail, he was set free.

The Paris police were the target of criticism for the way they had handled the case. An officer had interviewed Perugia himself, since he had been employed by a contractor of the Louvre, and he had managed to smooth-talk his way through the interview without arousing any suspicion. But Perugia had a criminal record; since his fingerprints were already held by the police, why had they not been checked against the print found on the discarded glass pane at the Louvre? Parisian fingerprint authority Alphonse Bertillon stated that under the system used by his department, which had three-quarters of a million criminal records, only the right thumbprint was used for classification purposes, and the print recovered from the glass pane was that of a left thumbprint. Other criticisms included the failure by the police to follow up on Jean Guiffrey's suggestion to check the Louvre's freelance glaziers.

Alfredo Geri, the Florentine art dealer Perugia had contacted, received a cash reward from the Société des Amis du Louvre (Society of the Friends of the Louvre), but he felt he was entitled to an additional reward equal to 10 percent of the painting's value. According to the *New York Times,* some major Parisian art dealers appraised *Mona Lisa* at a minimum of five hundred thousand dollars, while others estimated its worth to be in the millions. Still others, because of its history, deemed it priceless. In the end, however, a court ruled that Geri was not entitled to a percentage for a reward.

With *Mona Lisa* restored to the Louvre and Perugia having had his trial, it seemed that the tale of its theft had come to a conclusion. But a story was to emerge that showed there was much more to it—there was a mastermind behind the crime, and a forger and others were involved as well.

A reporter named Karl Decker wrote that Eduardo de Valfierno, a South American art swindler, had told him a story on condition that it not be published until after his death. Valfierno died in 1931, and Decker then revealed what the swindler had secretly divulged. According to Valfierno, it was he who had hatched the whole *Mona Lisa* theft as part of a forgery scheme to make money from selling copies of the portrait.

Valfierno had devised the perfect art theft: Find several wealthy art collectors who were known to buy stolen masterpieces and promise them the world's greatest painting. Have an expert forger create perfect reproductions of that painting, then steal the painting, hoping the theft received plenty of publicity so the buyers of the forgeries knew it was stolen. The buyers would not be able to have their copies authenticated for fear of being implicated in the sensational criminal act, or of being vulnerable to bribes.

This is what Valfierno claimed to have done, recruiting a forger and a team that included a former Louvre employee who knew the layout of the museum and the habits of its workers. His only fear, he told the reporter, was that the Louvre would substitute a copy for the real da Vinci to avoid a public outcry, and that his buyers, unaware of the theft, would not believe they were purchasing the actual *Mona Lisa.* But of course none of this happened, because the theft was revealed and received worldwide attention in the press. Valfierno claimed he had sold six forged copies of *Mona Lisa* at three hundred thousand dollars each.

The *Mona Lisa* heist was carefully planned, and although there were a few minor glitches, the culprits pulled it off, avoiding detection for over two years. Fortunately for posterity, the painting was not harmed or lost, intentionally or accidentally, while the perpetrators had it in their possession.

The heavens occasionally "shower the richest gifts on human beings," the art historian Vasari mused, and sometimes, "supernaturally, they marvelously congregate in one single individual." Grace, talent, and beauty are entwined in such extravagant abundance, he wrote, that wherever the man plucked from the sea of ordinary individuals may turn, his every action is transcendent, leaving all others far behind. Such a man clearly demonstrates that he did not acquire his preeminence by the teaching or power of mortal humans, but that his genius is specially endowed by the hand of God. "This was seen and acknowledged by all men in the case of Leonardo da Vinci," concluded Vasari.

Leonardo's sublime gifts indeed "marvelously congregate" in his portrait of *Mona Lisa*. Having survived the vicissitudes of time, including its spectacular theft in 1911, this display of his genius in a single glorious work of art will be savored by untold future generations.

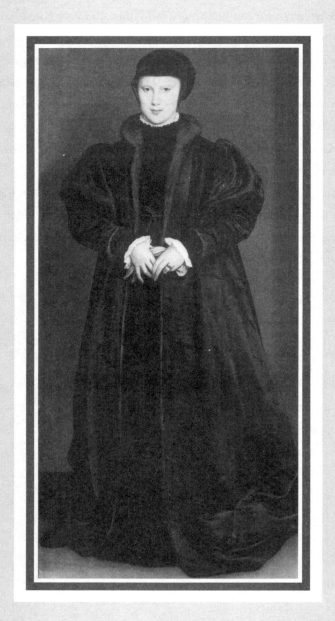

Christina of Denmark, Duchess of Milan

(1538)

Hans Holbein the Younger

✠

Before the age of photography, people, particularly royalty, commonly used painted portraits to see what a potential spouse looked like. If a king, for instance, was in the market for an eligible queen, he would send his court painter to the royal courts of foreign lands to paint for the king's appraisal pictures of promising candidates. In the wrong hands, however, this could be a dangerous enterprise, for if a marriage were arranged on the basis of an inaccurate likeness, the outcome could be bitterly disappointing when the future spouses met in person.

Here is a tale of a king, his advisers, his court painter, and how all their lives were affected by the consequences of vital decisions based on portraits.

FOR LONG, HARD years, a dark cloud hovered over continental Europe. Blood ran through its fields and streets, and the fabric of society was torn with political and religious conflict. Armies marched on cities, treaties were signed only to be boldly repudiated. There were invasions and sackings, massacres and revolts, alliances and betrayals. The bold new ideas of the Protestant Reformation took hold of the minds and hearts of many, creating

deadly friction even over the most fundamental values. The continent was a hotbed of mayhem and strife.

Charles V, the Holy Roman Emperor, and Francis I, the king of France, were constantly warring over duchies: Burgundy, Milan, Naples, Savoy. Charles, whose imperial lands spanned southern and central Europe and extended to Spanish America, tried to maintain his vast empire; Francis, surrounded by Charles's lands, wanted to control Italy. The Ottoman Turks, always a threat, cast their avaricious eyes on the eastern parts of the empire. There were constant clashes as the quake of the Reformation rocked the continent. In 1536 war between Francis and Charles erupted again, precipitated by imperial aggression and the French invasion of Milan, but what threatened to be another drawn-out affair appeared to subside with the intercession of the pope. Indeed, as the year 1537 drew to a close, it looked as though longtime rivals Francis and Charles might be headed toward a truce, leaving them free in their new amity to turn their attention elsewhere. And in England it was feared that when the great Catholic leaders Francis and Charles were no longer rivals but a mighty military alliance, they— along with the pope—would look to their isolated neighbor to the north. England's iconoclastic king, who had brazenly cast off the authority of the pope to suit his own personal needs, was in danger of being ousted so his nation could be reunited with the Catholic Church.

IN EARLY DECEMBER 1537 a servant of John Hutton, the English envoy to the Netherlands court, departed Brussels for London carrying a letter from Hutton to Thomas Cromwell, the chief minister of the English king, Henry VIII. Cromwell had issued instructions to English agents in the European royal courts to search quietly among the noblewomen of the continent for a suitable bride for the widowed king, whose wife, Jane Seymour, had tragically died in October after giving birth to a son. The king's counselors had considered the current political situation and decided that a foreign queen consort, with the resulting alliance of her homeland, would serve

England's security. Hutton, having "made as much secret search as the time would permit," was writing to inform Cromwell that he had come up with four potential mates. First he mentioned the fourteen-year-old daughter of the lord of Breidrood, who waited upon Queen Mary of Hungary, the regent of the Netherlands, the sister of Emperor Charles V. Her beauty, he observed, was "competent." Next he suggested a "widow . . . being of goodly personage . . . the wife of the late Earl of Egmond." Her forty years, wrote Hutton, "doth not appear in my judgment by her face." The third candidate was "the Duchess of Milan, whom I have not seen, but . . . is reported to be a goodly personage and of excellent beauty." Finally, the duke of Cleves, a principality of the Holy Roman Empire on the Rhine, had a daughter, "but I hear no great praise neither of her personage nor beauty." Hutton shrewdly absolved himself of responsibility for judging female desirability, noting that he had "not much experience among ladies, and therefore this commission is to me very hard. . . . I have written the truth, as nigh as I can possibly learn, leaving the further judgment to others, that are better skilled in such matters."

The advantages of marriage with one of the noble damsels were carefully weighed. The Breidrood princess had youth on her side, but the amity gained from a marriage with her would be limited. The widow of the earl of Egmond might look well for her years, but she was probably too old to bear another son for Henry. The daughter of the duke of Cleves, even if her father had power over the important German principality, was probably plain-looking. The duchess of Milan, however, appeared to have much going for her.

A few days after Hutton wrote the letter, the duchess arrived at the court in Brussels, then part of the Netherlands. Hutton filed a follow-up report, this time showing some enthusiasm about this potential bride for the king. The duchess, he reported, was sixteen years old, fit for having children, "a goodly personage of body, and competent of beauty, of favor excellent, soft of speech, and very gentle in countenance." She mostly spoke French but reportedly could converse in other languages, including Italian. Hutton

noted that she resembled Mistress Shelton, who had waited on Henry's second wife, Anne Boleyn; and that she wore, in the manner of Italy, mourning apparel, being a recent widow. Again, Hutton begged to excuse himself from personal error in his appraisal, acknowledging his "judgment herein very ignorant, albeit I have employed my wits to certify your Lordship of the truth."

The pedigree of the imperial duchess was distinguished. Her father was Christian II, the deposed king of Denmark, Norway, and Sweden. Her aunt was Queen Mary, the Lady Regent of the Netherlands. Mary's brother—the duchess's uncle—was Charles V, the Holy Roman Emperor, and grandson of Ferdinand of Aragon and Maximilian I. Marriage with the Danish-born noblewoman would preclude an alliance between Charles and Francis against England.

As for the English king's own suitability as a mate, his conjugal history would surely be of concern to any prospective bride. Henry—who had succeeded to the throne following the death in 1509 of his father, Henry VII—had first taken to wife Catherine of Aragon. She was the daughter of Ferdinand and Isabella of Spain, and the widow of Henry's brother Arthur, who had died of tuberculosis soon after their marriage. Henry married Catherine, who was five years his senior, to maintain an alliance with Spain. But the union produced only one surviving child, a daughter, Mary. Growing tired of Catherine, Henry had earlier tried to end the marriage by a suit that he had then put aside. A decade later, advised that she was no longer of childbearing age, he became determined to discard her. In 1519 Henry had an illegitimate son with Elizabeth Blount, one of Catherine's waiting women; later, another lady-in-waiting, Anne Boleyn, whose sister Mary had been one of his mistresses, became an object of great passion for him.

The approval of the Church was needed for a legal divorce from Catherine. Henry tried to obtain it from the pope on the grounds that his marriage to Catherine was not valid in the first place, as she was his

brother's wife; but the pope was under the control of Charles—Catherine's nephew—whose troops sacked Rome and imprisoned the pope.

Knowing the pope would not accede to his request, Henry induced the English clergy to acknowledge him as the head of the Church of England, whereupon he was able to grant himself his own divorce. He was already cohabiting with Anne, and in January 1533 he married her; the marriage was not revealed until Easter, when her pregnancy was announced. Those who opposed Henry in his endeavors to obtain a divorce from Catherine were executed or imprisoned. So onerous were Henry's demands that many secretly wrote to Charles's ambassador asking for an imperial invasion (the request was refused). The pope invited Henry's overthrow; indeed, Henry got his divorce, but made an enemy of the pope.

When Catherine died in January 1536, Henry and his new queen wore yellow in symbolic celebration. But Henry had already wearied of Anne Boleyn. She had given birth to a daughter (who later became Queen Elizabeth), but not to a son. Taking this as a sign from God that the marriage was doomed, Henry accused her of fornicating with her brother and other members of Henry's court and put her head on the block. The only bit of mercy he extended to his former love was to summon an expert French swordsman who could do the deed swiftly. No sooner had Henry disposed of Anne than he took his third wife, Jane Seymour.

In October 1537, Jane Seymour fulfilled Henry's wish and delivered a legitimate son, the legal heir to his throne, the future promulgator of his royal seed and the thread to the Tudor lineage. The birth brought the king boundless joy, but Jane Seymour was beset by childbed fever and other maladies. Her dismal fate twelve days later was not hard to foretell, and Cromwell—the king's minister, adviser, and guide to keeping England on the right course—immediately set himself to the task of finding a proper new consort for Henry. English envoys at the foreign courts were asked to consider available princesses.

Henry was dispirited after Seymour's death, but it was not long before his mood changed and he began to consider taking a new wife. He was fully cognizant of the political expediency of taking a foreign queen, but he was even more wary of the precariousness of a dynasty that rested on the life of a single fragile newborn. Another son would provide extra insurance for his own immortality. And besides, given the right lady, what could be wrong with falling in love again?

At the time, leaders routinely traded the hands of daughters and sisters to create alliances and acquire dowries, and indeed, Henry recognized that a rapprochement between Charles and Francis could threaten his reign. Finding a new mate was of considerable urgency, yet Henry couldn't just take any noble woman for his new queen, regardless of her pedigree or the consequent political alliance that would be formed. Although he was middle-aged and had already gone through three wives, he wanted a wife with whom he could have romance, some relief from the draining duties of a monarch. His new bride had to offer joy and excitement; for that, she had to be physically desirable, to strike within him some chord that aroused his sensuality.

Hutton, the envoy at Brussels, thought the duchess of Milan with her youthful comeliness would appeal to the king. In a letter to Thomas Wriothesley, a royal official, he wrote, "There is none in these parts of personage, beauty and birth like unto the Duchess of Milan. . . . She hath a singular good countenance, and when she chances to smile, there appeareth two pits in her cheeks, and one in her chin, the which becometh her right excellently well."

By a proxy marriage when she was thirteen, Christina had become the wife of Francesco Sforza, the duke of Milan; Charles had reinstated Sforza to the Milan duchy after ridding it of the French. But Sforza died in 1535, leaving the dimpled duchess a widow, but also leaving open the question of succession of the duchy, which Francis answered by attacking the duchy in an effort to once again control it. At her tender age the duchess had many childbearing years ahead of her, no doubt an inviting prospect for Henry.

With the duchess of Milan seeming to make a propitious new queen, the proper protocol was put in place to consummate the match. Early in 1538 the English ambassador in Spain made an official conveyance to the Holy Roman Emperor that the king of England wished to have the hand of the duchess of Milan. A response came through the imperial ambassador in London: The emperor was amenable to the idea if negotiations could be successfully completed.

Given Henry's requirement for beauty in a mate, before he could enter into marriage with a lady unknown to him it was first necessary for him to inspect her personally, or, failing that, at least to see her portrait. Hutton, the ambassador, proposed a meeting at Calais, the British possession in northern France, but was refused. Acting on Cromwell's instructions, Hutton then made a diplomatic appeal for a portrait of the Milanese duchess.

Although Hutton was promised the required portrait, Cromwell thought it prudent to have an official interview with the duchess, and to ensure that her portrait was painted by someone who could be trusted not to produce a falsely flattering view of the subject. To this end in early March of 1538 he sent Philip Hoby, a diplomat, and Hans Holbein, Henry's court painter, to the court of the Netherlands. Shortly before they arrived, however, a portrait of Christina was made and Hutton had ordered a servant to convey it to Cromwell. But now with the king's diplomat and painter expectantly present at court, the painting became in Hutton's opinion "not so perfect as the cause required, neither as the said Mr. Hans could make it." He promptly sent another servant to retrieve it.

Since a painting had already been officially furnished by the Brussels court, Hutton met with Queen Mary to arrange the delicate diplomatic details of a sitting with the duchess for Holbein. The next morning Hutton addressed himself to the Lady Regent, announcing that an earnest overture had been made to the emperor for a marriage between his majesty King Henry and the duchess of Milan. As much praise as Lord Cromwell had for the beauty, wisdom, and other fine qualities with which God had endowed

the duchess, surely the Lady Regent, Hutton suggested, could perceive no greater advancement for the marriage than for the king "to procure her perfect picture." To that end, he told her, Cromwell had sent "a man very excellent in making of physiognomies."

The regent, thanking him for the "good news," graciously consented, and an audience quickly followed for Hutton with the duchess herself, at which he obtained her personal permission.

The young widow altruistically let herself be proffered as connubial booty for the king of England, even if Henry, born in 1491, was at forty-six much older, corpulent, and unattractive; even if each of his three previous wives had coincidentally died; and even if, as rumor had it, her great-aunt, Catherine of Aragon, Henry's first wife, had succumbed not from natural causes but by poison administered by Henry's agents. As pernicious as Henry's behavior was in both political and personal affairs, perhaps Christina was inured to the tyrannical behavior of the men close to her. After all, when her father's mercenary troops conquered Sweden, a bloodbath had ensued following Christian's festive coronation; more than eighty opponents who had been promised amnesty—burghers, clergy, nobles, and townspeople—were seized and led to the chopping block in the chief square of Stockholm.

But other factors weighed too heavily for this daughter of the empire to withhold her hand. As the daughter of a sister of the Holy Roman Emperor, Christina no doubt thought it her natural duty to submit to the wishes of her venerable uncle Charles, and while she surely recognized she was a pawn in a men's game of chess, it was not for her to raise her voice in defiance.

The next day, Holbein was given three hours to paint the duchess.

Holbein had to be careful to portray the sitter accurately. If Christina's beauty was not apparent, it would reflect poorly on Hutton and the others who had issued favorable reports on her physical appearance and could lead Henry to reject the potential bride. On the other hand, a too-flattering rendition could be an even greater disaster, raising Henry's expectations only

to leave him crushed on the day of the wedding when he met his future wife. The task of the court painter was to capture the likeness of his subject with perfection, thus exculpating himself from any injudicious decisions made on the basis of his work.

As it turned out, Holbein succeeded spectacularly. Hutton wrote that Holbein had showed himself to be the "master of that science, for it is very perfect," while the previous portrait, in comparison, was "slobbered," as Cromwell would soon perceive. That evening Hoby and Holbein departed Brussels bearing the hastily finished painting.

"Mr. Hans" Holbein had come from Germany, where he was born around 1497 or 1498 in Augsburg, an important mercantile center with a burgeoning art trade. He received instruction in the Augsburg studio of his father, Hans Holbein the Elder. He painted in Basel, probably in the workshop of Hans Herbst, and in Lucerne, improving his style over time and earning a reputation for himself. Over the years he moved back and forth between London and Basel, and in 1532 was back in London again. Holbein painted many fine portraits, including those of Erasmus and the family of Thomas More. An introduction to Thomas Cromwell brought him to the court of Henry VIII as court painter in 1536.

Holbein's picture of the duchess of Milan warmed Henry's heart. As the imperial ambassador in London, Eustace Chapuys, wrote to Queen Mary, he had been informed that the picture "has singularly pleased the King, so much so, that since he saw it he has been in much better humor than he ever was, making musicians play on their instruments all day long." He "cannot be one single moment without masques, which is a sign he purposes to marry again."

With Holbein's "perfect" image of the duchess, Henry was no doubt pleased to see that the reports of Christina's beauty had not been exaggerated. But he desired something more substantial, something grander to gaze upon, and he set Holbein to painting a full-length portrait. What the artist produced was astonishingly beautiful. The duchess wears a black

mourning coat that drapes about her in vibrant folds. Her face looks fresh and lively, her eyes directed to the viewer. Her hands, pale and smooth like her face, are held in a lifelike manner.

For royal parties with specific interests in tense times, marital contract negotiations were a formidable endeavor. With fears of invasion troubling his mind, Henry wanted peace guarantees for England. In the event of a French-imperial treaty, Charles required of Henry a dispensation from the pope regarding his first wife, Catherine. Difficult contract terms could sometimes be stumbling blocks to an international royal marriage.

Any search for a new queen would naturally embrace several candidates, and consideration was given to others in the attempt to find the most suitable bride for Henry. One lady who attracted the king's interest was Mary of Guise, a twenty-two-year-old widowed French duchess whose reportedly generous figure appealed to him, given his own ample frame, but she was intended for King James V of Scotland, so he had to look elsewhere. Indeed, so many French candidates had been suggested that Henry unabashedly requested a parade of princesses at Calais so he could inspect them individually. The French court objected, asking why he could not trust another man's opinion. But depending on someone else's judgment in the delicate matter of choosing a wife, even if it was customary, was simply out of the question for Henry. He declared, "The thing touches me too near. I wish to see them and know them some time before deciding." But the king would have to settle for portraits. Again, not trusting such an important matter to unknown painters, he sent Holbein across the Channel several times to capture some of the candidates' likenesses. Meanwhile, negotiations for the Milanese duchess were dragging on.

The English tried to breathe life into the deflating negotiation. Hutton, who had so wisely chosen a daughter of the empire to join with the English king, was now deceased, and another envoy took over the diplomatic duties of cultivating the duchess's interest. But resistance arose on the imperial side in the form of rigid stipulations. Had Charles really intended for his niece to

become the wife of the English king? Was Charles really ready to embrace Henry after he had cast aside his aunt Catherine? What political advantage was to be gained from having Henry as an ally? What was to be gained in giving Henry, as the husband of the duchess of Milan, power in the coveted duchy? Indeed, with the hindrance of negotiations, could the emperor rather have been cunningly engaged in political chicanery to stop Henry from marrying a French woman and creating an alliance with Francis? And finally, even if she had never actually uttered the bon mot that would be famously attributed to her, that if she had two heads, she would risk one in the king's service, could the astute young duchess actually have had input into the implausible negotiations?

In June 1538, with the intercession of the pope, a ten-year truce between Francis and Charles was negotiated at Nice. The next month the French king and the emperor, longtime rivals, met face-to-face at Aigues-Mortes to confirm the treaty. In England this powerful new Catholic alliance was deemed a threat to the country; the combined power of France and the Holy Roman Empire threatened any country that cast off papal authority. In the ensuing panic the nation prepared for an attack, building, fortifying, digging, and mustering townspeople. It was a tense time for England. It also signaled that the prospect of marriage with the duchess of Milan, born of a Catholic dynasty, was all but over. Cromwell, seeing the inevitable rise of Protestantism, wanted an alliance with a state that had repudiated the authority of the pope. A political alliance with a German Protestant duchy might be a sharp political move. Cromwell, ever the king's counselor, always England's servant, who sought the diplomatic benefits of a marital union for his majesty, looked to the House of Cleves.

THE DUCHY OF Cleves was in the Lower Rhineland, a small Germanic principality that sat on both banks of the River Rhine.

About Anne, the duke of Cleves's daughter, John Hutton had written in 1537 that he heard "no great praise of her beauty." But that was then, in the

aftermath of Jane Seymour's death. Times had changed. People had changed. Taste was subjective. Duke John of Cleves had died and been succeeded by his son William. A marriage with either of William's two sisters, Anne and Amelia, could forge an alliance with the German principality.

The usual portraits were offered, but ever the untrusting suitor when it came to likenesses of prospective mates, the discriminating monarch in 1539 dispatched his faithful Holbein to Düren to record the images of the sisters of the House of Cleves so he could determine which one appealed to him more.

It was the portrait of Anne that overwhelmed him. The salient feature of Holbein's three-quarter-length painting was her decorative embroidered gown and headdress. The headdress completely covers her head and extends down the sides of her face, framing it. Her eyes are cast downward, her face devoid of expression, but she is wholly palatable. Anne was twenty-four years of age, possessing neither the glowing looks nor the fertility of youth, but she appeared to be an attractive, clear-skinned woman sheltered in exotic garb, and this mysteriously sensual image sent Henry into amorous raptures. And if he had any doubts about this lady of the Rhine, they were allayed by Cromwell, who had informed him of a report he had received that Anne's beauty surpassed that of Christina "as the golden sun did the silver moon."

Henry was exuberant about his potential new mate, and a marriage contract was successfully negotiated. He planned a wedding to befit his spectacular new bride and had his royal living quarters embellished while he waited breathlessly for Anne's arrival. Anne and her large entourage would journey by ship to England, and the royal couple would be married in London, where he would see his bride for the first time. But when word reached Henry in late December 1539 that Anne had arrived at Deal, he was unable to contain his ardor. He needed, as he said, "to nourish love." On New Year's Day, the king and several members of his privy chamber disguised themselves in colored cloaks with hoods and traveled secretly, bearing a New Year's gift, to meet Anne at the abbey at Rochester, a resting

stop on her way. In his incognito attire, Henry eagerly strode into her chamber to greet his future queen.

And then he stood frozen, appalled. Anne's nose was long, her face pitted by smallpox. The beauty that shone in Holbein's painting was not to be found in the lady herself.

Henry composed himself. He embraced her and offered her the king's token. Not knowing who he was, she thanked him and turned away. The king repaired to another room and returned wearing his purple velvet coat, whereupon his knights bowed humbly, and Anne, astonished, quickly followed. Anne did not speak English, so their conversation was of few words. On the return journey to London, Henry was reportedly uncharacteristically silent.

The king was sunk in disappointment and anger. How could Anne have turned out to be unlike the glowing reports? How could Holbein, a master portraitist, paint the plain sitter so flatteringly? Could he have painted to please the Düren authorities who would inspect his work? Was Cromwell not forthcoming about letters recounting Anne's physical appearance? How could Cromwell, who had negotiated the marriage on his behalf, not be aware of the looks of the bride, knowing how important they were to the ever-amorous king?

With all the elaborate preparations that had been made for the wedding, there was no graceful way for Henry to withdraw from it. For the sake of the realm he went forward with the marriage ceremony on January 6, 1540, in the most gentlemanly manner he could muster. But the king, so hopeful of love and romance, would not be duped. His court painter had failed him, his chief minister had failed him. Somebody had to pay for the grave and embarrassing error. Holbein fortunately escaped the king's blade, but not so Cromwell. Henry made him earl of Essex, but six months after the wedding a captain of the guard came to arrest the chief architect of the betrothal of Henry and Anne. Imprisoned in the Tower of London, incredulous that he, the king's minister, should be charged with treason, Cromwell was

understandably livid. But he had little time to brood; on July 28 he went to the block, and his severed head was publicly displayed.

Henry obtained a divorce from Anne that same month. The threat of an invasion of England that had prompted Cromwell to ally with the Cleves duchy was over, as Charles and Francis were on the verge of war. Overcoming his despair from this unsavory conjugal experience, Henry would take two more wives, bringing the final tally to six. Wife number five, Catherine Howard, should have heeded the fate of wife number two, Anne Boleyn. Both she and her lover lost their heads.

As for Christina of Denmark, the duchess of Milan, in July 1541 she married François I, the duke of Lorraine and Bar, at Brussels. François was only four years older than Christina, but this marriage, too, would be relatively brief, as the duke would leave her a widow just four years later.

In any case, Christina was permanently out of Henry's life, but at least the king left behind a token of the imperial damsel he was never to meet, a magnificent portrait of a beautiful woman who had put him in "much better humor than he ever was," had led him to make "musicians play on their instruments all day long," and who could not be "one single moment without masques"—clear signs of a royal heart overflowing with rapture, thanks to his talented court painter, Hans Holbein the Younger.

Eleonora of Toledo
with Her Son Giovanni de' Medici

(1545)

Agnolo Bronzino

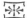

 One of the odd utilitarian functions of paintings is as evidence in historical detective work. Like a DNA sample in a modern criminal case, elements of a painting can fill in the missing pieces in a longstanding mystery. But like any real-life detective story, the plot can have many twists and turns.

FLORENCE, 1857: A certain matter of shameless plundering over the previous six or seven decades draws the attention of Leopold II, the grand duke of Tuscany. Following physical alterations made in 1791 by Austrian grand duke Ferdinand III to the old and venerable basilica of San Lorenzo, several coffins of the Medici, the powerful dynasty of the Florentine Renaissance, were moved from a ground-level mausoleum to a subterranean crypt, where they were left in disarray and subsequently raided for their jewels. The coffin violations have dishonored the glorious heritage and honor of the eminent and noble family, and Leopold determines that an official examination and proper reorganization of the coffins and their contents are warranted.

It was the tradition of the Medici family, which ruled Florence from the fifteenth to the eighteenth centuries and whose members included popes, cardinals, and queens, to inter their dead in the cavernous Florentine church. But like the ancient dynastic Egyptian pharaohs who were buried in heavily fortified royal necropolises along with troves of their earthly possessions, the Medicis failed to prevent the plunder of many of their tombs by determined thieves.

Leopold appoints members to a government commission, including physicians and municipal authorities, and they set about opening forty-nine coffins of the Medici to identify and examine the corpses inside, as well as any burial garments and accompanying valuables. So solicitous are the overseers of this enterprise that guards are assigned to watch over the laborers to prevent any purloining of the remaining valuables.

In one section of the crypt lie the remains of a distinguished sixteenth-century family of the Florentine dynasty, Cosimo I de' Medici, his wife, Eleonora, and two of their eleven children.

COSIMO'S REIGN WAS one of the most colorful epochs of the Medici dynasty, encompassing a majestic wedding to a beautiful young bride, merciless suppression of his political enemies soon after his election as a duke, totalitarian rule, a fierce war against Siena, the restoration of order to the Tuscan state, stimulation of trade, and efforts to embellish the city of Florence.

From the time he assumed the mantle of leadership at the tender age of seventeen, Cosimo, blond, handsome, and powerfully built, wisely considered taking a wife of royal blood who could bolster his somewhat tenuous position as head of state. A search for a suitable bride at the Spanish court by Cosimo's envoy was unsuccessful. Then the Spanish viceroy of Naples, Don Pedro de Toledo, offered his eldest daughter, Isabella; but Cosimo instead asked for the hand of Don Pedro's younger daughter, whose beauty he may have glimpsed on a visit to Naples in 1536. Negotiations were undertaken

in late 1538, and after a dowry and other matters were worked out, Eleonora of Toledo was promised to Cosimo as a wife.

For Cosimo, it was a propitious move. Eleonora, the daughter of an immensely rich father and of royal lineage herself, would bring the impoverished new leader the wealth he needed. Moreover, as it turned out, Eleonora's insightful nature and calming presence moderated Cosimo's fits and furies and dark moods. At a time when marriage was more for political gain than love or passion, they seem to have had a deep and genuine relationship.

Eleonora not only proved to be a devoted wife and mother, she had many notable accomplishments as a duchess, both charitable and diplomatic. Most important, however, she bore male progeny for the Medici line to continue its reign. A beautiful woman, her grace and elegance were captured by the official painter to the Medici court, Agnolo Bronzino. Indeed, Bronzino's portrait of Eleonora with her son Giovanni was the artist's tour de force. Bronzino had painted Eleonora once before, and she had been so delighted with the picture that she commissioned him to paint another. But she wanted something a bit different, and Bronzino obliged.

The richly detailed portrait, painted in 1545 when she was twenty-three, shows a composed young woman of fine features and delicate beauty sitting upright with her right arm curled affectionately around the shoulders of a young boy standing close by her side. Her little towheaded companion, dressed in a blue suit, his left hand resting gently in her lap, is her son Giovanni. The boy, wide-eyed, stares innocently at the viewer. But the salient feature of the striking portrait is Eleonora's elegant dress.

The duchess is wearing a brown, black, and white brocaded gown. The bodice fits snugly around her chest, and the skirt ripples with rich folds. Around her waist is a sash with a cord ending in a thick tassel that rests just below her long, slender left hand. Gold piping runs down the length of the full sleeves from the shoulder rolls to the cuffs. A wide gold netting covers her shoulders, and a long rope of huge pearls hangs over her bodice. A shorter

pearl necklace with a pendant fits snugly around her neck. Her dark hair, parted at the center, is confined in a bejeweled snood.

In the fall of 1562, Cosimo and Eleonora and three of their sons embarked on a trip to Pisa, where the balmy winter climate would be better for Eleonora's now delicate health. But the trip proved to be a disaster. They had gone by way of the Maremma, a swampy area where there was an outbreak of malarial fever, and the scourge took its toll on the travelers. Nineteen-year-old Giovanni, a cardinal, died of malaria in November. A few weeks later his younger brother, Don Garzia, fifteen, expired. The parents were grief-stricken, but the calamity was not over. On December 18, Eleonora, who had long suffered from tuberculosis, succumbed to malaria herself.

Eleonora did not get to see her husband, who later relinquished his reign as duke of Florence to their son Francesco, achieve his highest honor: being crowned the first grand duke of Tuscany by Pope Pius V in 1569, just a few years before his own death in 1574. At the end of December 1562, the unembalmed body of Eleonora di Toledo de' Medici, dressed in an exquisite gown, was placed in a wooden coffin in a crypt of the San Lorenzo church in Florence for her eternal slumber.

IN THE COURSE of the 1857 government examination, a startling discovery is reported. No inscription identifies Eleonora's wooden casket, but after medical analysis the bones therein are determined to have been those of a woman not far over the age of thirty. The remains are enclosed in a long satin gown with an embroidered bodice and skirt, an undergown, and a hair snood.

The official examination reports (as translated by G. F. Young in his book *Medici*), "The body was recognized with certainty by the rich dress of white satin richly embroidered with 'galoon' trimming all over both the bodice and the skirt, exactly as she is depicted in the portrait by Bronzino which is in the Gallery of the Statues [Uffizi Gallery] together with the same net of gold cord worn on the hair."

The commission's discovery of the gown Bronzino had immortalized in his famous portrait of Eleonora appears to be a remarkable find. The work is known for its magnificent depiction of the dress. Now, three hundred years later, here evidently is the gown itself, enveloping the duchess in her eternal sleep—a charming ending to a storybook tale.

FLORENCE, 1983: DECADES after another study of the burial garments by the Bargello National Museum in the 1940s, the clothing is taken to the Costume Gallery housed in the Pitti Palace, the former Tuscan grand dukes' residence in Florence, for conservation. For the most part the garments are in a very deteriorated condition. A meticulous study begins of Eleonora's burial dress, parts of which are missing or separated.

For many years now, Agnolo Bronzino's portrait of Eleonora and her son Giovanni has been associated with the romantic story of Eleonora's magnificent gown being found in her coffin three centuries after her death. It is the art world's version of the kind of exhilarating archaeological excavation that turns up great lost treasures, rivaling in importance such later events as the discovery of Tutankhamen's tomb and the recovery of the lost body of the acclaimed American Revolutionary War naval hero John Paul Jones from under the streets of Paris. For decades people have reveled in the enchanting story of an important and beautiful sixteenth-century duchess and the reemergence of her famous gown hundreds of years later.

Over the course of ten years, a team labors to conserve the recovered burial garb of Cosimo, Eleonora, and their son Don Garzia. Eleonora's burial dress is reconstructed, chiefly by the renowned English historian of Western costumes Janet Arnold. Although Arnold's reconstructed gown is floor-length and made of satin with a velvet bodice, like the dress in the Bronzino portrait, it becomes clear upon careful examination and detailed comparisons that there are distinct differences between the two. As it turns out, the report of the 1857 tomb examination that led people to believe

Eleonora's burial dress and her famous Bronzino portrait gown were one and the same was simply not accurate.

PAINSTAKING MODERN ANTHROPOLOGICAL research had supplanted what seems to have been an unscientific and superficial rush to judgment. Alas, this appealing evidence for the identity of an aristocratic corpse has crumbled like the famous gown's remains, yielding some unglamorous loose ends—was this, in fact, Eleonora's body after all?—and the hard lesson that detective work, as exciting and fascinating as it can be, has no more of a claim on happy storybook endings in the world of art than it does in life.

Mars and Venus United by Love

(c. 1576)

Paolo Veronese

❧

Under the surface of a painting may lie unseen brushstrokes that tell a story about the work other than the one visible to the naked eye. When the underpainting is revealed through X-raying, the analyst may gain insight into the original intentions of the painter, as well as the artistic and perhaps psychological processes that shaped the painting's final form. X-ray studies are commonly performed on paintings not only to amplify the understanding of a painting's creation but also to determine whether it is a forgery, to learn about the artist's technique, or to facilitate repairs.

Mars and Venus United by Love, by the sixteenth-century Italian Renaissance painter Paolo Veronese, was seemingly painted with the grace and finesse that typifies the rest of his oeuvre, but as X-rays show, even this brilliant painter had his struggles.

Commissioned by Emperor Rudolf II of Austria, a patron of the arts prone to melancholic moods, *Mars and Venus United by Love* shows the two gods of Roman mythology in a pastoral scene of romantic tranquility. Venus stands naked, her left arm casually encircling the shoulder of Mars, who sits hunched over before her in his armor, artfully guarding her modesty with a piece of drapery. Holding her right hand to her breast, the nubile goddess of

love is in the full bloom of her femininity. In the background stands Mars's war horse, bridled and tethered, suggesting that the god has been tamed by his amorous yearnings. A chubby cupid twines a ribbon around Venus's leg, which rests lightly on that of her lover. Cupid's bow binds the gods to each other, uniting them in love.

But this serenity of mood does not reflect the process by which the painting was created. Veronese apparently made many changes as he went along. According to the X-ray studies described by Alan Burroughs in his book *Art Criticism from a Laboratory,* Venus's head, shoulder, breast, right arm, and left hand were all originally positioned differently. Moreover, according to Burroughs, brushstrokes around certain parts of the figure of Venus provide evidence that the goddess was not to be naked but covered with drapery, and the extension of the strokes composing the drapery into the space occupied by Cupid suggests that the winged cherub was not even part of the original picture.

Even minor alterations can transform the meaning, complexity, and symbolism of a work of art. They may show that its original conception was quite different from that of the finished painting. The underlying brushstrokes may tell us of the artist's emotional turmoil, from suffering to liberation, from anguish to euphoria, as well as the creative challenges the artist had to deal with. But these considerations lead to even more questions:

Why did the artist change his or her mind as the painting progressed? Was this part of the artist's creative process, or could it have been the demand of the person who commissioned the piece? Did anyone observe the artist at work, and if so, what conversations may have taken place in the studio that led to alterations? Were the changes the triumphant solution to a problem, or were they an unhappy compromise? Did the alterations change the story or message or theme of the work?

In the absence of clarifying statements from the artist or observations from witnesses, the answers to these kinds of questions are taken by the artist to the grave. But the secrets of the process revealed by X-rays are left

open to intelligent speculation based on many factors, including what is known of the artist's temperament, the external influences the artist may have had to deal with, and the morals of the times.

In making the changes he did, Veronese appears to have given his *Mars and Venus* a different character. A draped Venus might have suggested a prudish, proper goddess, whereas the voluptuously naked figure implies the opposite. But by incorporating the mythological messenger of love, not carrying the usual bow and arrow but tying a cord of devotion around Venus's leg, Veronese gave the lovers a new dimension of spirituality and innocence.

The changes in the poses might hint at composition difficulties encountered by the artist. Some were quite subtle. According to Burroughs, Venus's fingers were not originally parted at the center but separated by equal small distances. As Burroughs points out, there is a quality of struggle in the underpainting that contrasts with the easy form of the final painting. "When the artist revised his composition," Burroughs wrote, "he freed the design, and this in turn altered the spirit of the whole."

Was Veronese's liberation of the design and changing of the character of the work a matter of his striving for artistic perfection, or was it a reflection of his own personal metamorphosis? Could he have had subconscious motivations for revising his famous *Mars and Venus United by Love?*

Just a few years before, Veronese had painted a Last Supper, including various figures that were considered blasphemous. Called before the Inquisition to justify his insertion of "buffoons, drunkards, dwarfs, Germans, and similar vulgarities" into the sacred scene, he courageously insisted that he had used them for aesthetic reasons and that as an artist he was entitled to such creative license. The Inquisitors recommended changes, but instead of yielding to their wishes, Veronese simply renamed his painting *Feast in the House of Levi.*

By making Venus naked and voluptuous, and at the same time portraying Cupid as gently uniting the two gods not by bow and arrow but by a ribbon, was Veronese subconsciously making a statement about his own

inner conflicts? Were the changes that created a more serene mood a reflection of his repression of his rebellious side? Had he in his youth been a rake, and did he now, as he neared fifty, value love over libidinous fulfillment? Had he been tamed like the bridled horse in the scene? Does Cupid represent the Holy Office, and does his sanctification of the gods' union testify to the artist's acquiescence to authority? Does Veronese's underpainting reveal his own personal transformation?

By comparing the underpainting of *Mars and Venus United by Love* with the finished painting, we can envision Paolo Veronese in his sixteenth-century workshop both in the throes of personal tensions and in the triumph of artistic attainment.

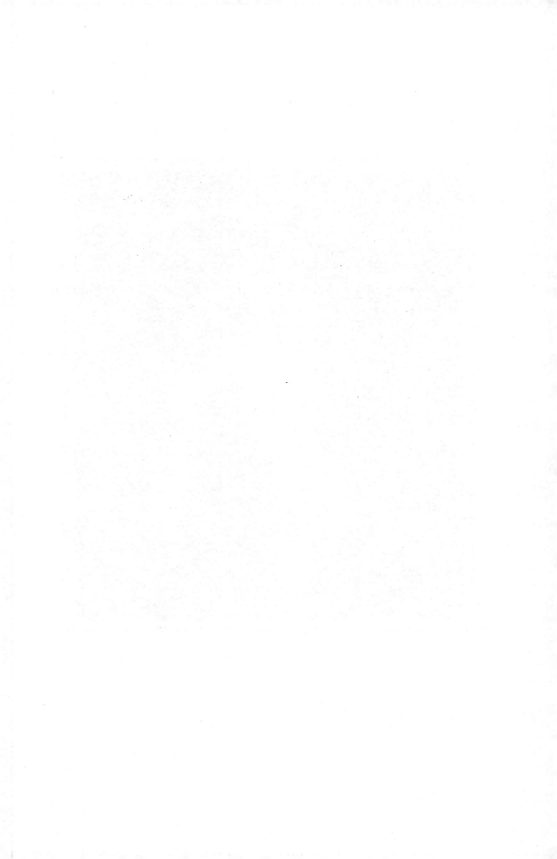

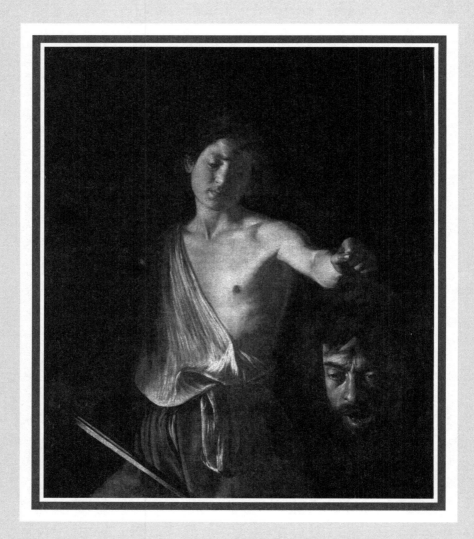

David with the Head of Goliath

(C. 1609–10)

Michelangelo Merisi da Caravaggio

How does an artist deal on canvas with his own emotional crisis? Michelangelo Merisi da Caravaggio, a troubled soul, certainly had his share of problems, the most acute of which, along with a proffered symbolic resolution, seems to resonate in his *David with the Head of Goliath*.

ON A LATE May evening in the year 1606, a man nearly thirty-five years of age with deep-set black eyes, a mop of dark hair, and a rapier by his side stood face-to-face with another man almost a decade younger, who was likewise armed with a deadly weapon. Violence promised to erupt, as a feud between the two men had apparently been simmering. The older man, who was known by the name Caravaggio, was a painter, and while he had a reputation for having a tempestuous nature, he was also regarded as one of the greatest artists of his time in the land that in the previous century had spawned Leonardo, Michelangelo, Raphael, Giorgione, Titian, and Correggio. His opponent, Ranuccio Tomassoni, although he came from a respectable military family, was a notorious pimp. The two foes were not alone; each had a small retinue waiting to join in the fray if necessary.

By some contemporary accounts, the confrontation between the two men was over a wager the painter had lost to his foe in a game. But that may only have been the catalyst. There was likely something more serious at the root of the dispute: a conflict over a courtesan. Ranuccio may have been her pimp as well as her lover; Caravaggio had painted her and was deeply enamored.

On the Via della Scrofa in Campo Marzo, the two men exchanged words, and it appears a duel followed. Contemporary accounts are unclear or even contradictory, but according to a surgeon barber's report, Ranuccio, having been struck in his groin's femoral artery, bled to death that night. The nature of the wound may indicate that Caravaggio, standing over his fallen opponent with his rapier, had attempted to sever his testicles but slashed a femoral artery instead. If the altercation had indeed been over a woman, castration of one's rival would have been in line with the tradition in Rome at the time.

With Ranuccio done for, his brother and other compatriots joined the melee, along with those on the painter's side. In the bloody end, one of Caravaggio's friends was severely cut up, and Caravaggio was injured badly with a slash on the head. Those who could fled the scene before the authorities arrived, but the artist's friend was so severely wounded that he could not escape and instead was put in jail.

No stranger to trouble—his past peccadilloes included sundry scuffles, brawls, and assaults, throwing stones, as well as carrying a concealed weapon—Caravaggio now had mortal blood on his hands. Homicides were treated very harshly by the authorities. Caravaggio was about to have a price put on his head, and if he were caught, that head would be summarily removed from his body and hung on a public street. Allies of Ranuccio bent on revenge were likely to be after him as well. It was imperative that he flee the city and beg his powerful allies to intercede for him. And so, as soon as he had recovered sufficiently from his painful gashes, he slipped quietly out of Rome.

Caravaggio, the celebrated Italian painter, was now a notorious wanted killer.

HE MAY FIRST have headed north for the Sabine mountains, but probably around September 1606 he sought refuge southeast of Rome at the fiefs of the Colonna family, which had been his own family's feudal protectors.

But he did not stay there long. Caravaggio moved furtively from Zagarolo, to Palestrina, to Naples, hoping for a grant of clemency so he could return to Rome. But it was not forthcoming.

Next Caravaggio traveled to Malta, where he hoped to receive the Cross of Malta, an honor, the artist felt, that might help him in his quest for clemency. He arrived on the Mediterranean island south of Sicily in July 1607 and was invited to meet the Grand Master Wignacourt. The grand master lost no time in commissioning works from the artist. No doubt delighted to be generously received by the eminent French nobleman, Caravaggio painted such works as *St. Jerome Writing* and *The Beheading of St. John the Baptist,* as well as two portraits of Wignacourt.

In appreciation for his work, the grand master presented Caravaggio with the cloak of his order, making him a Cavaliere di Grazia. But the artist could not restrain the belligerence that had made him a fugitive, becoming involved in a fracas with a contingent of the Knights of Malta, insulting the cavaliere of justice, and losing the support of the grand master, who promptly imprisoned him. Having come so close to receiving a pardon, Caravaggio was now in a sorely abject state. But he was apparently still determined. Despite the formidable conditions that kept him captive, Caravaggio seems to have escaped by a rope ladder, fleeing to Sicily.

Caravaggio landed at Syracuse and later made his way to Messina and Palermo, painting wherever he went—*The Burial of St. Lucy* in Syracuse, *The Resurrection of Lazarus* in Messina, *The Adoration of the Shepherds with Saints Lawrence and Francis* in Palermo—but now he was under an additional threat: retribution for the altercation with the Maltese knights. He was beset by

paranoia, often retiring for the night fully dressed, his dagger close at hand. It is a testament to his artistic brilliance, passion, and resolve that despite his desperation, wherever he went he painted astonishingly well and usually received great praise from his patrons.

By the time he reached Palermo, Caravaggio felt wholly unsafe, sure his enemies were only a step behind him. There were many who wanted him—the papal authorities in Rome, vindictive Maltese knights, even the family of the late Ranuccio Tomassoni. On a felucca he returned to Naples in the early autumn of 1609, intending to wait there until he received his pardon and could once again take up residence in Rome. Although in the aftermath of the duel his life had been one of difficulty and strife, he had the good fortune of having powerful friends, including two cardinals and the Colonnas, who admired his prodigious talent and took up his cause for freedom. He hoped he would be safe in Naples. In a gesture intended to mollify the grand master back in Malta, Caravaggio sent him as a gift a painting of Herodias with the head of St. John the Baptist.

But one day, probably in October, outside a public venue, a group of armed men surrounded him and beat him severely. So serious were his wounds that it was reported that he had been killed. His assailants cut up his face so badly that he was almost unrecognizable. Despite the near-fatal attack, probably by the Maltese knights, he decided not to seek revenge. Waiting for his papal pardon, he continued to paint. Among his works during this Neapolitan phase were *The Martyrdom of St. Ursula, St. John the Baptist,* and probably *David with the Head of Goliath.*

Although he had visited this theme twice before on canvas, the *David with the Head of Goliath* that Caravaggio painted around 1609 or 1610 may have more deeply reflected his psychological state after years of evading justice and revenge by his enemies. A contemporary writer, Giovanni Pietro Bellori, reported that Caravaggio had produced a "half-figure of David, who holds the head of Goliath by the hair, which is his own portrait." The David figure may also be a self-portrait in a psychological sense.

Having eschewed Mannerism to paint from nature, Caravaggio portrayed his biblical figures and scenes in a vivid, often gruesome style. The curly-haired youth in the painting wears a tunic draped over one shoulder and holds a rapier in his right hand. The boy bears an expression of revulsion as his extended left arm holds up the ghastly severed head, whose face seems plaintive and remorseful.

There are many ways to interpret this work. It may be an admission of guilt and contrition. The severed, battered head of Goliath, one eyelid half-closed over a lifeless eyeball, the mouth gaping open, epitomizes sinfulness, but the boy's expression of disgust acknowledges his own guilt and begs for forgiveness. Perhaps Caravaggio was, consciously or otherwise, symbolically offering his painted head as a substitute for the real one the authorities wanted to cut off. The painting may evoke its creator's own fears of dying, or confusion over his sexual identity, with its two faces, one youthful, the other older and anguished, cut from its roots, emasculated. The boy's expression of anguish may be for having taken a human life, as had the real-life Caravaggio.

Caravaggio may have felt himself to be both David and Goliath, hero and monster, beneficent artist and fugitive murderer. The good Caravaggio slays the evil one and cuts off his head, exorcising his evil side so the good one can be free, both acknowledging his mistake and atoning for it. With remorse and hope, he carries his sinful self to the authorities, offers it for merciful judgment, surrenders it for all time, leaving to carry on the good Caravaggio, the delicate artist, the Caravaggio before Ranuccio, the youth Michelangelo Merisi, who, like the youth David, had commanded the respect of his peers.

THANKS TO THE efforts of those who had interceded on his behalf with papal authorities, it seemed a deal was close to being consummated for Caravaggio's pardon for the murder of Ranuccio Tomassoni in 1606. The recent assault in Naples had left the artist in a weakened condition. Still in great pain from his injuries, he departed the city, carrying some paintings

for the pope and for his longtime patron Scipione Borghese. Sailing north from Naples, he may have been headed for Rome, but it is possible he planned to wait elsewhere for the official announcement to be made that his capital sentence had been lifted. In any case, he probably believed this would be his final journey in his life as an outlaw.

Cruising along the coast, the felucca carrying Caravaggio and his possessions put in at the Spanish-controlled port town of Palo, near Civitavecchia, perhaps due to inclement weather. There, astonishingly, the artist was mistaken by a guard for another wanted man, and Caravaggio was arrested and imprisoned. Two days later he was released, but to his dismay he found that the felucca he had arrived in had already left, carrying his possessions and the gifts he intended to offer to help expiate his offense. In the sweltering summer heat, Caravaggio ran along the beach to catch up with the vessel at its next destination, Porto Ercole. By the time he arrived, he had been overtaken by a burning fever. Within a few days, on July 18, 1610, Caravaggio died.

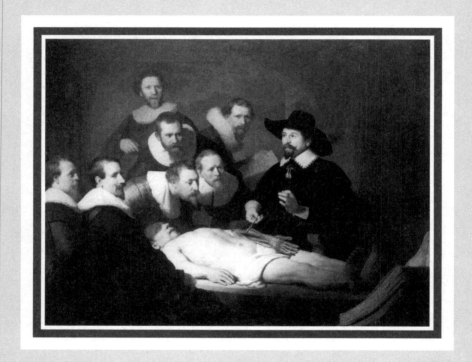

The Anatomy Lesson of
Dr. Nicolaes Tulp

(1632)

Rembrandt Harmensz van Rijn

Besides talent, what is the secret to an artist's success? Centuries ago, the "right" commission could bring attention to the artist if it were fulfilled to the sponsor's satisfaction, especially so if it broke new artistic ground. Of course, an artist usually had to have already achieved some recognition to obtain the commission in the first place, so it often took a combination of several propitious circumstances to make it all happen. Luck favored one young artist in just this way long ago, enabling him to establish a reputation that would endure through the ages.

AT LEIDEN IN mid-1631, a young artist named Rembrandt Harmensz van Rijn was preparing to move a short distance away to the city of Amsterdam, leaving the town where he had been born twenty-five years earlier and had spent most of his life. The artist, a striking presence with his long, scraggly hair, bulbous nose, and fiery, intense dark eyes, was well known and popular in his hometown, but patronage there was limited. Moreover, he frequently had to travel to Amsterdam to fulfill portrait and other commissions from the residents of that city.

Although there was some professional risk in beginning anew in a different city that was already home to a number of successful, established artists with steady stables of patrons, Rembrandt's career was on an incline and seemed poised for positive developments. He had a studio, promising students, and a working relationship with another talented artist, Jan Lievens, and the poet Constantijn Huygens was singing glorious praises of his talents.

But what would the future bring for this talented but unproven artist in his new residence? Giving up the security of his Leiden studio would not benefit his career unless he were able to attract satisfactory commissions. His reputation in Amsterdam was growing, however, and he was savvy enough to know that advancement doesn't occur without some risk. So Rembrandt uprooted himself from the university town and moved to the vibrant, thriving, world-class mercantile capital, not knowing quite what to expect, not fully matured, but full of hope and expectation.

EACH YEAR, USUALLY during the winter when cadavers were easier to preserve, the Amsterdam Guild of Surgeons held an "anatomy lesson," at which a human body was dissected before an audience. The anatomical demonstration was open to the public—tickets were sold to the event—and typically hundreds of people would gather to watch the praelector of anatomy open the body and eloquently address the audience on its mysteries. The intent of these demonstrations was to edify and stimulate the audience. It was also sheer entertainment.

The praelector would begin methodically to dissect the corpse with his sharp cutting tools, narrating as he proceeded. As the unappealing body was peeled open—usually the abdomen first—revealing the internal organs, the viewers no doubt felt a thrill of excitement and curiosity. Once the unique phenomenon known as life had pulsed through the veins and organs within that cavity of hardened flesh. The body had spoken and moved about; it had done deeds with vigor and emotion. But now the vessel that had contained

and nurtured that energy was unable to move, forever drained of sentience and vitality, vulnerable to being violated in the cruelest, coldest way.

To document and commemorate a public anatomy lesson, a formal portrait was sometimes commissioned of the first demonstration of the year, featuring the praelector of anatomy, the cadaver before him, and fellow surgeons. The portraits, some paid for by those who appeared in the painting, were hung in one of the rooms of the Surgeons' Guild. Only artists of the highest caliber were commissioned by the guild.

Corpses were not easy to obtain for the anatomical demonstrations. The Church forbade public dissections of regular citizens; it viewed the cutting up of a cadaver as a mutilation of both body and soul. But dissections of criminals were often overlooked, tacitly considered one of the consequences to the criminal of his or her misdeeds. Civic authorities would sometimes release to surgeons the cadavers of these miscreants, as well as the occasional hapless indigent who had died in the poorhouse. As Caspar Barlaeus would inscribe in Amsterdam's first permanent anatomical theater later in the decade: "Evildoers who, while living, have done damage, are of benefit after their death. . . . Their skins teach this, even though they have no voice."

The public dissection the Surgeons' Guild planned for January 1632 was to be presided over by an experienced and highly regarded surgeon, accompanied by a number of Guild members. A body would be needed.

SHORTLY AFTER HIS move to Amsterdam, Rembrandt painted a portrait of an Amsterdam merchant named Nicholaes Ruts, following this with a portrait of another Amsterdam merchant, Maerten Looten. These were solid commissions from respectable merchants, but Rembrandt needed a more noteworthy project that would make his reputation and bring him to the attention of potential wealthy patrons.

That break came soon enough. The Amsterdam Guild of Surgeons, in search of an artist to paint the upcoming first anatomical dissection of the year, passed over the established artists de Keyzer and Pickenoy and made a

surprising choice, a young artist who had never before painted a major group portrait. Perhaps the Guild's pick was influenced by the art dealer Hendrick Van Uylenburgh, with whom Rembrandt had worked for a time; or, more likely, by the new Amsterdam professor Caspar Barlaeus, who for many years had lived in Leiden and was a mutual acquaintance of both the artist and the Surgeons' Guild praelector. Rembrandt had his first big commission.

THE PENAL SYSTEM of seventeenth-century Holland could be harsh. Even petty criminals sometimes ended their lives at the end of a rope. The knowledge that the Civic Guild Authority sometimes turned over the bodies of executed criminals to be publicly eviscerated made incarceration emotionally difficult for the condemned.

In the early winter of 1632, a man named Adriaen Arisz awaited sentence in an Amsterdam jail for attempting to steal a gentleman's cloak. His violation was not egregious, but he was a recidivist whose crimes had led to banishment from his hometown of Leiden. Now his troubled past had caught up with him. This time there would be no escape for the hapless lawbreaker, who used the alias Aris Kint, from the stern judgment of the legal authorities.

Aris Kint was sentenced to death and was hanged on January 31, 1632.

A FRESH CORPSE had arrived for the Surgeons' Guild public anatomy lesson, a criminal fresh from his execution. The anatomical demonstration began on January 31, 1632, or very shortly thereafter, and continued for four or five days.

Dr. Nicolaes Tulp was chief anatomist of the Amsterdam Guild of Surgeons; in 1628 he had been appointed the Guild's praelector. Although portraits were usually commissioned for a surgeon's first anatomy lesson, Tulp's second demonstration was to be the one recorded on canvas for posterity. Rembrandt chose not to paint a precise rendition of Dr. Tulp's

presentation. Instead of showing the abdomen being opened, which would be the first part of the body dissected in an anatomical demonstration, Rembrandt showed only the cadaver's left hand and arm being dissected. But the painting's dynamic composition and the manner in which the artist portrayed the sitters were remarkable.

The viewer's attention is drawn to the lower center of the painting, where the pallid, expressionless corpse lies diagonally on a narrow bench. The mouth is open, a shadow falling eerily over the closed right eye. A white cloth covers the private area, the right arm rests by the body's side, and the left forearm and hand, tendons exposed, rests on the other side.

Behind and to the right of the lifeless body, his dark attire in stark contrast to the cadaver's pale skin, is the Surgeons' Guild's *praelector anatomiae,* Dr. Nicolaes Tulp, thirty-nine years of age. He is the only one wearing a hat, indicating his exalted position; his small white collar also distinguishes him from the seven observing Guild members. Dr. Tulp sits upright on a chair, his left hand raised slightly, fingers delicately curled as he illustrates a point. In his right hand he grasps a pair of forceps in which are held the tendons of the dissected left arm.

The seven spectators from the Guild are gathered closely behind the corpse to the left, arranged in a pyramidal form around the top of the body. The three immediately above the head, forming their own smaller triangle, are the keenest observers; the bottom two are leaning over to get a better view and intently following the demonstration, their expressions suggesting their eagerness to gain wisdom about the secrets of life. The figure at the apex of this small group is focused on Dr. Tulp. To the left of this group of three are two other observers. The man on the extreme left looks on casually; the other man's attention has been caught by something to the right side. The man who is highest in the picture seems to be looking out at the viewer. The man to the right holds a roll-call sheet of the observers' names. At the bottom right, before the cadaver's feet, is an open medical book. The scene is close to the viewer, as if to include him or her in the audience.

As a whole, the scene appears to symbolize humankind's fearless exploration of the unknown, the drive to unravel its mysteries and find solutions that will relieve suffering and improve the human condition.

FROM ORIGINAL PRODUCTIONS of Shakespeare plays at the Globe Theatre to the Dutch settlement of Manhattan Island, the early seventeenth century was a vibrant time for Europeans. Although he was destined to become the greatest artist of the Renaissance in northern Europe, Rembrandt, like other great artists, was no doubt at times mired in self-doubt and frustration. But his 1632 *Anatomy Lesson* would mark a significant change in his career, the first of the master's works to become celebrated. It far outclassed the more traditional Italian and Dutch paintings of anatomical lessons, introducing startling innovations. Previous Dutch works commemorating public dissections, such as Aert Pietersz's 1603 *Anatomy Lesson of Dr. Sebastiaen Egbertsz,* were little more than portraits of Guild members arranged symmetrically in parallel planes around the cadaver. Rembrandt's complex, tightly knit pyramidal composition, with its strong diagonal created by the cadaver and the dramatic lighting of the faces, Dr. Tulp's hands, and the cadaver—the chiaroscuro effect for which Rembrandt would later become famous—makes the presentation come alive in three dimensions. The expressive faces and expectant poses of the subjects draw viewers into the emotional atmosphere of the demonstration.

Rembrandt's painting of the anatomy lesson is not just a document, not just a record of its period, not just a group portrait, but a compelling portrayal of a specific moment of life and death. In this painting Rembrandt's talents shone. Its fresh style created a sensation, and numerous commissions for the artist followed. The artist's name and reputation became firmly established, and his fame rose steadily throughout the 1630s.

It had all happened because Rembrandt was at the right place at the right time to receive the perfect commission; because a man, however unjustly, had been sentenced to death on the right schedule to supply a

corpse for the anatomy lesson Rembrandt was to record; and because the young artist had risen to the occasion with a creative brilliance that far surpassed the abilities of his colleagues. With this astonishing group portrait, Rembrandt had created his ticket to immortality.

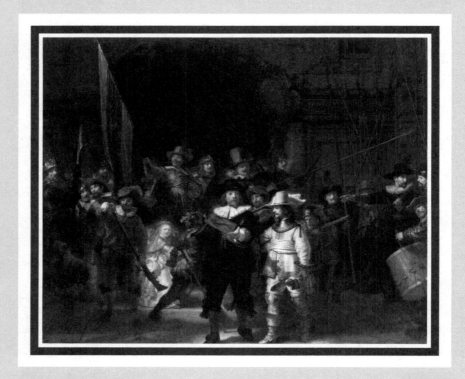

The Night Watch

(1642)

Rembrandt Harmensz van Rijn

That any painting survives through the centuries, given the vicissitudes of time, nature, and human behavior, is nothing short of a miracle. War, theft, disaster, neglect, mistreatment, and the natural deterioration of materials all threaten the existence of a delicate painted canvas or wood panel. Yet when a work of art is maliciously attacked by an individual bent on causing it harm—for reasons ranging from a deranged whim to the desire to make a political statement—that act of vandalism strikes not only at the artist but at the heart of civilized society as well, rending the unique cultural bond among people of different cultures, eras, and locales.

The Night Watch is one of the most famous paintings in the world; many consider it Rembrandt's greatest artistic achievement. But the painting was viciously assaulted on three different occasions in the twentieth century alone.

The first destructive mishap for the Rembrandt masterpiece occurred on January 13, 1911, at a time when the world was gearing up for war. A Dutch cook who had been dismissed from the navy entered Amsterdam's Rijksmuseum, the home of Rembrandt's masterpiece, and plunged a knife into the seventeenth-century canvas. He badly defaced the picture and slit through the main figures at the front. The man claimed he was motivated

by his recent dismissal from the service. He had wanted to exact retribution, and while the Netherlands had many cultural treasures on which he could have taken vengeance, he deemed Rembrandt's *Night Watch* the greatest of them all.

The second act of violence against the Dutch master's magnificent work occurred on September 14, 1975. The weapon was again a knife, and the culprit this time was a retired schoolteacher. The burly man slashed repeatedly at the canvas, ripping off a section around the middle before being overpowered by guards and museum patrons. The perpetrator, who had a history of emotional disturbance, later took his own life.

Fifteen years later, on April 6, 1990, *The Night Watch* suffered yet another attack. This time the assault was waged with a chemical: A Dutch man sprayed sulfuric acid on the painting. Like the first assailant early in the century, the vandal was unemployed.

THE NIGHT WATCH shows an Amsterdam militia company milling around under an archway as they prepare to march out under the authority of their captain and lieutenant. Since the Middle Ages, many militias—armed citizens' groups—had been formed around the Netherlands to defend the country against invasion. By the time Rembrandt had painted this portrait, however, the threat of attack, in particular by Spain, had subsided, and such companies, while continuing their military functions, had evolved into something more like gentlemen's clubs. Companies typically commissioned militia paintings for exhibition in their halls. The militiamen, or arquebusiers—named after the arquebus, the long-barreled predecessor of the musket, that they carried—were leading citizens of Amsterdam who contributed to the artist's commission fee in amounts based on their prominence in the picture.

Despite the dark background of *The Night Watch*, the scene takes place not during the evening but during the day; a cleaning of the painting in the 1940s revealed that what had been thought to be shadows were actually

hard coats of dirt that had built up over time. The painting was erroneously titled many years after its creation because the militia companies' main military function was that of sentries during hours of darkness.

In all respects the painting displays the superb technique and intelligence of the artist. It is a group portrait of a body of people portrayed not in conventional static poses but in dramatic motion. From the jerkins and sashes to the weapons and architecture, the details and colors are rendered with consummate artistry. The captain's hand and the lieutenant's shaft are depicted with a startling three-dimensional effect. The contrast of light and shade exhibits Rembrandt's mastery of chiaroscuro, intensifying the drama of the composition. The two main figures, Captain Frans Banning Cocq and Lieutenant Willem van Ruytenburch, brightly illuminated as if by a spotlight, step boldly into the middle of the composition. To their left, a young woman caught up in the excitement of the martial gathering is also highlighted, drawing the viewer into the crowd of spectators.

PAINTINGS DISPLAYED IN museums face a peculiar challenge. They are usually mounted on a wall without any sort of protective shield between them and the public, leaving them vulnerable to public attack. Because the appreciation of art is primarily visual, it is generally considered that any barrier between the painting and its audience would mar the experience, preventing the viewer from savoring the subtle nuances that painters painstakingly work into their creations. Even the presence of vigilant guards may not be enough to deter the determined vandal.

Over the centuries, several famous paintings have suffered physical indignities at the hands of the public. Among works of art that have been vandalized in the twentieth century are Picasso's *Guernica* (at the Museum of Modern Art, New York City) in 1974, Dalí's *Christ of Saint John of the Cross* (Kelvingrove Art Gallery and Museum, Glasgow) in 1961, and Rembrandt's *Danae* (Hermitage Museum, St. Petersburg, Russia) in 1985.

Surely, malicious damage to a masterpiece tears at the soul of artist and art lover alike. But the three twentieth-century attacks on *The Night Watch* fortunately did not cause irreparable harm. Each time skilled, dedicated experts were able meticulously to restore the painting to its original appearance. Despite the best efforts of the art assassins, today *The Night Watch* continues to reflect the magnificent spirit of both a brilliant artist and a dedicated company of seventeenth-century arquebusiers.

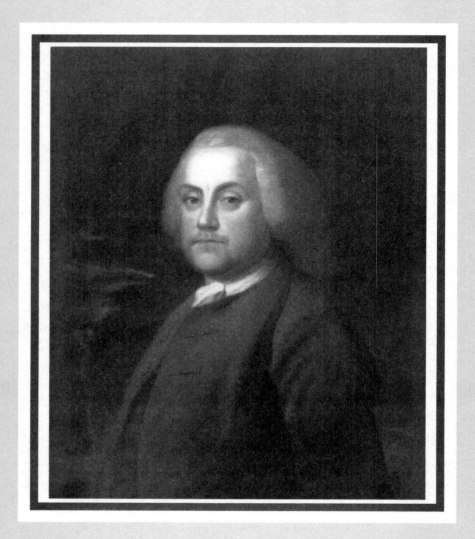

Benjamin Franklin

(1759)

Benjamin Wilson

༝ཊྛ༝

What happens when a painting is stolen during wartime? Should it be returned to its rightful owner after the conflict is over, or is it fair game as the spoils of war? The 1815 Congress of Vienna ordered France to return all booty taken by Napoleon during his conquests. But what if there is no governing body to mandate returns? Let us look to the American Revolution to see what happened in one particular case.

HE MEANT IT to be a gift to ease her loneliness. She was back in America, across three thousand miles of ocean that she was deathly afraid to cross. Now, with his diplomatic mission incomplete, it became clear that an extended stay in England would be necessary. Benjamin Franklin apparently felt the pangs, and perhaps the guilt, of being a world apart from his wife, Deborah, and resolved to send her a portrait of himself.

Franklin was devoted to his wife. He had first met Deborah Reade in Philadelphia in 1723, when he was seventeen years old. Their courtship was intermittent due to Franklin's frequent travel on business ventures; Deborah became tired of waiting and married someone else, only to be deserted by him. In the meantime Franklin was having his own amorous affairs. He and

Deborah finally renewed their relationship, and they married in September 1730, a few months before Franklin's son was born to another woman whose identity he did not reveal. Notwithstanding, Franklin noted in his diary that Deborah "proved a good and faithful helpmate, assisted me much in attending the shop; we throve together, and have ever mutually endeavored to make each other happy."

Franklin's many accomplishments and international reputation were also sufficient reasons for Franklin to commission a portrait of himself. He had already had his portrait painted in America, but he was in Europe now, in the exciting cosmopolitan center of London, thoroughly enjoying its intellectual and artistic stimulations. A portrait by an English artist, he thought, would surely make a splendid keepsake.

With its aristocracy and other wealthy denizens, London was a mecca for excellent portrait painters. There were many artists Franklin could have approached to portray him on canvas, but he settled on Benjamin Wilson, a talented but lesser-known artist who had studied with the portrait painter Thomas Hudson and had painted in Dublin before coming to London almost a decade earlier. Franklin could surely have afforded to hire a painter of stature, such as Joshua Reynolds or Allan Ramsay, but Wilson had one distinguishing trait that may have intrigued the Philadelphia sage: Like Franklin himself, Wilson had a keen interest in science and performed experiments in electricity. (The two would later have a contentious dispute concerning whether Franklin's pointed lightning rods would protect powder magazines better than Wilson's rods, which had rounded tips.)

A year after his arrival in London with his son, William, Benjamin Franklin, the scientist-statesman, posed for Benjamin Wilson, the scientist-artist. In a thirty-by-twenty-five-inch oil on canvas, Wilson captured Franklin looking sedate but straightforward.

Franklin wears a wig, a brown suit neatly buttoned, and a white cravat. Franklin's high forehead suggests his intellectual capacity and wit, while his sober expression reflects his seriousness of purpose. His lips are pressed

together. At the time, it would have been bad form for a scholar of Franklin's reputation to smile and expose his teeth, but his eyes have a hint of sparkle. In the background Wilson has painted a thunderstorm, alluding to Franklin's experiments with electricity.

After the portrait was finished in 1759, Franklin shipped it to his home on Franklin Court in Philadelphia. It was hung there, to be joined later by a portrait of Deborah, also by Wilson. (Deborah never visited England; Wilson painted the portrait from an existing portrait, as Franklin wrote in a letter to Deborah in June 1758: "Yours is at the painter's, who is to copy and do me of the same size.")

Benjamin Franklin's excursion to the mother country was occasioned by political business. The Pennsylvania Assembly, of which he was an elected member and a leader, was entangled in a dispute with the British colony's absentee proprietors, the Penn family. Descendants of William Penn, who had founded Pennsylvania in 1681, the Penns had been granted by charter the right to choose and direct the colony's governors. During this turbulent time of the French and Indian War, in which the English and French were fighting for control of the Ohio Valley, the Penns had prohibited the governor from raising money for defense unless he exempted their immense landholdings from taxation. Outraged by the unfairness of the financial burden such a loss of revenue posed to the colonists, the assembly appointed Franklin as its agent to present its petition directly to the Crown's Privy Council.

Franklin's mission was successful, and he returned to America, where the Colonies' relationship with Britain was worsening. Over the next few years the Crown adopted harsh new policies to assert stronger control. But new disagreements with the Penns developed, and Franklin was again dispatched to England as an agent, leaving in early November 1764. His stay in Europe this time was much longer. Among other activities, in 1765 he tried to prevent the Stamp Act from passing, and in 1767 he crossed the English Channel and was presented at court in France. In 1774, during his absence, Franklin's beloved Deborah died.

Franklin returned to America at the beginning of May 1775, about two weeks after the skirmish at Lexington, Massachusetts, that ignited the American Revolution. As the Colonies along the Eastern Seaboard began their War of Independence against Great Britain, Franklin took up residence in his house in Philadelphia, where his daughter, Sarah, lived with her husband, Richard Bache, and their two children. The political situation was roiling at a feverish pitch, and Franklin was chosen to be a delegate at the Second Continental Congress. He served on committees and was involved in numerous other activities, and his home became the center for much of this work. It was at his house, in fact, that in late June or early July 1776 he wrote some suggested changes to Thomas Jefferson's "Rough Draught" of the Declaration of Independence.

Along with his political pursuits, Franklin was continually occupied in making improvements to his Franklin Court estate. But he was pulled away from all domestic activities when, at the end of 1776, he was again selected as the agent for the Colonies and left for France to enlist its support. Once more Franklin headed east over the ocean, leaving behind a homeland embroiled in war and a home filled with precious possessions, including the portraits by Benjamin Wilson of Franklin and his departed wife.

FIGHTING IN THE colonial war raged all the way up to Canada, and in the summer of 1776 General William Howe, the commander of the British army in North America, occupied New York. Over the next several months he continued to fight George Washington's forces in different areas in the region, often dealing heavy blows to the Continental Army. He planned to capture Philadelphia, the seat of Congress, and in late July 1777, some eighteen thousand Redcoats sailed out of New York headed for Delaware, south of Philadelphia. Tensions ran high in the city with the anticipated assault of the British, and many of the rebels fled.

When the British began their occupation of Philadelphia in late September 1777, the Franklin home was vacant. Franklin was in France; his

wife, Deborah, was dead; and his daughter, Sarah Bache, and her family had left for the countryside. Nevertheless, the occupation would still have a heavy effect on the colonial agent.

On Franklin Court, the British came upon the spacious home of the famous archrebel, which they requisitioned for quarters for staff officers. In this house the Redcoats would find coziness and comfort, as well as the cultural amenities and trappings of Franklin's interests: shelves of books, musical instruments, and scientific apparatus.

Through the fall and into the winter, the British continued their occupation of Philadelphia. The winter of 1777–78 was harsh, and while the Continental Army at Valley Forge suffered through the freezing months without adequate food or supplies, the British, in warm, fancy colonial homes, entertained by the friendly local Tories, enjoyed the comforts of the city of Philadelphia, including balls and pretty ladies, perhaps to the point of distraction. Indeed, so seductive were the charms of the city to the British warriors that Franklin, in Paris, was inspired to comment, "General Howe has not taken Philadelphia. Philadelphia has taken General Howe."

One of the British officers who took up residence in the Franklin home was Major John André, who had previously served under General Charles Grey and was now an aide-de-camp to the British army's second in command in America, Sir Henry Clinton. A handsome, charming, and brave young man in his midtwenties, he had something in common with his absentee landlord—an appreciation for the arts. André himself was a bit of a bard, setting down several poems during the Philadelphia occupation.

The British ended their occupation of Philadelphia in June 1778. But when the Baches returned home, they made the not-unexpected discovery that some of the family possessions were missing. In a letter of mid-July 1778, Richard Bache, Sarah's husband, informed Franklin, "I found your house and furniture upon my return to Town, in much better order than I had any reason to expect from such a rapacious crew. . . . Some books and

musical instruments were missing. A Captain André also took with him the picture of you, which hung in the dining room."

Perhaps it was in the spirit of spoils of war that André appropriated his notorious absentee landlord's artwork and presented it to his former commander, General Grey. But in his new capacity as an intelligence officer, André was assigned a task that he found distasteful but carried out as an obedient soldier. In the spring of 1779, using an alias, the American general Benedict Arnold had entered into correspondence with Sir Henry Clinton. The purpose of the communication was clear: Arnold would supply the British with military information in exchange for compensation and other privileges. It became André's duty to be the British army's liaison with Arnold.

Arnold had served valiantly in numerous engagements against the British, but he had felt slighted on several occasions when he was investigated on charges of misconduct or denied the promotion he felt he deserved. When Arnold was seriously injured at Saratoga, Washington placed him in charge of Philadelphia after the British evacuated the city. There Arnold befriended many Loyalists. He also fell in love with and married Margaret Shippen, a society widow who had attracted the interest of a number of British officers during the occupation. Her father, Edward Shippen, may have had some sympathy for the British and was an acquaintance of John André. So although on opposite sides of the war, André and Arnold had a personal connection. But in Philadelphia, Arnold, receiving paltry colonial army pay, was trying to keep pace with a society that had just entertained the prodigality of the British military, and he soon became ridden with debt.

The British spurned Arnold's monetary demands, and the negotiations broke off, but the next year Arnold contacted André again, offering information on the defenses at West Point, a strategic site of rebel fortifications in the Hudson Valley.

After meeting with Arnold on September 21, 1780, André found himself marooned behind enemy lines. Two days later, wearing civilian

clothes, André was captured by the Americans, prompting Arnold to defect to the British. A military court found André guilty of spying and condemned him to death. On the second of October 1780 at Tappan, New York, Major John André was hanged.

The Treaty of Paris ended the American Colonies' War of Independence, but at some point before the treaty was signed in 1783, General Grey, taking with him the Benjamin Wilson portrait of Benjamin Franklin that John André had given him, returned to England. The painting of Franklin, the great American patriot, was hung in the Grey family home, Howick House, in Northumberland. Ironically, the portrait of Franklin created in England for adornment of the rebel's American home now graced the English home of a British commander. It hung at Howick House from about 1780 to 1906. But before the story's denouement, parts of it grow a little more complex.

Benjamin Franklin probably assumed he would never see his Wilson portrait again. He bemoaned the empty space next to Wilson's portrait of Deborah in his Franklin Court home and was not shy about letting others know of his displeasure. In 1779 he was appointed the American minister to France. While he was there, an artist named Joseph Duplessis painted his portrait, but Franklin never owned it. Franklin did own a pastel version of it, which he gave to a friend in France before returning to America, perhaps thinking a pastel, a rather fragile medium, would not survive the ocean crossing. During his time in France, Franklin became friends with Marie-Anne-Pierrette Paulze, the wife of the eminent French chemist Antoine-Laurent Lavoisier (who, during the French Revolution, would die by the guillotine). A talented amateur artist, Madame Lavoisier in 1788 made a copy in oils of the Duplessis pastel Franklin had left in France and sent it to him in Philadelphia, where he had returned for good. Franklin was delighted to receive Madame Lavoisier's copy and thanked her in a letter dated October 23, 1788. "Our English enemies," he wrote, "when they were in possession of this city and of my house, made a prisoner of my portrait, and carried it off

with them, leaving that of its companion, my wife, by itself a kind of widow: You have replaced the husband, and the lady seems to smile as well pleased."

Benjamin Wilson himself had painted two replicas of his Franklin portrait: a more elaborate, larger version in which Franklin is shown standing at half-length with a raging thunderstorm in the background (now at the U.S. State Department), which he completed while the original was still in England; and another that was a near duplicate of the original painting. An engraving of the former, larger replica was made in 1761 by the well-known British mezzotint engraver James McArdell.

After the larger replica was engraved, Wilson seems to have sold it, although no bill of sale is known to exist. But the painting came into the possession of the earls of Albermarle and remained in England until 1946, when it came to the United States and was offered for sale by a gallery before the State Department acquired it.

The near-duplicate portrait was commissioned by Franklin as a present for a friend in Philadelphia, Dr. Thomas Bond. It was shipped to Philadelphia probably after Franklin's own picture was sent to his wife, and when Franklin returned to Philadelphia and called on Dr. Bond, he noticed that Dr. Bond's portrait of him had cracked. In response to Franklin's complaint, Wilson blamed the cracking on a new type of varnish he had been using and painted the picture again. He sent it to Dr. Bond and gave him the option of either keeping the new one or retaining the old one. Wilson had probably used the earl of Albemarle's picture as the model for the new portrait, and the fact that the surviving painting has no cracked varnish indicates that Bond kept the new one and returned the old one. The new painting remained in the possession of Dr. Bond's descendants until 1855, when it was bought by a great-grandson of Franklin. This replica was acquired by the Franklin family almost a century after the original had been painted.

The Wilson portrait of Franklin given to General Grey by Major André remained in Grey's Northumberland family residence for many years. But at

the beginning of the twentieth century, events took place that would bring the painting home.

As Charles Henry Hart related in *Pennsylvania Magazine* in 1906, Joseph H. Choate, the U.S. ambassador to England, during a visit with Albert Henry George Grey in Northumberland six years earlier, noticed the Franklin portrait over the mantel in the library. Back in London, Choate mentioned the painting to Francis Rawle, a visitor from Philadelphia who was a member of the American Philosophical Society, which Franklin had founded. When Rawle returned to Philadelphia, he mounted an effort to restore the portrait to his country. He urged Ambassador Choate to suggest to Earl Grey, since 1904 the governor general of Canada, that this might be the gracious thing to do, and recruited mutual friends to gently press Grey for the portrait's return.

In February 1906, Earl Grey wrote from Ottawa to President Theodore Roosevelt:

The fortune of war and the accident of inheritance have made me the owner of the portrait of Franklin, which Major André took out of his house in Philadelphia and gave to his Commanding Officer, my great-grandfather, General Sir Charles Grey. . . . Mr. Choate has suggested to me that the approaching Franklin Bicentennial Celebration at Philadelphia April 20, provides a fitting opportunity for restoring to the American people a picture which they will be glad to recover. I gladly fall in with his suggestion. In a letter from Franklin . . . dated October 23, 1788, to Madame Lavoisier he says: "Our English enemies, when they were in possession of this city and my home, made a prisoner of my portrait and carried it off with them." As your English friend, I desire to give my prisoner, after the lapse of 130 years, his liberty.

President Roosevelt graciously accepted the offer. The portrait was received at the White House on April 14 and was promptly sent to Philadelphia for

Franklin's two hundredth birthday celebration. At a reception held by the American Philosophical Society on April 20, with the portrait present, Ambassador Choate announced that Earl Grey had recently presented the portrait to the nation.

Although the painting could have gone permanently to Philadelphia instead of Washington, it could not have been hung in Franklin's Franklin Court house, which had been torn down in 1812, just a couple of years after Sarah Bache's husband, Richard, by that time a widower, died there.

On just two occasions in the twentieth century did Benjamin Wilson's portrait of Benjamin Franklin leave its new home at the White House. The first time was in 1936, when it was loaned for exhibition to the Metropolitan Museum of Art in New York City, and the second was in early 1956, when it was loaned to the American Philosophical Society in Philadelphia for an exhibition on the occasion of the 250th anniversary of Franklin's birth. Since the American Philosophical Society owned Wilson's portrait of Deborah, Mr. and Mrs. Franklin, on canvas at least, were reunited for a short time.

With its return in 1906, America had back Franklin's portrait, painted not as a copy but from life. Owned by the man who was originally called the "father of his country" and the "apostle of modern times," it hung in the inner sanctum of America's premier freedom-seeking savant; was plundered during the British occupation of Philadelphia by a British officer who, as a result of his association with Benedict Arnold, America's most nefarious traitor, was himself hanged; and was given to a high-ranking British commander, whose family kept it for four generations before finding an apt occasion to return the portrait to America as an official gift in honor of its esteemed subject's two hundredth birthday.

Benjamin Franklin, ever the diplomat, maintained a calm demeanor during the chaotic years he represented a new world's interests abroad. That air of tranquility, reflected in Wilson's 1759 portrait, is in sharp contrast to the intrigues and adventures to which the canvas itself was subject.

The Tribuna of the Uffizi

(C. 1772–78)

Johan Zoffany

🕆

What toll does a painting take on an artist's life? The sometimes arduous task of executing a work of art may inflict great personal losses on the artist, from health to money to loved ones and more. Surely many paintings could speak of the misfortunes they brought on their creators, but as an example let us look at the cost to the eighteenth-century portrait and genre painter Johan Zoffany of his remarkable work, *The Tribuna of the Uffizi*.

IN THE ROYAL country residence at Kew in southern England, the voluptuous reclining nude of Titian's famous *Venus of Urbino* was on display near the center of the room, surrounded by an admiring cluster of primly attired cognoscenti. Hanging on the walls as a regal backdrop to the profusion of classical marble statuary on ornately sculpted pedestals were several Raphaels and Rubenses, a portrait from the unmistakable hand of Hans Holbein the Younger, and a selection of works from other prominent European artists. No, all these masterpieces had not been imported from their home at the Tribuna in the legendary Uffizi Gallery; they appeared in a single canvas by the Royal Academician Johan Zoffany, who had spent several years

in Florence painstakingly capturing their images. The completed painting now hung in Kew House for the pleasure of King George III and his consort, Queen Charlotte.

Anxious to hear the opinions of others on his acquisition, the king invited other members of the Royal Academy to Kew House to view Zoffany's painting. There was general agreement among these outstanding artists that the painting was superb, and that for his achievement Zoffany should be awarded a generous annual payment. But the king was apparently not receptive to this recommendation.

What had prompted Zoffany to go off to Florence was his disappointment at the collapse of a very different plan. He had been tapped by the naturalist Joseph Banks to accompany James Cook in his second exploratory voyage to the South Seas on the *Resolution,* but the group of scientists and artists canceled when they deemed the ship's compartments inadequate to hold their ample supplies. Zoffany, who had uprooted himself from his domestic and professional life in anticipation of the global journey, found himself disoriented by the trip's cancellation.

His taste for roaming having been aroused, Zoffany resolved to travel to Italy, where he had previously studied and practiced art. He informed his patron, Queen Charlotte, of his plans. In turn, King George's consort, who had never set foot on foreign soil, commissioned the artist to paint the famous repository of great art treasures, the Tribuna of the Uffizi.

With a return trip planned to Italy and a splendid royal commission in hand, Zoffany apparently had reason to be cheerful. The prospect of practicing his art, about which he was so passionate, was certainly inviting. But in his private life, the brilliant painter who traveled in elite circles harbored another kind of taste for roaming, one that was lacking in certain principles. Before he arrived in Florence, his misconduct caught up with him.

The artist had a wild streak when it came to the fair sex. He seemed to have a penchant for young girls and had his eye on one such lass, a pretty fourteen-year-old from a poor family. Nearing forty at the time, the artist

impregnated the young girl before he embarked for Italy. She was forced to leave her parents' home in disgrace, and in desperation stowed away on the ship Zoffany was to travel on before the artist boarded, revealing herself to him only once the ship was at sea. To his credit, he resolved to arrange for her to be cared for during her confinement and to provide for her education.

All this time Zoffany had been married, but his wife had returned to her native Germany, feeling that her husband was not treating her well. After the birth of his child, Zoffany learned that his wife had died. He then married the adolescent mother of his son.

Meanwhile, in Florence, Zoffany attended to the arduous task of fulfilling his commission at the Uffizi. Construction of the building had been begun in the second half of the sixteenth century by Cosimo I de' Medici, a devoted patron of the arts, and was completed after his death by his son Francesco I, the grand duke of Tuscany. During the Renaissance, it was the practice of noblemen to include in their palaces galleries for the exhibition of their art collections; such a gallery was built on the top floor of the Uffizi. The east wing included a room called the Tribuna, designed to house various masterpieces. Over the years noble successors added works to its collections. Museums like this Florentine gallery were great repositories of culture and centers of learning and were a prime destination for gentlemen taking their Grand Tours.

Of course, artists from many countries wished to come to the Uffizi Gallery to study and copy its great masterpieces, but obtaining permission to work in the gallery was sometimes difficult. Armed with letters of introduction from Queen Charlotte and with the assistance of Horace Mann, England's envoy at Florence, Zoffany was able to secure the permission he needed to come to the gallery and paint.

His family settled, he began to work, and all was well for a while. Mrs. Zoffany was reportedly a wonderful mother to their son, and she displayed her devotion to her husband by learning Italian and undertaking to make herself

suitable for society. The little boy was the treasure of his parents, providing them with much delight.

But tragedy struck the Zoffanys during their sojourn in Italy. When the boy was a year old, he fell down a flight of stairs and died three weeks later from an injury to his brain.

Zoffany was inconsolable; he was never able to recover emotionally from the devastating loss. Before going to Florence, Zoffany had been an active painter, and in his eager anticipation of a voyage to a far-distant corner of the world, he seemed to have a great zest for challenge. After the tragic turn of events, however, his health and enthusiasm declined. Engulfed in inner turmoil, he managed to complete the Uffizi painting, but on his return to England, he did not appear to be the same man.

The Royal Academicians summoned to Kew by George III thought Zoffany should be awarded an annual stipend of seven hundred to one thousand pounds for the remainder of his life. But the matter of the allowance arose while England was waging an expensive war with the American colonists across the Atlantic, and a royal barrage of criticisms was issued chastising Zoffany for various purported derelictions of his artistic duty to his patron, which Zoffany vigorously denied.

Zoffany was accused, among other things, of having spent time while he was supposed to be working on his commission painting portraits of Joseph II of Vienna and his family, thus extending his stay in Italy at considerable cost to the king.

Zoffany countered by noting that he had painted the portraits when he was not working on his commissioned painting. Therefore, he claimed, they in no way interfered with his official work.

How much Zoffany was ultimately paid for the painting is unclear, nor do we know whether he ever received the recommended stipend.

A decade after the painting was completed and hung at Kew House, as King George III's madness was beginning to take shape, Zoffany's painting was removed from the royal residence for its own protection after the

troubled king had reportedly pulled it from the wall and attempted to deface it.

At what cost to the artist was *Tribuna of the Uffizi* executed? The English royal family was certainly not to blame for the fatal mishap of the baby boy, but the fact remains that had Zoffany not been in the service of the monarchs, the tragedy might never have happened. In contemplating the painting, how could Zoffany not have seen in it the devastating subtext of the state of despair in which he had painted the work? The failure of his health from toiling relentlessly in a chilly gallery was yet another consequence of the effort to fulfill his commission and please his patron. Rather than default on the Uffizi commission, the artist had also, he claimed, turned down an offer from Joseph II to move to Vienna to work and be given the title of baron.

So the painting came with great tragedy and significant personal loss, and it is undeniable that these blows were a source of distress that the artist endured until his death at the age of about seventy-seven in 1810.

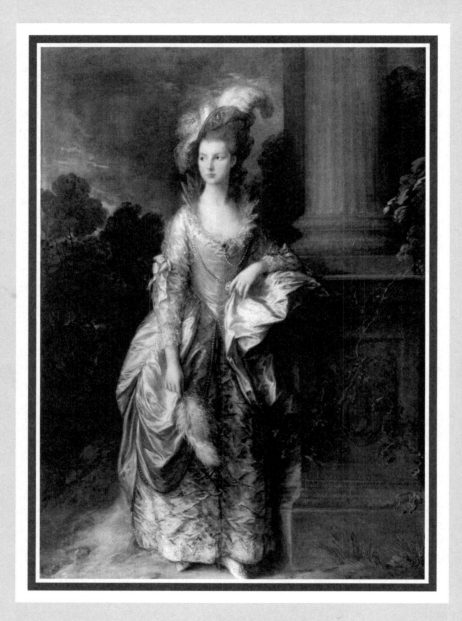

The Honorable Mrs. Graham

(1775–77)

Thomas Gainsborough

᙭

To many art lovers, a painting is just a painting, an image to be admired for its artistry and beauty. To those who know the story behind a painting, however, the work may evoke a range of powerful emotions. Thomas Gainsborough's *The Honorable Mrs. Graham,* a national treasure in Scotland, represents one of the greatest love stories ever to be reflected on canvas.

THE LETTER NO doubt came as a surprise to Robert Graham shortly after the death in 1843 of his dear cousin Thomas, Lord Lynedoch of Balgowan. As the heir to Thomas Graham, who had had the apparent good fortune to live to the remarkable old age of ninety-five, Robert was informed of some rather odd news. It seemed that the doughty old general had put some paintings in storage more than forty years previously but had never come back for them, not even to take a look. They remained in their original cases, as hidden from human eyes as the day they were sealed. Upon remittance of the storage fee, the letter said, the London firm would be pleased to release to Robert Lord Lynedoch's small cache of art.

Paintings? What paintings? Why, for heaven's sake, would Thomas consign the paintings to storage and leave them there? It seemed impossible that he could simply have forgotten about them.

To his long end, Thomas had remained active and vibrant, his mind and memory sharp. He was above all else a tenacious fighter who ardently savored the precious gift of life and adamantly resisted yielding it to the inevitable clutches of death.

He had been a valiant fighter on the battlefield as well, seeing his first action in 1794 at Toulon as an aide-de-camp to Lord Mulgrave. Even though Thomas was only a volunteer, Lord Mulgrave noted that Thomas's officers praised him highly as a "gallant example" to his fellow soldiers. Over the years, Thomas had continued to demonstrate his bravery in campaigns at Minorca, Malta, Coruña, Walcheren, Barossa, Badajoz, Salamanca, Vittoria, and numerous other locations. Disguised as a peasant, he had made his way fifty miles through hazardous conditions, evading enemy battalions, to procure help for the beleaguered Austrian army garrison at Mantua; as second in command to Wellington, he had become a celebrated hero in the Peninsular Wars; and when poor intelligence had doomed his efforts at Bergen-op-Zoom, he surrendered without shame rather than sacrifice his men in the name of honor.

Lord Lynedoch seemed driven by an indomitable spirit to which neither fear nor age was an impediment. His leadership was legendary, celebrated in verse and song. In recognition of his contributions, he was raised to the peerage and given the title Lord Graham of Balgowan, and was later made a full general. The exploits of Lord Lynedoch at Toulon had even earned him the deferential praise of an ambitious young enemy artilleryman named Napoleon Bonaparte, who had called him "a daring old man."

It would not have been characteristic of this shrewd leader and man of great diligence to cast off valuable personal possessions unless it were a purposeful act, so Thomas's secret cache of paintings was something of a puzzle to his cousin Robert. As one of a small circle privy to Lord

Lynedoch's distant past, however, Robert was aware that the paintings' very age might be the reason for their long seclusion. Their subjects might recall a time before the turn of the century when an unspeakably dark cloud had blighted the very charmed life of the country gentleman Thomas Graham, when the sun had dimmed on his grand estates, the flowers wilted, the birds became suddenly silent, and, in the cyclone of despair that had engulfed his life, he had questioned whether he himself could even go on.

PERTHSHIRE IN CENTRAL Scotland was a breathtaking patch of country, with its imposing mountains, tree-covered hills, sunken glens, winding rivers, sparkling lochs, and verdant meadows. Here, in great houses and wretched hovels, people lived at the unpredictable whim of nature, with its abundant lively game and harsh, cold winters. It was to his Balgowan home in Perthshire that Thomas Graham returned from his Grand Tour in 1771, the finale of an education that included being tutored by future "Ossian" bard James Macpherson and studying as a gentleman commoner at Christ Church, Oxford. His father had died in 1766, leaving all his dispersed properties to Thomas, the only surviving son of three, but the young landowner found time to break away from managing his vast holdings and become a parliamentary candidate. Losing by a slim margin, he returned home to attend to his life of agriculture, horseback riding, and hunting. But for this vigorous young man whose heart was yearning for a happy life, yet another change was on the horizon.

Around the time in the summer of 1772 that Thomas made his failed run for political office, a British ship was speeding across the sea from Russia carrying one of Scotland's most distinguished families. On board was Charles Schaw Cathcart, the ninth Baron Cathcart, with his sons and daughters, headed home after Lord Cathcart's position as ambassador to the court of Empress Catherine II was terminated. After a stay at the family residence in London, the Cathcarts journeyed north to their Scottish estate.

Resuming life at Schaw Park in Clackmannanshire after several years in a foreign country must have been a bittersweet experience for the close-knit Cathcarts, for now they were at home for the first time without Lady Cathcart, beloved wife and mother, who had succumbed to tuberculosis in Russia. Still, there was a sweet new addition. Catherine Charlotte had been born during their sojourn abroad, a baby sister for Jane, William, Mary, Louisa, Charles, and Archie.

Now that the lively sounds of an ebullient family once more filled the rooms of the estate, visitors hastened to its door. One of them was that laird from Balgowan, Thomas Graham.

Thomas was no doubt captivated by the charm of its female residents. While all three older Cathcart daughters were possessed of radiant good looks, the beauty of one stood out. Just blossoming into womanhood, Mary was the second Cathcart daughter, probably sixteen years old when Thomas first saw her.

Thomas was duly smitten. Here was a lass who not only shone with loveliness, but in her sweet disposition seemed to have stepped out of a fairy tale. Courtship soon followed. On the twenty-sixth of December, 1774, at Lord Cathcart's residence in London, Mary, seventeen, became the bride of Thomas, twenty-six. It was a double wedding; at the same time Mary's sister Jane was married to John Murray, the fourth duke of Atholl. The brides' father later wrote: "Jane has married to please herself, John, Duke of Athole, a peer of the realm; Mary has married Thomas Graham of Balgowan, the man of her heart and a peer among princes."

The simultaneous marriages of Jane and Mary marked the first permanent separation from the household of members of the Cathcart family other than by death, but the children remained entirely devoted to one another. They engaged in heartfelt correspondence, reporting on the minutiae as well as the chief events of their lives and passing on one another's accounts to their other siblings.

The newlyweds Thomas and Mary chose not to return immediately to chilly Scotland after their honeymoon but rather to continue their sojourn in London, where they had been wed. Thomas had arranged for Thomas Gainsborough to paint his wife's portrait, and probably by the spring of 1775, she presented herself at the painter's studio. Gainsborough had studied in London when he was thirteen and later returned to paint in Sudbury, Suffolk, his birthplace, before moving on to Ipswich and Bath, the fashionable society spa town, and finally back to London, the most important location for a professional portrait artist in England.

Even Gainsborough, who had painted portraits of many a society lady, was taken by the beauty of Mary Graham, who would be eighteen on March 1, 1775. Gainsborough painted Mary at least three times. The first of these portraits was probably a half-length (the "Kitcat" portrait), which became the basis for the second, a full-length; the third portrait is said to have been inspired by Gainsborough's fancy that the radiant Mary would look just as alluring costumed unglamorously as a housemaid, broom in hand.

But it was Gainsborough's full-length oil on canvas of Mary Graham that over time would most grip people's imagination, as it stunningly displays a woman of timeless beauty. The painting shows a stylish young lady standing beside two ancient-style temple columns, a verdant landscape and a dark-gray sky behind her. The ingenue's head is turned to the left, her eyes averted in the same direction. Her face is slender, her cheeks rosy, lips red, eyebrows full, hair upswept and powdered. She wears an extravagant jeweled gray hat with white ostrich feathers and a tight-fitting silver satin bodice decorated with a glimmering lace ruff and a long pearl necklace. Her right hand grasps an ostrich feather. Mary's elegant Van Dyck attire, innocent countenance, svelte figure, averted eyes, and exposed upper chest are portrayed in exquisite detail and soft, creamy tones, making the painting richly sensual and romantic.

The full-length portrait became known, as Mary was known in real life, as *The Honorable*, or *Hon'ble, Mrs. Graham.*

The newlyweds settled into the harmony of a couple deeply in love. If Thomas had any ambitions other than for a tranquil and blissful domestic life, he put them on hold as he devoted himself to Mary. Although endowed with qualities that would have made him a distinguished statesman or tradesman or scholar, Thomas eschewed any such career and dedicated himself to enjoying the sweet companionship of his wife and to maintaining and beautifying his properties.

Thomas and Mary made a striking couple—as one observer called them, a "matchless pair." Thomas was tall, sturdy, rugged, athletic, dark, and handsome, with strong features; Mary was the quintessence of feminine beauty. Thomas's love for Mary was strong as a Perthshire tree stump, and many tales were passed around of the chivalrous acts he performed for her.

In 1776, the year of the great American Revolution, more changes were to come in the Cathcart family. At the age of fifty-five, the adored patriarch, Lord Cathcart, died of tuberculosis, like his wife. And with the cannons roaring across the ocean, William and Charles, the two eldest sons, set off for America to take up the British cause against the colonists.

Meanwhile, Thomas and Mary continued their privileged existence. Mary's fame as an outstanding beauty grew, for Gainsborough's full-length portrait of her was exhibited in 1777 at the Royal Academy, showing the young society matron to a wide and important audience.

Over time, however, Mary's health became a concern, and the peaceful charm of the Grahams' rustic Perthshire life was interrupted. She was beset by a cough, and of course this raised the specter of the insidious disease that had claimed her mother and father. Believing that the cold winters in Scotland could be having an adverse effect, the Grahams occasionally traveled south to warmer climates, with young Catherine Charlotte, who had come into the childless couple's charge after Lord Cathcart passed away, in tow.

Still, Thomas and Mary's days were full in this time between the American and French revolutions, and they were quite happy living in their splendid domiciles. There were brief periods of separation when Thomas

went off hunting or Mary visited with one of her sisters, but whenever the two were apart, they exchanged affectionate letters. When a nearby rustic country manor with wilderness and a river on the grounds was put up for sale in the mid-1780s, they purchased it. It was the Lynedoch, or Lednoch, estate in the Almond River Valley. On this realm Thomas, with the pride of a new homeowner, put his indelible and talented touch: colorful gardens, sculptured trails, magnificent bridges, and finely crafted outdoor ornaments; the house was renovated and adorned with fine furniture that Thomas and Mary had picked out in their travels to the Continent.

In the autumn of 1787, Prime Minister William Pitt asked Charles Cathcart, then almost twenty-eight years old, to meet with the emperor of China about establishing relations with England. Some of his sisters, including Mary, came to London to see him off. Not wanting Mary to worry, he had not let her know that he too had developed a cough. Charles sailed for his mission to China, but his illness had progressed, and he died en route.

Then Jane was stricken. Like Mary, she had been distraught at the loss of Charles, but then another devastating tragedy had occurred when her ninth child, Frederick, died in April 1789 when he was just an infant. William and Lady Cathcart and other family members were summoned to the failing duchess's side, but Mary was not informed of her illness. The Cathcart children maintained a gentle conspiracy to hide from Mary any upsetting news that could have a negative effect on her own fragile health. But then, like her parents and brother before her, Jane died of the scourge that was slowly wiping out her family.

The grief at her siblings' deaths did take a physical toll on Mary, and the Grahams often headed south in search of life-giving warmth. Thomas attended to Mary so constantly that his business at home suffered, but his concern for her overrode all others.

Mary's health continued to worsen, and the trips south became more desperate. In 1791, in the midst of the French Revolution, the Grahams journeyed to a town near Nice in the south of France, where they rented a

small house. But Mary must have begun to realize her condition was hopeless. Very much missing her family and the surroundings she loved, she begged to return to Britain.

By this time she was seriously debilitated. The once-beautiful woman whose glowing countenance had brightened the room lost its sparkle and vitality; her cheeks became gaunt and her eyes hollow. Thomas tried not to show his dismay, but he could not have failed to see the ravages of illness on her face.

Respecting Mary's wish to return home, Thomas and her brother William sought a way to take her back to England by ship, since she was now too weak to make the journey over the Continent. But she continued to decline, and the plan for the long voyage was put on hold. Thomas decided instead to take Mary on a cruise; it would be unlikely to help her physical condition, but it might be emotionally uplifting. They were to sail on the Mediterranean off the south coast of France. But on the twenty-sixth of June, 1792, while the ship was anchored off Hyères, the Cathcart curse of tuberculosis took Mary's life.

Thomas now had the arduous task of transporting Mary's corpse through revolutionary France back home for proper burial. As if Thomas were not already grief-stricken enough, the journey turned out to be a nightmare. One night a mob of half-drunken rascals forced their way onto the barge in which Mary's body was encased in a set of lead and wooden coffins, and against Thomas's most adamant pleas, tore open her sarcophagus, believing it contained valuable contraband. The desecration of his wife's eternal repose was a scene that would fester in his mind for the rest of his life.

With Mary gone after eighteen years of marriage, it was time for Thomas to start life anew, but how difficult this was! He could no longer occupy Balgowan or Lynedoch, with their ever-present specters of his adoring wife, her footsteps reverberating lightly in the rooms, her exquisite taste emanating from the decorations, her spirit in the air buoyantly calling out about a walk in the meadow or a ride through the park. For Thomas,

home was a place to be shared with Mary, a place to grow lovingly old together, a place where cherished memories were supposed to be created, not wistfully recalled.

He needed a radical change, something to make him forget, something to launch him into a new phase of life in which he could try to forget the old. So Thomas Graham, the erstwhile country gentleman, agriculturist, stockbreeder, and man of many interests, hopelessly disconsolate over the loss of his wife, embarked with the fleet on the Mediterranean to the south of France.

As an aide-de-camp to Lord Mulgrave at Toulon, which had not yet been usurped by the French revolutionists, Thomas helped the English forces defend the port. Something about it appealed to him, perhaps the action, perhaps the opportunity to finally help his country, perhaps the reckless feeling that he might be killed and would then be relieved of his agony—or perhaps all these factors.

The next year Thomas returned to Scotland to raise a regiment, and soon he was assaulted by more catastrophic news. After Mary's death, Catherine Charlotte had gone to live with her sister Louisa. The separation had been painful for both Thomas and Charlotte, as the two had developed the most tender mutual affection; and for Thomas, who had had no children with Mary, Charlotte was both a surrogate child and a piece of his deceased wife. But Catherine Charlotte, still grieving hard over Mary's death, suffered the same miserable Cathcart fate that had taken so many of those dear to her, except that she would be cut down at an age much younger than any of the others. On the twentieth of October, Catherine Charlotte, the baby of the family, the ninth and last of the children born to Lord Cathcart and his wife, Jane, Mary's sibling by birth but the child Mary never had, died of tuberculosis at the age of twenty-four.

Life had once been so kind to Thomas Graham. After Mary's death it had seemed fate could pay him no crueler trick, but this last blow was crushing. It was time to chart a permanent course that would keep him away from the

painful memories that surrounded him. Even though he was middle-aged, he resolved to become a full-time soldier. But before he took a path that would allow him to avoid Scotland, there was a task he had to attend to.

It concerned Gainsborough's full-length portrait of Mary. Far from evoking tender memories, the portrait, painted from life, may have had unpleasant psychological associations. It may have reminded him of the horrible exposure of her corpse by French hooligans, or of Thomas's inability to protect his adored wife either from disease or from desecration. Rather than destroy the painting, he decided to put it in storage and let it repose as peacefully and as undisturbed as Mary was now in death.

Thomas dispatched the portrait and the other paintings in sealed cases to the offices of a storage concern, and then he went off to war.

Thomas fought in many places, including France, Italy, Malta, Egypt, Turkey, Austria, Germany, the West Indies, Ireland, Sweden, Spain, Portugal, and Holland. Attributing his ability to determine distances on the battlefield to the keen eye for planting and hunting that he had developed on Perthshire lands, he became thoroughly immersed in the strategies, science, and execution of war, often with thousands of troops under his command and on missions of vital importance to his country. With his great victory at Barossa on March 5, 1811, he became renowned as a Peninsular War hero.

Around 1814, Thomas retired from the military at the age of sixty-six. In his second life he had become accustomed to action, adventure, excitement, and the comradeship of others. Although melancholy thoughts of Mary undoubtedly continued to plague him throughout his military career, he apparently once again came to appreciate the gift of life. As the years went on, Thomas kept busy in more peaceful pursuits. He became the lord rector of Glasgow University; he was raised to the peerage with a title, given the full rank of general in 1821, and appointed governor of Dumbarton Castle in 1829. He traveled much, made friends, and maintained his properties with great pride, but he did not remarry. His

heart was fettered to Mary, and although he surely had been eager to have an heir, he was now resigned to a solitary life, for a liaison with any other than Mary would have seemed incongruous.

Lord Lynedoch had many friends, but he did not speak of Mary to them. He did retain his Lynedoch estate and hired workers to care for it while he spent much of his time in London and traveling in Europe and Russia, staying robustly active into very old age. When Thomas was nearing ninety, the Scottish judge Lord Cockburn wrote of him:

> His mind and body are both perfectly entire. He is still a great horseman, drives to London night and day in an open carriage, eats and drinks like an ordinary person . . . has the gallantry and politeness of an old soldier . . . and with a memory full of the most interesting scenes and people of the last seventy years. . . . He is one of the men who make old age lovely.

But age eventually took its toll. By his ninth decade, the legendary Lord Lynedoch had grown enfeebled physically, although he retained his mental powers and continued to tend to the maintenance of his homes. But on December 18, 1843, at his Stratton Street home in London, the "gallant Graham," who had plumbed the depths of sorrow when his beloved left him all too soon, and had lived a full life when the world was high with spirit and adventure, who had demonstrated valor of the highest degree in war, and who afterward had retired to peaceful, contented existence, fell to his eternal sleep. On his finger when he died was an object he had always faithfully worn, the enduring symbol of his steadfast, absolute love for one woman: his plain gold-wire wedding band.

One day not long afterward, Robert Graham of Redgorton received the letter concerning the stored paintings of his second cousin. Thomas had no direct descendants and had outlived all Mary's siblings, but he had forged a closeness with Robert through their travels together. Robert had also been

present with his cousin at his end. Intensely curious, Robert immediately sent off the fee requested to release the paintings.

The paintings were duly dispatched from London. Robert could barely contain himself. The paintings Thomas had hidden away were from another time, another century, an era from the eminent Lord Lynedoch's distant past. Could something of the woman who occupied Thomas's most blissful years be part of this mysterious treasure? Robert, as the Graham family story goes, rushed out to greet the cart at Dalcrue Bridge, and there by the River Almond, he ordered the cases opened with the eagerness of an archaeologist uncovering a long-buried tomb. When the Gainsborough painting was exposed, there was Mary in all her magnificent youthful loveliness.

Her portrait was sealed in darkness for decades after Thomas could no longer bear to look at it, but Mary paradoxically came to life after his death. There was Mary again, not with the shadow of death draining her face of its vitality, as Thomas had last seen her, but as the incandescent seventeen-year-old bride at the joyous time of her honeymoon, soon to return to bonny Scotland where she and Thomas would take romantic walks through their woodlands, ride adventurously through their grounds, and share laughter and passionate interludes. Seeing her intoxicating image, Robert Graham may have recalled the happiest days of his late cousin Thomas's life, days preserved in the beautiful vision of his bride captured by Gainsborough for posterity.

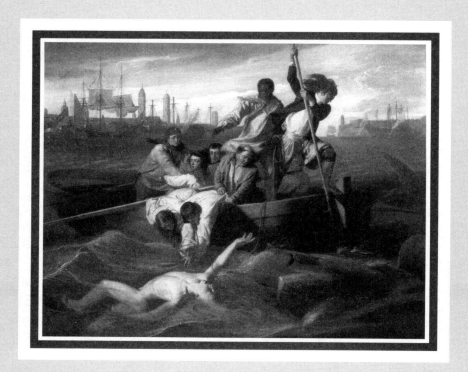

Watson and the Shark

(1778)

John Singleton Copley

※

What better way for a controversial figure to memorialize himself than to commission a sympathetic portrait? Surface impressions may be deceiving, however, and it is necessary to know the details before the true story behind a painting can be appreciated.

THE MERCHANT VESSEL out of New England lay peacefully at anchor in the Havana harbor on a calm day in 1749. A group of sailors waited patiently in a boat for the captain so they could escort him ashore. Another crew member, a lad of fourteen, had decided to pass the time by going for a leisurely swim in the Spanish colony's scenic harbor. The warm air bathing the Caribbean waters was a far cry from the chilly, damp atmosphere of his home in Boston.

The waiting men were idly watching their young mate cavorting in the water about two hundred yards away when they were startled to see a shark swiftly advancing toward him. The boy was unaware of the predator's deadly course, but so close was the shark and so rapidly was it closing in on him that the horrified men could not issue a warning in time. Before they could

act, the ravenous beast, its mouth gaping wide, sank its sharp teeth into the boy and forcefully pulled him beneath the surface.

The men on the boat, experienced seamen who had undoubtedly braved many a rough challenge, did not hesitate. They quickly turned the boat toward the spot where the boy had vanished beneath the waves and began to row with all their strength, bent on saving him from the hungry sea creature. Every second was crucial—but as they drew near where the boy had gone under, there was no sight of him. One agonizing minute passed, then another. What hope could there be for the tender lad?

Then, about a hundred yards away, the boy's body suddenly surfaced, and they raced to it. But once more the voracious sea monster savagely attacked, clamping its jaws around its victim and dragging him under the water.

The poor boy seemed doomed, but the mariners diligently prepared for rescue even if it meant putting their own lives at risk. Breathlessly the men searched for any sign of their missing mate or his vicious predator. Almost another two minutes passed before the boy miraculously rose to the surface again, but so did the shark, determined to finish his lethal mission. The shipmates positioned themselves for a final showdown as the animal drew near: One man stood at the prow of the rowboat, armed with a harpoon; the others stayed starboard to pull the boy aboard. Before the shark could once more rend human flesh with its knifelike teeth, the man at the prow thrust his harpoon into it. The shark retreated underwater, and now its victim could be rescued. He was bloody and badly mangled, but he was alive. In its first attack, the beast had stripped all the flesh from the boy's right leg from the calf downward, leaving only the bone. With its second bite, the shark had severed his foot at the ankle.

The sailors rushed the injured boy to a Spanish hospital, where a surgeon amputated his right leg below the knee. It had been a ghastly experience, but at least the shark had been denied a full meal, and the boy had his life.

For young Brook Watson, the trauma would be an indelible moment.

What psychological effects would he suffer from having been ruthlessly dismembered by a voracious monster while helpless in the sea? The boy was surely glad just to have survived, but now, in the flower of his youth, when the heads of boys are filled with thrilling notions of travel and romance and adventure, instead of a leg he would have an ugly wooden stump; instead of being able to run free in the fields or in battle, he would be able only to hobble about like a broken man. It was in this marred condition that the lad went forward with the rest of his life.

AMONG HIS COUNTRYMEN, Ethan Allen was known as a fierce and daring patriot. Captured by the British in September 1775 near Montreal on an ill-planned expedition against Canada and brought on board the *Adamant,* the American—renowned, with his Green Mountain Boys, for having a few months previously seized Fort Ticonderoga from the British in an early colonial victory of the Revolutionary War—refused to enter the "filthy enclosure" into which his men had already been forced.

It was, as he described it in his memoir, *A Narrative of Colonel Ethan Allen's Captivity Written by Himself,* "a small place in the vessel enclosed with white-oak plank" and probably "not more than twenty feet one way, and twenty two the other," with "two excrement tubs." It was in this small area that the prisoners on the voyage to England would live, sleep, and eat. Some three dozen of his men were already confined there, all in handcuffs. Never one to refrain from speaking his mind, the freedom-fighter appealed to the man in charge of the prisoners, the man with a peg leg who walked with a limp.

Their jailer had written scornfully to a friend of the Americans' capture in Montreal:

Such is the wretched state of this unhappy province that Colonel Allen, with a few despicable wretches, would have taken this city on the 25th ultimo, had not its inhabitants marched out to give them

battle. They fought, conquered, and, thereby saved the Province for a while. Allen, with his banditti, were mostly taken prisoners; he is now in chains on board the *Gaspee.*

Until their transfer to the *Adamant,* the American prisoners had for the most part been treated decently. Allen had offered to surrender provided he and his men would be "treated with honor and be assured of good quarter" and had received assurance that they would.

Following about six weeks in captivity on the schooner *Gaspee,* the American prisoners had been led to an armed ship on a river near Quebec "under the command of Capt. M' Cloud, of the British, who," Allen wrote, "treated me in a very obliging manner, and according to my rank." A day later the prisoners had been taken to yet another vessel, whose captain "behaved in a polite, generous, and friendly manner." Allen continued: "I lived with them in the cabin, and fared on the best, my irons being taken off, contrary to the order he had received from the commanding officer; but Capt. Littlejohn swore, that a brave man should not be used as a rascal, on board his ship."

The prisoners were finally put on board the *Adamant,* which would carry them to England to stand trial for treason. The man with the peg leg under whose supervision they were placed was an English merchant from London, Brook Watson, "a man of malicious and cruel disposition," said Allen, "and who was probably excited, in the exercise of his malevolence, by a junto of tories, who sailed with him to England."

Watson had been born in England but was orphaned as a youth and sent across the ocean to stay with a relative in Boston. Here, as a lad, he had worked on merchant vessels and traveled the sea, but he considered himself an Englishman and remained steadfastly loyal to the Crown. After recovering from his youthful mishap in the Havana harbor, Watson had moved to Canada and served as a commissary at the sieges of Beauséjour in 1755 and Louisbourg in 1758. The following year he returned to England

and became a London merchant. Years later his sentiments against the American colonial rebels were undoubtedly exacerbated when a business matter in which he had been involved had a rather disastrous ending in a very infamous event.

As part of his mercantile activities, Brook Watson was involved in the British East India Company's shipment of tea that arrived in ships and sat in the Boston harbor. To protest the British tax on imported tea, on December 16, 1773, American patriots disguised as Mohawk Indians went aboard the ships and heaved forty-five tons of tea into the water.

During the voyage of Ethan Allen and his men to England, with the exception of Colonel Closs, Allen reported, "all the ship's crew . . . behaved toward the prisoners with that spirit of bitterness which is the peculiar characteristic of tories when they have the friends of America in their power, measuring their loyalty to the English King by the barbarity, fraud and deceit which they exercise toward the Whigs."

Insults from the guards and Tories on board came "in the cruelest manner." Allen's attempt to reason with Watson for better conditions for him and his men was in vain. Watson, Allen noted, told him that "the place was good enough for a rebel; that it was impertinent for a capital offender to talk of honor or humanity; that any thing short of a halter was too good for me; and that that would be my portion soon after I landed in England."

Allen described their appalling treatment in his memoir:

Rather than die, I submitted to their indignities, being drove with bayonets into the filthy dungeon with the other prisoners, where we were denied fresh water, except a small allowance, which was very inadequate to our wants; and in consequence of the stench of the place, each of us was soon followed with a diarrhea and fever, which occasioned an intolerable thirst. When we asked for water, we were, most commonly, instead of obtaining it insulted and derided; and to add to all the horrors of the place, it was so dark that we could not see

each other, and we were overspread with body lice.

After a journey of about forty days, the *Adamant* arrived in England. Throngs of curious people in Falmouth turned out to see the prisoners, men and women alike, some standing on rooftops, the crowd being so great that soldiers had to draw their swords and clear a path to the castle where they were to be confined, about a mile away.

With some satisfaction, Allen recounted:

The rascally Brook Watson then set out for London in great haste, expecting the reward of his zeal; but the ministry received him, as I have since been informed, rather cooly; for the minority in parliament took advantage, arguing that the opposition of America to Great Britain, was not a rebellion: If it is, say they, why do you not execute Col. Allen according to law? But the majority argued that I ought to be executed, and that the opposition was really a rebellion, but that policy obliged them not to do it, inasmuch as the Congress had then most prisoners in their power; so that my being sent to England, for the purposes of being executed, and necessity restraining them, was rather a foil on their laws and authority, and they consequently disapproved of my being sent thither.

While several British officers treated Ethan Allen with a kindness befitting his rank and a civility deserving of a prisoner of war, this was not the case with Brook Watson, the survivor of a youthful shark attack. Perhaps in Watson's mind, consciously or subconsciously, Ethan Allen, the American prisoner, was to his Tory sentiments an individual to be loathed, a beast, a monster, a chimera, like the shark that had mangled him as a youth.

BROOK WATSON HAD a personal acquaintance with the American painter John Singleton Copley. In the course of his occupation as a commissary in

Canada and a merchant in England, Watson had worked closely with family members of Susanna Copley, the wife of the artist, and undoubtedly met Copley himself after the Boston-born artist had settled in England, feeling that the public in his native Boston lacked appreciation for the arts. It is almost certain that Watson commissioned Copley to paint the terrible scene of his youth in which he was attacked by a shark, as the canvas ended up in his possession.

And why not? Watson was a reputable merchant of London society, but with a peg leg, he was a conspicuous sight. Why not account for his affliction in a way that made him look romantic rather than merely an unfortunate cripple? Why not show that he had incurred his injury in his youth, when boys are expected to prove their mettle in risky exploits? Surely, a painting that depicted his fearsome encounter as a lad with a terror of the sea would prove him to be a daring and courageous individual.

Copley obliged by infusing his painting of the incident with energy, drama, and suspense.

A boy floats naked on his back in the water, extending his right hand to grab the rope tossed to him, while a shark with mouth open and teeth bared is inches from him and closing fast. Two shipmates reach out precariously from the boat to grab the boy; another seaman, standing at the prow of the boat, one foot on the rim, prepares to launch his harpoon into the predator. Will the mariners be successful in saving their young comrade before the monster can devour him? The expressions on the faces of the nine sailors in the boat reveal the urgency and peril of the situation, not just for the vulnerable boy but perhaps for themselves as well.

The palpable tension in the painting derives from both the composition and the scene. The bodies of the swimmer and the shark create a zigzag formation along the base of a triangle completed by the sailors and the boat. The right arm of the West Indian sailor holding the rope and the harpooner's spear, forming the triangle's sides, pull the viewer's attention down to the

desperate situation in the water, where it is uncertain whether the shark will reach the boy before the harpooner can strike.

Copley never traveled to Cuba, where the shark attack occurred, but he probably used existing materials such as prints and engravings to render a fairly accurate view of the harbor. He also made a small number of drawings and miniature oils in preparation for the painting. He exhibited the work, originally called *A Young Man and a Shark,* at the Royal Academy of Art in London in 1778; the exhibition catalog stated the painting showed "a boy attacked by a shark, and rescued by some seamen in a boat; founded on a fact which happened in the harbour of the Havannah." The gruesome subject matter generated a heated response; although there were criticisms, there was much praise, and the overall reception was very positive. In early 1779 Copley defeated several other candidates to become an elected member of the Royal Academy.

After the painting was exhibited, the merchant Watson went on to hold several important positions, including those of the British army's commissary general in Canada, a member of Parliament, a Bank of England director, a sheriff, and lord mayor of London, before being created a baronet in 1803. Indeed, Sir Brook Watson became a prominent and respected Englishman, but as measured by his treatment of Ethan Allen in 1775, what sort of man was he really? Was his cruel behavior the result of his hatred of the American rebels? Why did some of his compatriots not act similarly, but instead treat Allen with dignity and humanity? Having lived in America himself for years, could he not find some strain of identity with the rebels? Could not the man with the wooden leg who in his youth suffered a most humbling experience not find within him compassion for their suffering? Or was Watson an austere disciplinarian as a result of his days at sea and of his time period? The answers to these questions may never be known, but his youthful mishap, a paradigm of the perennial conflict between beast and human, is, thanks to his foresight in seeing that the fateful day in 1749 was

recorded by the talents of a noted eighteenth-century artist, forever enshrined in the annals of gruesome history paintings.

After Watson died, the painting, according to his will, went to Christ's Hospital, a school established for the education of boys. On the frame is an inscription that the painting might offer "a most usefull Lesson to Youth." This may express Watson's desire that youths be prudent and not risk life and limb in foolishly risky escapades; or it may represent the belief that hardship is no barrier to success in life. The inscription, like the uncertainty of the outcome of the rescue attempt in the painting that bears it, is somewhat enigmatic.

Almost a century after Watson's death in 1807, he was not entirely forgotten as a historical figure. When Samuel Isham published his sweeping *History of American Painting* in 1905, although the United States had long ago won its independence from Great Britain, the depraved behavior of the British toward the heroic patriots who fought for America's freedom still resonated in some people's minds. Thus in relating the life of John Singleton Copley, Isham included a brief critical sketch of Brook Watson, concluding, "There are those whose sympathy is with the shark."

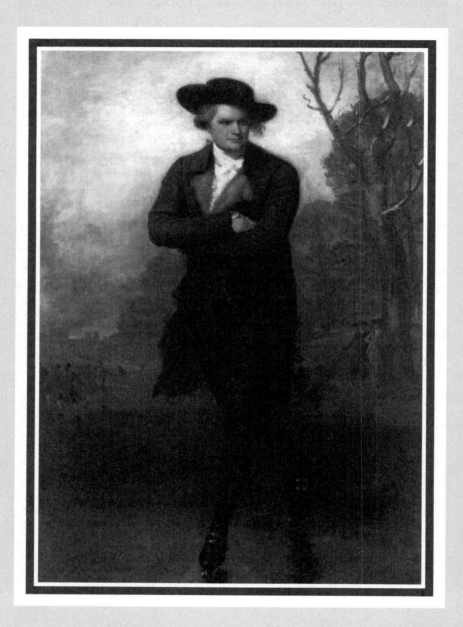

The Skater

(1782)

Gilbert Stuart

❊

When artists paint portraits, they bring all their experience and knowledge to the process. Sometimes painters may even see a bit of themselves in their subjects, and in such a case, sometimes the subject gets more than he or she asked for.

ON A WINTRY morning in 1782, William Grant arrived at the house of expatriate American artist Benjamin West on Newman Street in London. The young Scottish lawyer was coming to sit for a full-length portrait to be painted by Gilbert Stuart, West's chief assistant.

For a portrait painter, normally the arrival of a sitter would be eagerly anticipated. But on this occasion, Stuart was full of anxiety. The twenty-seven-year-old painter was adept at painting faces, but when it came to a full-length portrait, he was not at all sure he was up to the artistic task.

Self-doubt notwithstanding, Stuart had exhibited at the Royal Academy in 1777 and 1779. His reputation as a portraitist was growing, and commissions were coming his way. He had been hesitant to accept the commission from Grant but had finally come to the realization that it was time to force himself to confront the challenge of a full-length portrait.

The artist greeted William Grant as he strode in from the frigid London air, cheeks glowing. The Scotsman remarked cheerily that the day lent itself more to ice-skating than it did to sitting in a stuffy room for a portrait.

Stuart, still apprehensive, leaped at the excuse to postpone the inevitable. To Grant's surprise, Stuart took him up on his suggestion, and the artist and his client, suddenly chums, ventured off like mischievous schoolboys to the Serpentine River in Hyde Park, a popular place for skating.

Soon the duo were gliding across the frozen surface of the river. Stuart skated with some virtuosity, owing to much practice as a youth growing up in the colony of Rhode Island. Grant held his own on the ice but lacked the facility of his partner.

Stuart's dazzling display of blade work attracted the attention of others, and soon a crowd formed to gawk at the antics of the painter and his companion. But then Stuart spied a crack in the ice. Apprising Mr. Grant of the precarious situation, Stuart instructed his partner to hang on to the tail of his frock coat. Grant in tow, the artist glided over the frozen Serpentine safely to shore.

The playful respite over, the two returned to the artist's room, where Stuart, back to the tense reality of the task at hand, was suddenly seized with an idea for the full-length painting: Mr. Grant, the lawyer, in the guise of a skater. Grant was delighted, and Stuart, inspired, set to work.

Stuart's painting shows Mr. Grant as a dashing sportsman on ice. The figure is clad in black with white accents. His black hat is stylishly askew; a swatch of hair falls from underneath the wide brim on one side, and ringlets peek out from the other. His head is partially turned, his gaze slightly to the side. His arms are folded, his weight on his left leg, his right leg extended gracefully behind him, suggesting the assurance of a skater in his ability to flit across the ice with command and elegance and style—reflecting the confidence, perhaps, of a hitherto inhibited artist to face up to a test of his professional skill.

Portrait of a Gentleman Skating was exhibited at the Royal Academy in 1782 along with three other pictures by Stuart. The portrait created a sensation, and the artist, as he later wrote, was "suddenly lifted into fame by a single picture." Not only did his fame expand, but his belief in himself as well.

For Stuart, his skating picture was transformative. He had been unable to break free of the diffidence that had prevented him from fulfilling his talent. After years of waiting for his spontaneous side to emerge, he was, with this picture, released from his own psychological bondage. He was as free as the subject of his painting, liberated to twirl and spin and soar like a skater.

Stuart's portrait pictures the lawyer William Grant as the performer, but just as he had done on the ice of the Serpentine River, the lawyer was only riding the coattails of the true skater.

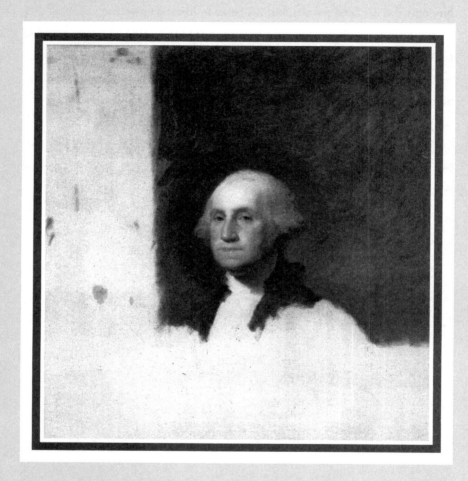

George Washington
(Athenaeum Head)

(1796)

Gilbert Stuart

⌖

What painting has been reproduced more than any other? That question is difficult to answer with precision, but one candidate is Gilbert Stuart's 1796 "Athenaeum Head" portrait of George Washington. It has been reproduced literally billions of times.

Although Stuart ultimately became the most renowned portrait painter of colonial America, his climb to success was, as for many artists, often a struggle. Even after he had achieved fame and could count among his sitters aristocrats and prominent political leaders, military officers and society figures, Stuart was beset by financial problems.

Gilbert Stuart was born in Rhode Island in 1755 as the flames of rebellion in the American Colonies were beginning to smolder. European countries had spread their tentacles over the globe; the American subjects of the British empire were becoming more and more outraged by the injustices imposed upon them by their mother country, and revolution was increasingly being perceived as a desperate but necessary course of action. As an ambitious youth in his teens, Stuart, a budding painter, ventured to Edinburgh to develop his career under the wing of a Scottish expatriate artist whom he had met in his hometown of Newport. But when his mentor suddenly died and Stuart

found himself without means, he was forced to return home, so impecunious that he probably had to work for his passage back.

In America in the mid-1770s, however, as the colonists were about to take arms against their British oppressors, Stuart found there was limited opportunity for a portrait artist. Soon after the first shots at Lexington rang out, he once again embarked on a transatlantic journey in search of an artistic future. He left his native land embroiled in battle and headed to a place where he could learn from eminent artists, and where sitters of means were plentiful and willing to commission portraits. He went to America's nemesis, England.

For a new artist, especially one in a foreign land, work could be difficult to obtain, and mere subsistence could be a formidable challenge. Stuart's contemporary biographer, William Dunlap, wrote that in London Stuart was so short of funds that he had trouble paying for his room and board. The painter eventually found a sponsor in the American expatriate artist Benjamin West, but even so his impoverished status did not improve immediately. The American painter John Trumball, noting Stuart's ripped clothing when they met, remarked that he "looked more like a poor beggar than a painter." One day Trumball called on him and found him apparently ill in bed, but later learned from Stuart that he was too weak to rise because, as Trumball recalled, he was so wretched that "he had eaten nothing in a week but a sea biscuit."

What Stuart lacked in money, he more than made up for in talent and ambition. His exhibitions at the Royal Academy brought him acclaim, and he was finally able to strike out on his own. As a portrait painter in London, he rose to the top of the profession. He had his own studio and plentiful commissions for which he commanded large fees, and he even took a wife, Charlotte Coats, a doctor's daughter, and started a family.

But the successful artist was also a profligate spender, and he ran up large debts. Unable to earn enough to meet his financial needs, he moved his family to Dublin in 1787. Here his prodigious talents were highly

appreciated, and he had a busy social calendar. But eventually he grew restless and decided to turn his professional attention elsewhere.

In Ireland, as in many other places, people often spoke of a legendary figure in America, a country that had made its great leap to independence a handful of years earlier. This figure was a valorous leader said to be endowed with the most sublime human characteristics: George Washington. Gilbert Stuart became consumed with the idea of painting the portrait of the first American president. Once again he uprooted his family, arriving with them in America in 1792.

Stuart first opened a studio in New York; in 1794 he moved to Philadelphia, then the seat of the federal government. The city was also a fashionable cultural center, attracting aristocrats and politicians from around the world. It was the ideal base of operations for a portrait painter. Stuart stopped by Washington's home to leave his calling card and a letter of introduction from the chief justice of the Supreme Court, John Jay. He soon received an invitation to attend a reception at which Washington would be present, and there he made the acquaintance of the illustrious American.

Of their meeting, the nineteenth-century writer H. T. Tuckerman reported, "No human being ever awakened in [Stuart] the sentiment of reverence to such a degree. For a moment he lost his self-possession . . . and it was not until several interviews that he felt himself enough at home with his sitter to give the requisite concentration of mind to his work."

Stuart's dream of painting the near-mythic American hero finally came true in 1794, but according to Dunlap it required more than one attempt before Stuart was satisfied with his work. In his first effort, the artist found the expression on his subject's face displeasing; he destroyed the painting forthwith and persuaded the president to sit for a second time. In 1796 Stuart again painted a portrait of George Washington from life, probably in his Germantown studio near Philadelphia.

When Washington, erstwhile commander in chief of the Continental Army, presiding officer of the Constitutional Convention, and now the

president of the United States, sat for Stuart in 1796, he was sixty-four years old; the portrait painter was forty-one. According to Stuart's daughter Jane, her father thought Washington's body was ungainly, with narrow shoulders and big hands and feet, but that altogether he cut an impressive figure. Her mother, she said, recalled that the first time she saw the president, she found him to be "the most superb-looking person she had ever seen."

Washington was not a very good sitter; he was beset by impatience and ennui and could become preoccupied, distracted, or apathetic. This was reflected in his facial expressions, which horrified Stuart. But with his fame at stake, Stuart did all he could to arouse in the president the great qualities of leadership he wanted to capture on canvas, and he persisted until he was finally able to find the key to Washington's spirit.

Another reason it was difficult for Washington to sit was his ill-fitting dentures. Washington suffered from periodontal disease and tooth decay, and over the years he had lost all his teeth. The dentures kept his face from appearing hollow. But these appliances were not easy to wear, as Washington was forced to continually tense the muscles of his lips and face to keep them from springing out of his mouth. This made him appear tight-lipped and gave him an unnatural appearance. Still, Stuart painted the dentally challenged president in a dignified manner. The artist ultimately decided his portraits were second only to Houdon's busts of Washington in capturing the leader's genuine likeness.

In his 1879 tome *The Life and Works of Gilbert Stuart,* George C. Mason related an incident that had occurred while Stuart was painting the president. The artist was just about to walk into the house one day when, to his astonishment, he saw through the door Washington, apparently in a rage, grab the collar of a man and fling him across the room. Feeling embarrassed to walk in at this awkward moment, Stuart sauntered on, but soon turned around and headed back to the house, where he found Washington sitting calmly on a chair. After exchanging greetings Washington said, "Mr. Stuart, when you went away, you turned the face of

your picture to the wall, and gave directions that it should remain so, to prevent it receiving any injury; but when I came into the room this morning, the face was turned outward, as you now see it, the doors were open, and here was a fellow raising a dust with a broom, and I know not but that the picture is ruined." Mason noted that the picture was not damaged and that Stuart continued working on it.

Stuart did not finish this portrait of Washington. With the president's permission, the artist kept the painting as a model from which to make copies, and also, according to Dunlap, in the hope that the portrait would be a legacy for his family if he did not alter it. "It would be . . . more valuable as it came from his hand in the presence of the sitter," Dunlap explained, "than it would be if painted upon at this late period."

Even though the portrait was unfinished, in the nineteenth century it became world famous. As Tuckerman later said about this portrait:

There seems to be a singular harmony between this venerable image— so majestic, benignant and serene—and the absolute character and peculiar example of Washington. . . . Self-control, endurance, dauntless courage, loyalty to a just but sometimes desperate cause, hope through the most hopeless crisis, and a tone of feeling most exalted, united to such habits of candid simplicity, are better embodied in such a calm, magnanimous, mature image, full of dignity and sweetness, than if portrayed in battle array or melodramatic attitude.

In 1805, Stuart moved to Boston in search of more commissions, taking the portrait of Washington with him. Dunlap noted that Stuart offered it to the state of Massachusetts for the sum of a thousand dollars, but was turned down. The painting stayed with the estate of Stuart, who died in 1828, until it was purchased by the Washington Association in Boston. In 1831 the Washington Association presented Stuart's portrait to an independent library, the Boston Athenaeum.

In the twentieth century Stuart's "Athenaeum Head" portrait of George Washington was chosen to grace the American one-dollar bill. The visage of the legendary first U.S. president was a natural choice for the bill. And of all the portraits of Washington, Stuart's "Athenaeum Head" seemed best fitted for the honor, as it was by then known around the globe.

The engraver at the Bureau of Engraving and Printing assigned to Stuart's "Athenaeum Head" portrait of George Washington was George Frederick Cumming Smillie. He began work on the image in early November 1917 and completed the engraving the end of the following April, after having logged more than two hundred hours.

The engraved image—or mirror image, since it was reversed, for design purposes, from the original painting—was used for the one-dollar Federal Reserve bank note in 1918, the one-dollar United States note in 1923, the one-dollar silver certificate in 1923 and 1928, and the one-dollar United States note in 1928. In 1928 the designs were standardized, and it was used in small-sized dollar notes (before 1928 larger notes were used). Since that time, the one-dollar bill has basically not changed. From 1928, when this currency was introduced, through 1995, more than one hundred billion one-dollar Federal Reserve notes with Gilbert Stuart's "Athenaeum Head" portrait were printed by the United States Treasury.

Stuart would no doubt have been proud to know that his portrait of Washington became the visual symbol of the dollar, the basic unit of American currency, used for countless everyday transactions—a pack of gum, a cup of coffee, a candy bar, a tip. The dollar's value is backed by the U.S. government; around the world the dollar is known for its strength and dependability. By virtue of its existence on the bill, Stuart's portrait is familiar to almost everyone in America, a work of art to which they have access at all times. The picture is carried in wallets and handbags and pockets and is stuffed in drawers and piggy banks and under mattresses; it is handed from person to person day and night, weekday and weekend, at all seasons of the year, from a few years after birth to shortly before death. Of

course, for all the great deeds the first U.S. president performed, it might be argued that he has received unequal treatment: It takes twenty Washingtons to make a Jackson, fifty for a Grant, and one hundred to equal a Franklin— but these worthies are all divisible by a Washington, and the sum total of Stuart's Washingtons is, after all, symbolic of the entire United States economy. Not bad for a once-starving artist without a dollar to his name!

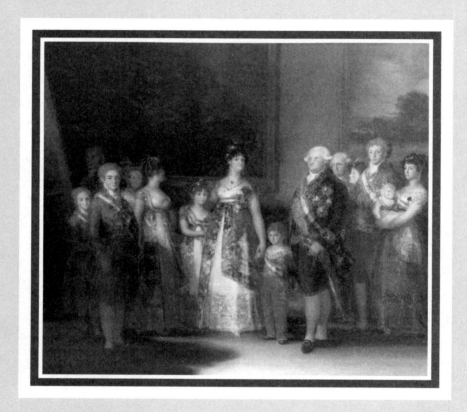

Charles IV and His Family

(1800)

Francisco José de Goya y Lucientes

⌐米⌐

Portrait painters tend to render their subjects in a flattering way. The painter, after all, works at the patron's pleasure and is therefore expected to show the sitter in a way that meets his or her wishes. Historically, sitters have been portrayed as regal, distinguished, beautiful, gallant, debonair, strong of character, gentle, pensive, ethereal, innocent, mysterious, spirited, reticent, or composed. Court painters, especially those in the service of sovereigns, needed to show their royal patrons in a manner that reflected their exalted positions, as these portraits would become valued family possessions and the images by which the monarchs would be remembered in history. Some painters took this duty to such a zealous extreme that the royal images were criticized as looking nothing like their human subjects.

But portrait painting took a bold and provocative turn around 1800, when a highly regarded court painter turned up his nose at convention and painted a royal family just as he saw them.

At the time he painted Charles IV and his family in 1800, Francisco Goya had reached the pinnacle of success for a Spanish artist: He was the first painter to the court. Goya had worked his way up through the years, painting frescoes and portraits and tapestry cartoons. In 1781 he received a

commission from the king, Charles III, for paintings that would be placed in a church; four years later he was made deputy director of painting at the prestigious national art institute, the Royal Academy of San Fernando, in Madrid; and in 1786 he was appointed painter to the king.

Charles III was seventy years old at the time. Having succeeded to the throne in 1759, Charles had inaugurated social reforms and promoted public works that benefited the country, and his government operated at high efficiency. Although he ruled like a tyrant and his foreign policy failed in many ways during these years of colonial rivalry among European powers, he was an enlightened despot, and Spain prospered under him. Despite his exalted position as king, after his wife, Maria Amalia of Saxony, died in 1760 at the age of thirty-six, he remained faithful to her.

When Charles died near the end of 1788, he was succeeded by his second son, Charles IV (his first son was an imbecile). It was the beginning of the French Revolution, a time when the so-called old regime, with its absolute monarchy and privileged classes, was being challenged. The century, dubbed the Age of Reason, featured writers and philosophers such as Voltaire, Rousseau, and Montesquieu railing against political, religious, social, and educational abuses.

Charles retained his father's ministers, but around four years into his reign, after Louis XVI was captured trying to escape France, Charles replaced his father's trusted cabinet. He installed Manuel de Godoy, an army officer and the favorite of the queen, as chief minister in 1792. Charles was intellectually feeble and obsessed by a passion for hunting; Charles's wife, María Luisa, effectively took control of the government, supported by Godoy, her young lover. The prosperity maintained under his father's reign declined sharply under Charles IV.

Francisco Goya had became court painter soon after Charles and María Luisa were crowned king and queen. But the political climate influenced his work. The revolution in France had alarmed the Spanish monarchs, and the old, dreaded Inquisition had been resurrected to prevent the ideas of reform,

justice, and civil liberties from stirring up radical ideas in Spain. Projects ordered by the court were halted, and Goya temporarily fell out of the king's favor after he was accused of disdaining the task of painting cartoons for the royal tapestry factory. In 1792 a serious illness left the painter permanently deaf. Despite his affliction, he remained prolific; he painted commissioned portraits and produced satires. In 1799 he published a series of etchings called *The Caprices* that used caricatures to deride various abuses of the powerful; they were almost immediately removed from sale.

Somehow Goya's acute social consciousness did not cause a breach with his sovereigns, and in October 1799 he was elevated to the top post of first court painter. Nevertheless, Goya spent much of his time away from the royal residences painting church frescoes or portraits or making etchings. In the spring of 1800, however, he was summoned to the royal residence in Aranjuez, south of Madrid, to paint the king and queen and their family.

Goya had made numerous studies of the royal family members, and it is unlikely that they ever posed for him together as he painted them from life. The ensemble grouping seems to have been contrived in the atelier of the artist, who himself appears in the picture in the shadowy background to the left. In painting this work, Goya must have recalled a painting that he had once engraved, Diego Velázquez's *Las Meninas,* in which the artist similarly portrayed himself at his easel looking at the viewer.

Goya shows in his portrait thirteen individuals of the Spanish royal family gathered in a room hung with large paintings. It is a harsh and candid depiction informed by the painter's inside knowledge of the court. The figures seem ill at ease and lack warmth, an altogether unattractive group. Instead of an appropriately regal atmosphere, the painting has a coarse, repellent tone.

Goya appears to have highlighted the most undesirable qualities of the principal figures, María Luisa and Charles IV. The queen, standing at the center, dominates the painting just as she controlled the royal power in real life. Her ornate clothing and jewels emphasize her homeliness. Her jaw juts

out imperiously, and her eyes are frozen in a harsh, cold stare, aloof from the observer.

The king, mentally shallow and ineffectual, stands to the right of the queen dressed in full official regalia, the stars, banner, and rapier with which he is bedecked the artificial symbols of a mere figurehead. His features are weak, and his expression is vacant.

Other family members are shown no more sympathetically. On the left, one woman's head is turned to the wall, and behind her an elderly lady's visage is almost corpselike. Curiously, the royal family did not take umbrage at Goya's ruthlessly unflattering painting.

Around the turn of the nineteenth century, as great political and social changes were sweeping through Europe, mobs protested in France against the king and stormed the Bastille. In Spain, Francisco José de Goya y Lucientes, in the service of the king and queen, showed that even a highly regarded court painter could use art to humble the Crown.

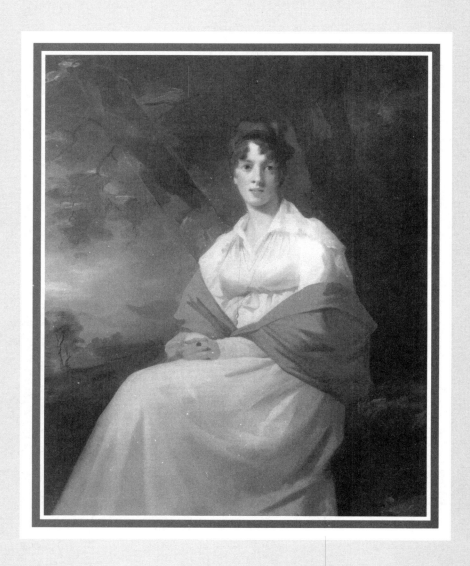

Lady Maitland

(C. 1817)

Sir Henry Raeburn

☩

What goes through a sitter's mind when he or she is posing for a portrait?

Sometimes sitters record their thoughts, but when a sitter's reflections are not to be found in any documents, historical and personal circumstances surrounding the painting can provide a basis for speculation. Around 1817, while Henry Raeburn painted a portrait of Lady Maitland, the wife of a distinguished British naval commander, it is entirely possible that during the long, tedious hours her thoughts wandered back to an enchanting incident that had occurred not long before, concerning the surprising and gratifying response to another likeness of her from the most famous man of the day.

———————

IT WAS ABOUT two years earlier, on the afternoon of July 27, 1815. Lady Maitland was on a boat on Plymouth Sound heading toward HMS *Bellerophon* in the company of Lady Strachan and her husband, Sir Richard Strachan, the commodore who, following the Battle of Trafalgar in 1805, had triumphantly captured four French ships of the line that had escaped the epic clash off southwestern Spain.

It seemed that all England wanted to approach the *Bellerophon* and have a brush with history. Swarms of boats filled with passengers ventured out into the sound to try to come close—and it was only Strachan's status as second in command of the Channel Fleet that made it possible for their boat to draw near the British line-of-battle ship.

Pursuant to orders of the Admiralty, security around the *Bellerophon* was tight: Two frigates were anchored hard by to prevent the escape of its celebrated passenger and any of his suite. There could be no communication with the shore. No visitor was permitted on board the ship; boats and small craft were strictly forbidden from entering its vicinity.

As the privileged small craft of Commodore Strachan and his party approached, the ship's notorious passenger was pacing the deck. The thirty-eight-year-old captain of the *Bellerophon,* Frederick Lewis Maitland, was aware that his wife was at the side of the vessel and mentioned this to the restless man. The news surely aroused both recognition and curiosity in the passenger. As Captain Maitland later recalled, when the man came on board the *Bellerophon* on the morning of July 15 and was led to his quarters by Maitland, he noticed hanging in the handsomely appointed cabin a miniature portrait of a woman.

"Who is that young lady?" he had inquired. The conversation took place in French, as the passenger claimed he could understand hardly a word of English.

Captain Maitland answered, "My wife."

"Ah! She is both young and pretty." The sight of Lady Maitland seemed to capture the man's attention, perhaps providing a moment of respite from his current troubles.

Now, on hearing of the presence of the visitors, the man stepped to the gangway and looked down at the boat below. There before him was the beautiful woman whose portrait had kept him company in his cabin on this voyage to England. Removing his hat, he bowed deeply. Lady Maitland was gazing upward at none other than the former emperor of France, the erstwhile master of Europe, the man who had been famously proclaimed the greatest

leader in the world since Caesar and Alexander. Smiling at her from the deck of a ship near the English port was none other than Napoleon Bonaparte.

FEW MEN OF history changed the world like Bonaparte. He marched hundreds of thousands of troops into battle, conquering nation after nation, tearing apart the fabric of Europe until he had subjugated the entire continent. Blood spilled where his armies marched, and to many he was a monster. But his nation—civilians and soldiers alike—held him in the highest reverence.

His exploits were legendary. He had slipped through the British blockade in the Mediterranean. He had led the famous assault across the bridge at Lodi. He had inspired his troops to battle with rousing words delivered before the Great Pyramids of Egypt. He had audaciously led his army across the Alps. And he ruled an empire that stretched from Spain to Holland.

After his failed invasion of Russia, however, his cause seemed lost; all Europe wanted to be rid of him. He abdicated and was exiled to the island of Elba but soon escaped, only to march to Paris and again take control of the nation. He was tireless. He was a military genius. He changed the destinies of nations and the very course of world history. Like no other man, it seemed, he was capable of weathering the ups and downs of the life of a supreme ruler. He was determined to rule once more.

But every despot is ultimately stopped in his grand plan. For Napoleon, there was Waterloo. His Grand Army was crushed by Wellington and Blücher, and with this disastrous defeat came the end of his remarkable career.

Having abdicated again, he had to consider his future. He did not want to surrender, but his enemies, who would not forget the countless lost lives and massive destruction that lay in his wake, were bent on ensuring that he would never again be able to return to power.

English vessels, among them the *Bellerophon*, lined the French coast, ready to seize the fallen emperor should he try to flee France by sea, and to bar reinforcements from coming to his rescue. Intelligence received by the

English included wild rumors, such as that he was preparing to escape in a barrel secreted in the ballast of a Danish boat, or that he had already slipped through the marine dragnet to the open ocean.

Vessels were searched, informants were interviewed. It became all too clear to Napoleon that the vigilant English surveillance made escape virtually impossible.

Then two of Napoleon's aides came to the *Bellerophon* in a schooner to deliver a letter, dated July 9, to the captain. Grand Marshal Count Bertrand wrote, "The Emperor Napoleon having abdicated the throne of France and chosen the United States of America as a retreat . . . expects a passport from the British Government, which has been promised to him." In conversation with the captain of the ship, the French emissaries asserted that the emperor still had many loyal followers at his disposal, but in the interest of humanity, wanted to avoid further bloodshed and therefore wished to leave Europe. Captain Maitland responded that the two countries were at war and that he could not permit "any ship of war to put to sea from the port of Rochefort."

Following this meeting, dispatches were sent to Rear Admiral Sir Henry Hotham, and communications with the British government took place. Strict surveillance was continued for any vessels trying to put to sea. For the next several days representatives of Napoleon continued to visit the *Bellerophon* to beseech Captain Maitland to intercede with the authorities so Napoleon could proceed to America. Maitland refused to interfere, stating only that he would convey Napoleon to England, and that he had no authority to state the terms under which Napoleon would be received there. These discussions were reported to Napoleon, and finally, on July 14, Count Bertrand wrote the captain that Napoleon would board the *Bellerophon* the next morning between four and five with an entourage that included his close aides and their wives and children, officers, valets, chefs, and other attendants. Bertrand also enclosed a copy of a letter, which would later become famous, written by Napoleon for conveyance to the Prince Regent:

A victim to the factions which divide my country, and to the hostility of the principal powers of Europe, I have finished my political career; and I come like Themistocles, to seat myself on the hospitality of the British people. I place myself under the protection of their laws, which I claim of your Royal Highness, as the most powerful, the most constant, and the most generous of my enemies.

Early on the morning of July 15, 1815, a French brig of war flying a flag of truce was sighted by the *Bellerophon*. A barge was dispatched to the French vessel to pick up Napoleon, who left his ship as his men wept. In full uniform, with epaulettes and stars, a gold-hilted sword, and a little cocked hat, he boarded the *Bellerophon* in the harbor of Rochefort just after six o'clock. He was soon taken to his cabin, where he noticed the hanging portrait of Lady Maitland.

DURING THE TRIP to England—first to Torbay and then to Plymouth Sound—Napoleon anxiously awaited the decision on his fate. The seamen were awed by his very presence, and Napoleon thought the "Capitaine," as he called Maitland, such a fair man that he wanted Maitland to have a portrait of himself adorned with diamonds (which the commander refused, since accepting such a gift would be deemed an impropriety by the Admiralty). Napoleon's aides-de-camp constantly implored Captain Maitland to use his influence to bring about a final decision in their leader's favor. The wife of General Bertrand, who had accompanied her husband to the *Bellerophon* with Napoleon, beseeched the captain to show Napoleon respect of the highest order at all times. But seeing the circumstances their emperor—as they called him—was in, his men could not hide their distress.

NAPOLEON BONAPARTE, STANDING on the gangway of the *Bellerophon* with his hat in his hands, deferentially asked Lady Maitland if she would care to come on deck to talk with him. Speechless, Lady Maitland shook her

head no. Captain Maitland informed Napoleon of the very strict instructions he had from Admiral Viscount Keith, the British government's representative to Napoleon, that no visitors be allowed on board.

Lady Maitland had married Captain Maitland eleven years earlier in 1804 but was still possessed of her youthful beauty and charm. As an anonymous midshipman on the *Bellerophon* later noted in his *Memoirs of an Aristocrat*, Napoleon "seemed greatly pleased with her appearance." According to Maitland, Napoleon exclaimed, "Lord Keith is a little too severe; is he not, Madame?" Then the former emperor turned to Captain Maitland. "I assure you," he declared, "her portrait is not flattering; she is handsomer than it is."

ON THE MORNING of July 31, Lord Keith and Undersecretary of State for War Sir Henry Edward Bunbury came on board the *Bellerophon* and were led to Napoleon's cabin. There they delivered to him the sentence of the British government: He was to be deported to the island of Saint Helena with a retinue of three officers and a dozen servants.

As the *Bellerophon*'s anonymous midshipman wrote, had Napoleon imagined he would be dealt the punishment he was given, "He would surely have made a desperate effort for personal liberty." Given England's past history in this regard, the midshipman contended, the thought of being exiled had never occurred to him: "We had never before refused the protection of our shores to a fallen foe, or to any one who claimed our protection. The expelled tyrants of every country had found their way to England, and been received with open arms, housed and pensioned."

Although he acknowledged he had been England's enemy, Napoleon had apparently boarded the *Bellerophon* under the impression that he would be a guest—he had even made provisions for his horses and carriages to be transported to England—but now he was a prisoner of war. The former ruler of France vehemently complained that in consigning him to Saint Helena, an island in the tropics cut off from the world, the British government was signing his death warrant. Nevertheless, he graciously thanked the

Bellerophon's "Capitaine" and its officers and crew for the politeness they had extended him.

After the prisoner was moved to the ship that was to take him to his final destination, "a horrid gloom," according to the midshipman, descended on the *Bellerophon*.

NOW, IN 1817, as Napoleon languished in exile on the remote south Atlantic island of Saint Helena, Lady Maitland, the former Catherine Connor, daughter of Daniel Connor of Ballybricken, County Cork—"a daughter of green Erin," as the nameless midshipman called her—was sitting for Henry Raeburn. A member of the Royal Academy, the prominent portrait painter was about sixty-one years old at the time. Born in a suburb of Edinburgh, Raeburn had apprenticed to a goldsmith in the city when he was sixteen and then began to paint miniature portraits in watercolor. At the suggestion of Sir Joshua Reynolds, he later studied in Italy.

In near full-length, Raeburn shows Lady Maitland (who was probably small in stature, as the midshipman on the *Bellerophon* referred to her as a "charming little woman") seated before a land- scape background. Her visage is youthful, and she is still very much in the bloom of womanly beauty. She wears a white dress, and a shawl is draped over her back. Her face is turned toward the viewer, but her gaze is unfocused, and she appears pensive, as if lost in thought.

While Raeburn was putting Lady Maitland's image on canvas, could she perhaps have been indulging in a fond reverie concerning her brief encounter with the powerful and charismatic Napoleon, who had apparently been so captivated by her likeness in a previous portrait that he had momentarily forgotten the disastrous collapse of his plans for empire?

Raeburn's portrait of Lady Maitland remained in the possession of her husband, Captain Maitland, until in 1839 he left her a widow when he died at sea. It is not unreasonable to speculate that the picture also evoked for him memories of Napoleon's admiration of his wife.

AFTER NAPOLEON HAD met Lady Maitland, he offered to Captain Maitland on her behalf a small gift, a few dozen bottles of fine French wine. This the captain accepted, but it was later seized by custom house officers.

Napoleon seemed genuinely taken by Lady Maitland, although we are left to wonder whether Napoleon shrewdly offered his compliments on her beauty to her husband in a last-ditch attempt to curry favor with his English captors. In his memoir, *Narrative of the Surrender of Buonaparte,* Captain Maitland himself wondered about Napoleon's motive:

> I have been induced to insert Buonaparte's observation on Mrs. M's portrait, as well as the one he made on seeing her alongside of the *Bellerophon* in Plymouth Sound, as they show, in a strong point of view, a peculiar trait in his character; that of making a favourable impression on those with whom he conversed, by seizing every opportunity of saying what he considered would be pleasing and flattering to their feelings.

We might even ask ourselves—a bit fancifully, granted—whether Napoleon's compliments on the portrait of Lady Maitland, and subsequently on her person, might have led a more easily influenced Captain Maitland to intercede on his behalf and obtain, as Napoleon may well have intended, more lenient treatment for the emperor. What if, rather than being condemned to exile on the lonely island of Saint Helena, where he became ill and died less than six years later, Napoleon had been taken to England and released, as he had expected?

Would Napoleon then have arranged to cross paths with Lady Maitland again? Could that possibility have occurred to her as well as she sat for Henry Raeburn?

As long as we are speculating freely on Lady Maitland's thoughts, we might as well venture a step further into alternative history from a modern perspective. What would have been the consequences for the world had the

Bellerophon's "Capitaine" and its officers and crew for the politeness they had extended him.

After the prisoner was moved to the ship that was to take him to his final destination, "a horrid gloom," according to the midshipman, descended on the *Bellerophon*.

NOW, IN 1817, as Napoleon languished in exile on the remote south Atlantic island of Saint Helena, Lady Maitland, the former Catherine Connor, daughter of Daniel Connor of Ballybricken, County Cork—"a daughter of green Erin," as the nameless midshipman called her—was sitting for Henry Raeburn. A member of the Royal Academy, the prominent portrait painter was about sixty-one years old at the time. Born in a suburb of Edinburgh, Raeburn had apprenticed to a goldsmith in the city when he was sixteen and then began to paint miniature portraits in watercolor. At the suggestion of Sir Joshua Reynolds, he later studied in Italy.

In near full-length, Raeburn shows Lady Maitland (who was probably small in stature, as the midshipman on the *Bellerophon* referred to her as a "charming little woman") seated before a land- scape background. Her visage is youthful, and she is still very much in the bloom of womanly beauty. She wears a white dress, and a shawl is draped over her back. Her face is turned toward the viewer, but her gaze is unfocused, and she appears pensive, as if lost in thought.

While Raeburn was putting Lady Maitland's image on canvas, could she perhaps have been indulging in a fond reverie concerning her brief encounter with the powerful and charismatic Napoleon, who had apparently been so captivated by her likeness in a previous portrait that he had momentarily forgotten the disastrous collapse of his plans for empire?

Raeburn's portrait of Lady Maitland remained in the possession of her husband, Captain Maitland, until in 1839 he left her a widow when he died at sea. It is not unreasonable to speculate that the picture also evoked for him memories of Napoleon's admiration of his wife.

AFTER NAPOLEON HAD met Lady Maitland, he offered to Captain Maitland on her behalf a small gift, a few dozen bottles of fine French wine. This the captain accepted, but it was later seized by custom house officers.

Napoleon seemed genuinely taken by Lady Maitland, although we are left to wonder whether Napoleon shrewdly offered his compliments on her beauty to her husband in a last-ditch attempt to curry favor with his English captors. In his memoir, *Narrative of the Surrender of Buonaparte,* Captain Maitland himself wondered about Napoleon's motive:

> I have been induced to insert Buonaparte's observation on Mrs. M's portrait, as well as the one he made on seeing her alongside of the *Bellerophon* in Plymouth Sound, as they show, in a strong point of view, a peculiar trait in his character; that of making a favourable impression on those with whom he conversed, by seizing every opportunity of saying what he considered would be pleasing and flattering to their feelings.

We might even ask ourselves—a bit fancifully, granted—whether Napoleon's compliments on the portrait of Lady Maitland, and subsequently on her person, might have led a more easily influenced Captain Maitland to intercede on his behalf and obtain, as Napoleon may well have intended, more lenient treatment for the emperor. What if, rather than being condemned to exile on the lonely island of Saint Helena, where he became ill and died less than six years later, Napoleon had been taken to England and released, as he had expected?

Would Napoleon then have arranged to cross paths with Lady Maitland again? Could that possibility have occurred to her as well as she sat for Henry Raeburn?

As long as we are speculating freely on Lady Maitland's thoughts, we might as well venture a step further into alternative history from a modern perspective. What would have been the consequences for the world had the

former emperor, free once again, decided to pursue his dreams, not of romantic but of political conquest?

And what if—as he had originally planned—he had come to America?

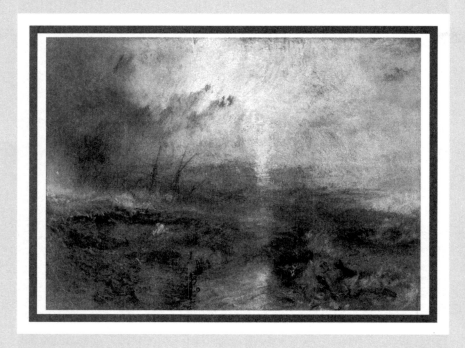

✳

Slave Ship
(Slavers Throwing Overboard the Dead and Dying— Typhoon Coming On)

(1840)

Joseph Mallord William Turner

⁜

Owning an original painting by an artist one greatly admires can be a thrill of immense proportions. But over time, could that painting have an ill effect on the enraptured owner and bring about a change of heart?

NEW YEAR'S DAY 1844 was a felicitous occasion for the Ruskins of Denmark Hill. The family was settled in at their stately new mansion outside London, to which they had moved just a year earlier from Herne Hill. The senior John Ruskin's wine distribution business continued to flourish, and son John, lately recuperated from a debilitating illness and graduated from Oxford, was enjoying remarkable success with his recently published tome on art and nature, *Modern Painters*. At this propitious time the father lavished on his beloved twenty-four-year-old son a gift that sent him into ecstasies of delight. The object of this elation was an oil painting by Joseph Mallord William Turner.

Young Ruskin was a devotee of Turner's work, and any canvas by the artist would doubtless have been sufficient to elicit the young man's joy and excitement. When he was thirteen, he had received from his father's business partner a gift to which he attributed "the entire direction of my

life's energies." It was the new illustrated edition of *Italy* by the English poet Samuel Rogers, and it contained vignettes by Joseph Mallord William Turner. Turner's artwork moved the boy deeply. As he would later write, no matter what the subject, he was fascinated by the pure artistic quality of Turner's work. It inspired the schoolboy to draw from it his own lessons, and he became an ardent admirer of the artist.

The gift from his father, *Slave Ship*, had special meaning for the blossoming art scholar. Ruskin's first volume of his seminal *Modern Painters* had grown out of his eloquent defense of Turner in an essay in *Blackwood's Magazine* in response to a scathing article that had appeared in the publication after Turner displayed three pictures—*Juliet and Her Nurse, Mercury and Argus,* and *Rome from Mount Aventine*—at the 1836 Royal Academy exhibition. In *Modern Painters,* Ruskin continued his focus on Turner, writing a rich and perceptive passage about Turner's *Slave Ship,* which had been disparaged by critics when it was first unveiled at the Royal Academy exhibition in 1840:

It is a sunset on the Atlantic after prolonged storm; but the storm is partially lulled, and the torn and streaming rain-clouds are moving in scarlet lines. . . . The whole surface of sea . . . is divided into two ridges of enormous swell . . . a low, broad heaving of the whole ocean, like the lifting of its bosom by deep-drawn breath after the torture of the storm.

Between these two ridges, the fire of the sunset falls along the trough of the sea, dyeing it with an . . . intense and lurid splendor. . . . The tossing waves by which the swell of the sea is restlessly divided, lift themselves in dark, indefinite, fantastic forms . . . leaving between them treacherous spaces of level and whirling water, now lighted with green and lamp-like fire, now flashing back the gold of the declining sun, now fearfully dyed from above with the indistinguishable images of the burning clouds, which fall upon them in flakes of crimson and scarlet. . . .

Purple and blue, the lurid shadows of the hollow breakers are cast upon the mist of the night . . . advancing like the shadow of death upon the guilty ship as it labors amidst the lightning of the sea, its thin masts written upon the sky in lines of blood, girded with condemnation.

For Ruskin, to write about a work of art he revered and then to become its owner must have been an unparalleled joy. His father, knowing well how to please his son, had bought this New Year's gift directly from the gallery where Turner's pictures were being sold. The young man could barely contain his excitement. "I had it at the foot of my bed the next morning," he later declared. And although he could empathize with the pleasure that comes with acquiring a first work of art, his new possession was nothing less than a collector's acme of bliss. "The pleasure of one's own first painting everybody can understand," he wrote. "The pleasure of a new Turner to me, nobody ever will and it's no use talking of it."

Ruskin's vivid panegyric on *Slave Ship* in *Modern Painters* showed prodigious insight into the painter's creative process. His interpretation of Turner's artistic imagery as the painter's commentary on the slave trade underscored his awareness of the painting's harrowing theme: the transportation of Africans aboard a slaver.

The bright, glowing canvas depicts a skeletonlike slaver in the middle distance being tossed about violently on raging waves. Mangled bodies struggle to stay afloat in the foreground, desperate hands outstretched above the water amid improbable tangles of chains. A viciously livid sun dominates the chaotic sky, searingly illuminating the sea below. The painting portrays the horrific practice of slave jettisons.

What inspired Turner to paint this ghastly scene?

One source was Thomas Clarkson's *History of the Rise, Progress, and Accomplishment of the Abolition of the African Slave-Trade by the British Parliament,* which was originally published in 1808 but had been reprinted

in 1839, the year before Turner painted *Slavers Throwing Overboard the Dead and Dying—Typhoon Coming On,* as the painting was titled when he exhibited it at the Royal Academy. The "typhoon" in the title referred not just to the typhoon at sea, but also to the furious storm of public indignation at the atrocities of the slave trade. Clarkson's book contained an account of the court case concerning the infamous *Zong* jettison, a widely circulated story that Turner, born in 1775, no doubt heard as a youth.

In early September 1781, the slaver Zong set out from the coast of Africa for Jamaica. More than four hundred Africans were stowed on board in chains, to be disposed of in the New World as slaves. As the ship neared Jamaica toward the end of November, Captain Collingwood called a few of his officers together. Illness on board ship was rampant; some five dozen slaves had perished, and it appeared that many others were not likely to survive. The captain was concerned about the economic loss.

ILLNESS WAS A major concern for slave traders; due to the austere conditions on board slave ships, Africans routinely became sick on the harsh Middle Passage voyages. Alexander Falconbridge, a British surgeon who served on slave ships in the late eighteenth century, was an eyewitness to the horrendous conditions. He wrote that when the slaves were brought on board, they were "immediately fastened together two by two, by handcuffs on their wrists, and by irons riveted on their legs." In their quarters they were "frequently stowed so close as to admit no other posture than lying on their sides."

The hardships suffered by the slaves, Falconbridge continued, were unimaginable. Perhaps most unbearable was the lack of fresh air; under these crowded conditions, the slave compartments were intolerably hot. When slaves became ill, said Falconbridge, the floors were so covered with blood and mucus that the deck "resembled a slaughterhouse." He described one slaver that had taken on almost seven hundred Africans, such a great number that they were "obliged to lie upon one another." Nearly half the slaves died before the ship arrived at its destination in the West Indies. The

sick slaves were put in a special compartment to lie on bare boards. Those who were emaciated, he wrote, frequently had "their skin, and even their flesh, entirely rubbed off, from the prominent parts of the shoulder, elbows and hips, so as to render the bones in those parts quite bare." The suffering slaves would be "obliged to continue in so dreadful a situation, frequently for several weeks," if they lived that long, and their excruciating pain was "not to be conceived or described."

WITH HIS OFFICERS, Captain Collingwood hatched a plan to throw the sick slaves overboard for the insurance money. The value of slaves lost at sea would be reimbursable, while that of slaves who died of sickness contracted on board would not.

Collingwood selected from his human cargo who would remain on board, and who would be cast over the side. From the ailing slaves, he chose more than 130 of those who were most gravely ill. Of this lot, 54 were immediately tossed to their deaths. The next day, 42 more were jettisoned.

Over the next three days, the remaining slaves selected by Collingwood were brought on deck. Some did not resist their masters and went overboard compliantly. Others would not go to their deaths at the hands of their murderers, and in this despairing moment found the courage to join their massacred brethren by leaping into the ocean of their own volition.

The *Zong* put in to Jamaica and off-loaded the surviving slaves, then returned to England, where the ship's owners put in a claim to the insurer for the full value of the jettisoned slaves, contending their loss was coverable by the underwriters. The ship's underwriters, however, claimed that the ship's crew threw the slaves alive into the ocean in order to fleece them.

In 1783 the *Zong* case was brought to trial. According to Clarkson:

The plea, which was set up in behalf of this atrocious and unparalleled act of wickedness, was, that the captain discovered, when he made the proposal, that he had only two hundred gallons of water on

board. . . . It was proved, however, in answer to this, that no one had been put upon short allowance; and that, as if Providence had determined to afford an unequivocal proof of the guilt, a shower of rain fell and continued for three days immediately after the second lot of slaves had been destroyed, by means of which they might have filled many of the vessels with water, and thus have prevented all necessity for the destruction of the third.

Although the excuse about the shortage of water was demolished, the jury surprisingly ruled in favor of Collingwood and the ship's proprietors.

TURNER, A PAINTER of landscapes and sea scenes, also drew inspiration for his painting from a poem by James Thomson. Thomson's was one of the few voices to speak out against the thriving British slave trade in the first half of the eighteenth century. Human bondage in various forms had long been a scourge of civilization, but perhaps never had so many people been so cruelly subjugated as under the colonial European slave trade. To many, slavery itself was appalling enough. But throwing slaves to their deaths in the ocean was the nadir of human cruelty.

In his 1727 poem "Summer," which became a section of his long poem *The Seasons,* Thomson bewailed the practice of ejecting slaves from ships, even hinting at divine fury over this vile act. In Thomson's summer day, "the aerial tumult swells," as if a harbinger of disaster. The storm is so awesome that the heavens seem to open, "exhausting all the rage of the sky." But the waters below hide a menace even more fearsome: a monster lurks in the roiling waters, "lured by the scent of steaming crowds, of rank disease, and death."

Behold! he rushing cuts the briny flood,
Swift as the gale can bear the ship along;
And from the partners of that cruel trade
Which spoils unhappy Guinea of her sons

Demands his share of prey . . . their mangled limbs
Crashing at once, he dyes the purple seas
With gore, and riots in the vengeful meal.

The content of Turner's *Slave Ship* was clearly painful to those who saw slavery as immoral, and Ruskin, a religious man, abhorred slavery. The *Zong* verdict was appealed, but surely the new outcome was hardly satisfying to the abolitionists. Charles Stuart described the arguments for and against the appeal in his 1836 *Memoir of Granville Sharp:*

A Mr. J. Lee, the counsel for the ship's proprietors, rejected the idea of taking the case further. The master, he asserted, had an unquestionable right to take the actions he did. "This is a case," he said, "of *goods and chattels.* . . . [The Africans] are goods and property—*whether right or wrong,* we have nothing to do with it."

Mr. Pigot, on the part of the underwriters, said, "The life of one man, is like the life of another man, whatever the complexion is. . . . I contend, that as long as any water remained, these men were as much entitled to their share, as the captain, or any other man whatever."

Lord [Chief Justice James] Mansfield, regarding the matter with a legal eye, declared, "The matter left to the jury, is 'was it from necessity'?—for they had no doubt (*though it shocks one very much*) that the case of *slaves,* was the same as if horses had been thrown overboard!! *It is a very shocking case.*"

Lord Mansfield granted a new trial.

Eventually the underwriters in the *Zong* case received a favorable verdict. But sadly, as Stuart pointed out, "so thoroughly corrupt and ferocious . . . was the state of legality then in England, that no prosecution could be had of the murderers."

Turner's painting was a strident reminder of the barbarity of the international slave trade, which had finally been outlawed in Great Britain, and its theme came to weigh heavily on its owner. For all the artistic merit Ruskin saw in it, the misery and injustice evoked by Turner's brushstrokes haunted him. After owning *Slave Ship* for a quarter of a century, Ruskin, who had so distinguished himself over the years that he would become perhaps the nineteenth century's most influential art critic, found that this graphic representation of cruelty and suffering was simply too painful to live with. He would have to relinquish the painting of which he had written, "I think the noblest sea that Turner has painted, and, if so, the noblest ever painted by man, is that of the Slave Ship, the chief Academy picture of the exhibition of 1840."

Ruskin turned the painting over to Christie's, but in the auction it held on April 1869, the bidding failed to meet its reserve. It occurred to Ruskin that America, which only a decade earlier had been in the throes of its own internecine battle over slavery, might be a proper place for it, and he had it shipped to Samuel P. Avery, a prominent art dealer in New York. In 1872 Avery arranged for his friend John Taylor Johnston, a railroad magnate, to acquire the painting from the British art critic. Johnston was also an avid art collector and a cofounder of New York City's Metropolitan Museum of Art, of which he served as president. When the sale was concluded, Ruskin was unburdened of Turner's frightful vision.

Ruskin had, however, already immortalized his opinion of the work. By this time, his dazzling passage about *Slave Ship* in *Modern Painters* had become world famous. It concluded:

I believe, if I were reduced to rest Turner's immortality upon any single work, I should choose this. Its daring conception—ideal in the highest sense of the word—is based on the purest truth, and wrought out with the concentrated knowledge of a life; its color is absolutely perfect, not one false or morbid hue in any part or line, and so

modulated that every square inch of canvas is a perfect composition; its drawing as accurate as fearless; the ship buoyant, bending, and full of motion; its tones as true as they are wonderful; and the whole picture dedicated to the most sublime of subjects and impressions— (completing thus the perfect system of all truth, which we have shown to be formed by Turner's works)—the power, majesty, and deathfulness of the open, deep, illimitable Sea.

The Outcast

(1851)

Richard Redgrave

⌖

A canvas is the natural place for an artist to denounce social ills. But does the artist always personally subscribe to the themes he or she conveys on canvas?

ON A COUPLE of occasions, presumably around the middle of the nineteenth century, the painter Richard Redgrave paid a visit to the home of a patron, Lord Northwick. Lord Northwick was a very old man, Redgrave recalled in his diary in 1860, but his mind was sharp and he had many stories to tell, having had numerous adventures in the prime of his manhood.

The painter was a captive audience as his loquacious host beguiled him with sensational tales. The distinguished old man had been present at some momentous events and was acquainted with the prominent English figures of the day.

On one such visit, the hoary picture collector told the story of a man in the service of the Crown who was held by their majesties in the highest esteem. But it was the fate of this gallant individual to become so infatuated with a woman that he completely surrendered to her charms and seriously complicated his life. Lord Northwick, no apparent admirer of the man's

paramour, described how the woman "used to dress in classic robes and pose in beautiful attitudes," causing the man "to be in raptures" while "she was as impassive as the statues she represented." The amorous relationship between the man and the woman would normally make for a diverting love story, except for the fact that both happened to be married to others, and two children resulted from the illicit affair. Although the man would eventually play a vital role in the service of his country, his obsession with the woman led to warnings from his friends, separation from his wife, and ill feelings at the highest levels of government; and the woman herself became the target of widespread scorn.

The affair had occurred more than a half-century earlier, around the time of Redgrave's birth in 1804. But now, during the reign of Queen Victoria, a much more austere propriety prevailed in the judgment of women's moral behavior. Sexual activity before marriage was shameful, and such a stain on a woman's virtue made her a pariah. The plight of fallen women was one of the social ills attacked by Richard Redgrave, who, in taking up the cause of the oppressed, had become a sort of Dickens of the canvas. His son noted that he "longed to fight for the oppressed and to help the weak, and could do it only with his brush." Such pictures as *The Reduced Gentleman's Daughter* and *The Poor Teacher* showed Redgrave's concern about women in distress.

Lord Northwick's story of the woman who bore one man's children while married to another must surely have struck a chord with Redgrave. He was the painter, after all, of *The Outcast,* which took up the theme of harsh patriarchal attitudes toward women who commit carnal sins. His provocative picture of an unsettling domestic scene, in which a young woman is ejected from her family home for her immoral behavior, was the Diploma work he presented to the prestigious Royal Academy in London after his election as a full member in 1851.

Redgrave's *Outcast* shows a man ordering his daughter out of the house as the rest of the family watches in distress. Standing at the open front door, the father glares sternly at the young woman, his finger pointing resolutely

into the cold and snowy night. The daughter, clad in a flimsy wrap, head bent in shame, protectively cradles in her arms the infant to which she has given birth out of wedlock. As the father issues his decree, his family is in anguish. One sister is on her knees, pleading, her hands clutching at her father's jacket. A brother, seated at a table, buries his face in his arms in despair. His mother rests a tender hand on his back, apprehensively watching the upsetting scene in the doorway. In the background another sister, her apron thrown over her face, pounds her clasped hands against the wall, while yet another sister looks on bewildered. Amid the hysterics, on the floor a letter has fallen, apparently from the daughter, informing her family of her wretched plight and announcing her imminent arrival with her child.

In his artistic commentary on society's sexual mores, Redgrave attempted to elicit compassion for the hardships suffered by young women who went astray. The father is the castigator (or the patriarch of society), the daughter the outcast (or victim), and the family members are the public from whom the artist hoped to draw compassion. Redgrave's painting is critical of the unforgiving father and sympathetic to the daughter, evicted from her own family. It shows his genuine concern for women who are ostracized for sexual behavior that does not meet society's approval.

The progressive attitude Redgrave expressed in his art makes his reaction upon hearing Lord Northwick's story rather perplexing. With an attentive listener in the middle-aged painter, Lord Northwick reflected aloud on a time when a revered national hero and the ambitious woman he loved were besieged with malicious gossip, snubs, and disdain. The tale he told was an enthralling episode of history.

SHE WAS BORN to poor parents in northwest England probably in 1765, with the unpretentious name of Emmy Lyon. Her father died soon after she was born, and her mother took her to her own parents' home in north Wales. Emmy lived a simple life in Hawarden, working as a nursemaid

when she was about twelve. Not long after, the girl left the quiet country village for London.

The great metropolis attracted many ambitious youths—painters looking to learn from masters, youngsters seeking trades and apprenticeships—and as a cultural and political center inhabited by many important people, it was an exciting place to be. Emma found employment, but having blossomed into a voluptuous beauty, she soon embarked on a different path. She became a mistress.

The sixteen-year-old first resided under the protection of a young heir, Sir Harry Fetherstonhaugh, and then after he tired of her, with a man named Charles Greville. Somewhere along the line Emma Hart, as she now called herself, had an illegitimate daughter, whom she gave to her grandparents to raise.

Although Greville and Emma were apparently not well suited for each other, the young woman was wholly devoted to her partner. Greville was controlling, irritable, and crafty. Emma was a lively girl who liked to sing and act and, to the chagrin of Greville, entertain in public. Glowing with charm and playfulness, Emma could catch the eye of many a man, but she remained loyal to Greville, turning a blind eye to her lover's unpleasant and sometimes cruel ways. As a small measure in his favor, Greville had a genteel, amiable uncle, Sir William Hamilton, a childless widower who was England's envoy at Naples and an antiquarian, whose acquaintance Emma made when he visited his nephew.

Greville had little money, so to assure himself financial security and the lavish lifestyle he coveted, he aspired to become his wealthier uncle's heir and to settle down with a lady of high birth and substantial means. Emma was beautiful, to be sure, but she met neither requirement. So Greville set his sights on one of Lord Middleton's daughters and devised a way to free himself of Emma and her mother, who had come to live with them.

Greville encouraged Emma to accept an invitation from Sir William to visit him in Naples. It was obvious to Hamilton that Emma was deeply in

love with his nephew, but Charles was sure she would make a splendid mistress for the older man. Unaware of Charles's intentions, Emma and her mother took up Sir William on his kind gesture and left for the Italian state.

The British plenipotentiary at Naples looked forward to the arrival of the fetching young woman, but surely not with any long-term considerations. He had established a respectful relationship with Queen Maria Carolina and King Ferdinand; having a mistress would only invite scandal and jeopardize his good standing with the royals. Besides, having been recently widowed after a long marriage, what was the necessity of taking another wife now that he was in his mid-fifties? In any case, it was hardly conceivable that Emma would view Sir William as an object of matrimony, given her attachment to Charles.

In Naples, Emma could not help but be dazzled by the exotic locale, the amenable weather, the lavish banquets she attended, and the opulence of Sir William's residence at the Palazzo Sessa; Sir William in turn was taken by the beauty and charm of the woman thirty years his junior. When Emma's heartfelt billets-doux to her lover in England went unanswered and she concluded bitterly that he had abandoned her, her friendship with the older Hamilton turned to passion. However, for an ambassador to live with a mistress in close proximity to the Court was considered scandalous, and even if Emma and Maria Carolina had become close, Court was officially off-limits for a mistress. In due time Maria Carolina registered her displeasure to the British envoy, who was quite aware of the animadversion frequently directed at his mistress's character. A wedding was in order.

Emma returned to England with Sir William so he could seek the king's permission to marry her. It was a bold request. The nation's esteemed Neapolitan envoy proposed to marry a woman from a poor background who had been cohabitating with him for five years and had been the mistress of other men. Some or all of these facts may have been known to George III. With no tributes, felicitations, or enthusiasm, King George gave his consent

to his longtime ambassador to marry. The queen snubbed the future bride altogether.

Emma, now Lady Hamilton, adapted well to the role of ambassador's wife. Coarse as she could sometimes be, her outgoing nature, charm, and beauty made her well suited for everything from the social life to intercourse with the king and queen. And life was certainly grand at the Palazzo Sessa, where Sir William collected his magnificent relics and important visitors were sometimes received. Some lucky guests were even treated to Lady Hamilton performing what she called her "attitudes," in which she enchantingly struck a range of poses in imitation of classical images.

In August 1793 the political currents pulled a distinguished British mariner to Naples. He was Horatio Nelson, back on the seas after half a dozen years of unemployment. He had proven himself a brilliant and dedicated seaman, even if the Admiralty, in his opinion, had left him without a command for more than half a decade. But now that he had received a commission to command the *Agamemnon,* his life was fully back in order. He had a wife—Fanny, whom he had married in the West Indies—he had a ship of the line, he had his dignity back, he was content.

The French were in revolution, and England was threatened. Nelson had been ordered to Naples to secure troops to help the French Mediterranean port city of Toulon resist the revolution, and to assist in evacuating the monarchists there. His liaison for official matters to the Neapolitan Court was through the British plenipotentiary.

Sir William and Lady Hamilton proved accommodating hosts and made introductions that enabled Nelson to receive a pledge for the needed troops. His mission accomplished, Nelson bid farewell to his friends in Naples. The king and queen, who loathed the revolutionists in France, no doubt admired the intrepid seaman, as did Lady Hamilton.

The years passed. Napoleon began his vicious assault on Europe, and Horatio Nelson gave an arm and an eye in service to the Crown. When Nelson put into the port of Syracuse in southeast Sicily for supplies and was

denied them by the regent, it was Lady Hamilton who used her influence to obtain what he needed. Then he went off to Aboukir Bay, where he decimated the French fleet in the sanguinary Battle of the Nile. Horatio Nelson was an exalted hero, and when he returned to Naples for repairs to his ship, his relationship with Lady Hamilton underwent a transformation. She almost fainted in his arms when she came out on a small boat with her husband to greet him, and romance escalated during the numerous fetes for the knighted seaman. By the time Nelson was helping the royals evacuate Naples for Palermo when revolution threatened, he and Lady Hamilton were lovers.

The new century dawned. Sir William, now seventy years of age and in poor health, withdrew from his diplomatic post. Nelson also had health problems, and he decided to travel with the Hamiltons on their overland journey back to London, where Nelson's wife, Fanny, awaited her husband.

The reunion was tense. Nelson's letters over the past couple of years had became less affectionate, and he often spoke of Lady Hamilton, whom he lauded as an honor to her sex. Perhaps ugly rumors had reached Fanny's ears, too, about her husband carrying on shamelessly with the ambassador's wife. When Lord Nelson arrived in November 1800 to greet his wife with his lover and her husband in tow, each of the women had to deal with her knowledge of the other's keen interest in the man they both loved.

At Court, King George was indecorously abrupt with the "Hero of the Nile." Several years ago his ambassador to Naples had come to him for permission to marry a woman of dubious background. Now his nation's hero had taken up with the same woman, who was still married to the same man, and while the valiant Nelson was married to another woman!

Nelson, though immersed in scandal, was lauded at celebrations, accompanied by his unhappy wife, while Lady Hamilton was sometimes not even allowed through the doors. Nelson could not shake his passion for Emma. Bitter arguments between Nelson and his wife followed, and soon he and Fanny separated.

In January 1801, Emma gave birth to Nelson's daughter, Horatia. To avoid the public disgrace of bearing an illegitimate child with England's hero, Lady Hamilton had a stranger care for the newborn. The baby had been born in October, she explained, a story designed to deflect any suspicion that she was the mother, since at that time she had been making her overland journey back to England. Likely that did not fool the recipient of the child; the girl entrusted to her care could not have been a week old.

Emma helped Nelson find a country home, Merton Place, outside of London. She and Sir William had leased a home at 23 Piccadilly but spent much of their time at Nelson's cozy estate nestled among the trees. If Sir William was aware of his wife's affections for his friend, he never let on. But he eventually tired of this living arrangement and returned to 23 Piccadilly, where in 1803 he died, with his wife and her lover by his side.

Nelson came back to Merton Place, but his stay there was short-lived; war was imminent again, and he was needed in the Mediterranean to monitor the French fleet. He bid farewell to Emma, although he was not exactly leaving her alone; she was carrying his second child. But Vice Admiral Nelson's second daughter did not survive long after birth.

Emma was acutely aware of her precarious financial situation. Sir William had made an agreement with his nephew, Charles, for his estate to pass to him, and Emma was to receive from it only a modest stipend. Moreover, Charles Greville ordered Emma to leave 23 Piccadilly. She appealed to the government for assistance. As the wife of England's plenipotentiary at the Kingdom of Naples, she had performed many valuable acts in the service of her country, even at times dispensing her own personal funds. Lady Hamilton's written pleas to the ministers were ignored. The king's feelings about her and the whole ménage à trois were painfully obvious.

As despairing as her situation was, it was only to become worse. In the great Battle of Trafalgar in October 1805, Lord Nelson, her lover, the father of her child, took a fatal musket ball in the chest. Before the battle, as if sensing his own approaching doom, he had written in his journal that he

was leaving Lady Hamilton and his "adopted" daughter, Horatia (as she was known), the annuities, pensions, titles, and stipends he had been awarded for his heroic contributions to the nation. As he lay dying on his ship, he repeated his insistence that this legacy go to his beloved Emma and Horatia.

But none of these rewards was to flow to Emma or Horatia. Nelson's siblings and his wife were the recipients of the fallen hero's remuneration. Lady Hamilton had no legal tie to Lord Nelson. She was nothing but his lover, a public embarrassment to the hero and the country. She was, in the eyes of society, an outsider, and outsiders have no privileges.

Now middle-aged, her looks faded, her figure gone, Emma was emotionally shattered. She drank, gambled, and fell ever more deeply in debt. She borrowed and begged until friends and acquaintances wrote her off, and even Horatia had to plead for money. Forced to leave her homeland to avoid debt, Emma became a recluse and ultimately died in poverty on foreign soil. Lady Hamilton was an outcast who could not be permitted to rise above the scandals and stigmas to which she had been attached.

ON HEARING LORD Northwick's tale of Lady Hamilton's sad decline, Richard Redgrave was not sympathetic. "I ventured to say," the artist recorded in his diary, "that her connection with Nelson was rather disgraceful."

"Disgraceful"? The painter of *The Outcast,* a champion of downtrodden women in the forbidding Victorian era, passing harsh judgment on Lady Hamilton, who bore children out of wedlock and was cruelly shunned? Was Richard Redgrave a hypocrite?

On the surface, Redgrave's remark seemed to approve of the very ostracism of a fallen woman that he had condemned in his art. Yet his remark was not necessarily inconsistent.

Although both outcasts, the pitiable young mother in Redgrave's painting has little else in common with Lady Hamilton. The girl in Redgrave's painting is clearly ashamed of her moral transgression. She

clutches her newborn tightly and keeps her eyes focused on the child. She is a loving mother and wants nothing more than for her little one to become part of her family. The letter on the floor probably describes how she had been taken advantage of by her lover, perhaps even raped. But her father has worked himself into a rage; she is nothing but a whore and a disgrace to the family, and under no circumstances will she be allowed to stay with her little bastard. She will now be on her own, her prospects for an income to support herself and her child almost nonexistent; she may even be forced to sell her body to survive.

Redgrave understood the awful predicament of such women, and with his art he tried to inspire a compassion that would ameliorate their situation.

That Lady Hamilton bore children out of wedlock does not put her in the same category as Redgrave's fictional unmarried young mother. She was a married woman of the upper class who committed adultery with a married man. When she became involved with Nelson she was already a mature woman who had been mistress to at least two men, and both mistress and wife to another. She was about thirty-five when Horatia was born in 1801, and she was a willing accomplice in her own impregnation. Lady Hamilton successfully contrived to destroy Nelson's marriage because she wanted him for herself, yet knew she could not hope to replace Fanny as the seaman's wife.

Lady Hamilton flaunted her relationship with Nelson practically under her husband's nose. Sir William might have suspected it, but he never accused her of salacious behavior; he treated his wife's lover very kindly. Lady Hamilton gave her children away, coldly disavowing her first child and dropping off Horatia in another home when she was just an infant. Lady Hamilton purposefully tried to avoid further scandal by not acknowledging that she had given birth to Nelson's children. Even when Horatia pleaded to know her parentage, Lady Hamilton, to her dying day, would not admit she had given birth to her.

Unlike the girl in Redgrave's painting, Lady Hamilton had had money when she gave birth, from both her husband and Nelson. Her subsequent distress at Nelson's death was deep, but while many widows learn to cope with their loss, Lady Hamilton chose to soothe her pain by drinking, gambling, and squandering what resources she had, then borrowing and begging for handouts when those resources ran out. When Emma Hamilton was perhaps the same age as the girl in the painting, she also had a child out of wedlock. But she continued her profligate ways, not caring about the great public scandal she had caused, or about jeopardizing her lover's career, or about the emotional welfare of her children, or about wrecking her lover's marriage.

But for all her transgressions, Lady Hamilton had many accomplishments, and it would be unfair to judge her too harshly. She rose from her poor roots to become an ambassador's wife, to serve her country well during a difficult time, to give children to Horatio Nelson who yearned to be a father, and to secure her place in history. With her dissolute reputation preceding her, Lady Hamilton suffered the humiliation of being shunned by many of the upper crust of society that she so wished to be a part of, but she determined to live the life she wanted and soldiered on. In a more modern era, her behavior would not be so out of the ordinary as to make her a pariah.

Redgrave appeared to condemn Lady Hamilton's adulterous behavior, but whether he approved of society's callous rejection of her is a different question entirely. Adultery in Lady Hamilton's time was looked down upon even if tacitly accepted, but that was not the social ill Redgrave addressed. *The Outcast* was a commentary on the brutal treatment by a patriarchal society of women who have children out of wedlock. Clearly, adultery and out-of-wedlock pregnancy were two distinct issues. The "product" might have been the same in each case, but the "sins" were different. In making his disparaging remark about Lady Hamilton's behavior, Redgrave did not betray his *Outcast* message.

Richard Redgrave wrote in his diary that he thought Lord Northwick's account of Lady Hamilton was "highly interesting." Its sad tale of human frailty impressed him sufficiently to record his feelings in his diary. And even if he thought Lady Hamilton's behavior was shameful, as a warmhearted, gentle man, he would probably have had compassion for her, just as he did for the girl in *The Outcast*.

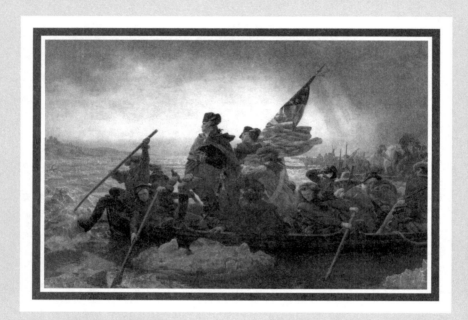

Washington Crossing the Delaware

(1851)

Emanuel Gottlieb Leutze

※

The canon of great paintings comprises many famous works of art that have captured the fancy of generation after generation. Surprisingly, not all the famous pictures that we come to know and enjoy are the original versions painted by the artists.

SOON AFTER IT was painted in Germany and shipped to New York City, *Washington Crossing the Delaware* became a national treasure in America. Crowds flocked to the Stuyvesant Institute in New York City to see Emanuel Leutze's spectacular new Revolutionary War painting of the future father of his country leading the nautical charge of the Continental Army against the enemy in the distance.

Visitors were moved by the arresting image before them: His eyes fixed intently ahead, his cape draped dashingly over his shoulders, General George Washington stood erect in the bow of his crowded boat as it crashed through jutting floes of ice in the turbulent river, guiding a flotilla of soldiers to war.

The admission fee was twenty-five cents for adults, half-price for children, and the gallery was open from eight in the morning until ten at

night. The *New York Times* declared Leutze's new work "probably the greatest historical picture in the country."

America had many dramatic historical pictures to enthrall its citizens. Paintings of the battle of Bunker Hill, the siege of Yorktown, the surrender of Cornwallis, and many other inspiring scenes of the colonists' relentless pursuit of freedom fed the public appetite for national glory. But Leutze's picture caught on like no other before it. From engravings and copies it became ubiquitous, hanging proudly in American homes, churches, and public buildings; for decades after its debut at the Stuyvesant Institute, American schoolboys and schoolgirls learned patriotism from Leutze's canvas.

Although Leutze's painting of Washington's Continental Army traversing the hazardous Delaware was laden with technical errors, what better symbol of patriotism could there be than a beleaguered band of soldiers, when defeat seemed imminent, advancing valiantly into battle for the noble cause of liberty and the birth of a new nation? The rousing image that told of a crucial event in the founding of the United States of America stirred in schoolchildren a fervor of dedication and love of country.

But there is a backstory. The painting by Leutze that soared to fame and went on to become one of the great icons of American culture is in fact not the artist's first *Washington Crossing the Delaware*. It is a second version of an original that suffered a dire fate.

EMANUEL LEUTZE WAS born in Württemberg, Germany, in 1816, at a time when Europe was trying to remake the continent after the defeat of Napoleon. Following the death in 1816 of Frederick I, the king of Württemberg, a new ruler, William I, was installed. In 1819 William promulgated a new, liberal constitution—his predecessor had abolished the old constitution in 1805 when he became king—and subsequently many residents left the German state. In 1825, Leutze's father uprooted his family and moved them to Philadelphia. Leutze showed talent as an artist and took up instruction in his new hometown. The young artist painted portraits, and

by the time he was in his midtwenties, he had saved enough money to return to Germany, settling in Düsseldorf.

It was not uncommon for American artists unhappy with the pedestrian art training they received at home to seek instruction abroad; London and Paris were the premier centers for art education in the early nineteenth century. But by the middle of the century the Düsseldorf school, which embraced the Romantic style of emotional and subjective storytelling, was held in the highest esteem.

In Düsseldorf, Leutze attempted to glorify his adopted country in historical paintings. No doubt inspired by heroic tales of the Continental soldiers in America nearly three-quarters of a century earlier, in his *Crossing the Delaware* Leutze endeavored to depict the sunset-to-3:00 A.M. ferrying of approximately 2,400 men from McKonkey's Ferry in Pennsylvania to a point across the Delaware. From there, they would approach the garrison of the British-employed Hessian mercenaries at the town of Trenton in the neighboring colony of New Jersey and attack them. Although on the verge of defeat, the Continental soldiers braved the fierce winds, rain, hail and snow, piercing cold, and river at flood stage to attack the enemy. Their resounding victory at the Battle of Trenton and the subsequent Battle of Princeton, the so-called ten crucial days of the American Revolution, provided a vital resurgence to the dispirited Continental Army, which went on to defeat the British and change history. The success of the journey that began under such forbidding conditions on the twenty-fifth of December was largely due to Colonel John Glover's 14th Continental Marblehead Regiment rowers, also known as the Marbleheaders. Experienced whalers, these Massachusetts oarsmen were adept at maneuvering through treacherous waters. Leutze chose to paint the event of the crossing to emphasize the bold spirit of the freedom fighters.

In 1849, Leutze applied the first brushstrokes of his artistic ode to Washington and his soldiers—that is, he began the first version of the painting. The canvas was large, with realistic portrayals of the actors, but

early on Leutze ran into an obstacle: He needed models for the human figures, and Germans simply wouldn't do.

According to the American landscape painter Worthington Whittredge, who visited Leutze in his Düsseldorf studio as he was working on the painting, the artist had "great difficulty in finding American types for the heads and figures, all the German models being either too small or too closely set in their limbs for this purpose. He caught every American that came along and pressed him into service." Whittredge, whose observations are recorded in his memoirs, at one point invited a friend from Ohio to meet him at Leutze's studio, but the six-footer was immediately recruited by the painter before the two could even engage in conversation. "This friend," Whittredge wrote, "a thin sickly-looking man—in fact all his life a half invalid—was seized, a bandage put around his head, a poor wounded fellow put in the boat with the rest, while I was made to do service twice, once for the steersman with the oar in my hand and again for Washington himself." The hapless Whittredge had to stand stock-still for two hours so Leutze could paint Washington's cloak at one sitting without disturbing the carefully arranged folds. Whittredge posed in the general's full military uniform, "heavy chapeau and all, spy-glass in one hand and the other on my knee, I was nearly dead when the operation was over. They poured champagne down my throat and I lived through it. This was all because no German model could be found anywhere who could fill Washington's clothes, a perfect copy which Leutze ... had procured from the Patent Office in Washington."

By the autumn of 1850, Leutze was nearing completion of his historical picture and planning to take it to America, when an artist's worst nightmare occurred: A fire broke out in his atelier. The canvas was saved, but it was seriously damaged. After making repairs as best he could, Leutze finished the painting. But apparently wanting an unmarred representation of the dramatic American operation in the country's quest for independence from the British crown, he undertook the formidable task of starting the picture over.

Leutze completed his second version of *Washington Crossing the Delaware* in 1851. The picture was dispatched to America, where it became a huge success despite being riddled with historical inaccuracies, among them: The river he had painted was not the Delaware but Germany's much larger Rhine. The crossing took place during hours of darkness, whereas in the painting, sunlight streams through openings in the clouds. There are no manifest signs of the severe weather that impeded the Continental Army at the time of the crossing. The soldiers' clothing appears pristine and fresh, although in fact at this point it was tattered and filthy and missing essential components; some soldiers were even barefoot or had rags wrapped around their feet. The boats appear a great deal shorter in the painting than they were in real life (up to sixty feet long). And the American general did not stand valiantly at the bow, but somewhere in the body of the deep craft.

Did it matter to the public that an iconic event was portrayed on canvas with inaccuracies?

Apparently the public wasn't bothered by Leutze's lack of factual precision. Paintings of iconic events are not designed to constitute a historical record but rather to evoke an emotional response in the viewer. Slavish adherence to accurate details in many cases is not only unnecessary but may actually detract from the feelings the artist wishes to inspire. The drama and excitement of the 1776 heroic crossing were captured in Leutze's painting, and that was what appealed to the public.

While Leutze's second version of Washington's aquatic excursion to the December 26 Battle of Trenton was becoming a cultural triumph, the singed original was now apparently in safekeeping and headed for its own success. Although the artist had first intended the work to be exhibited in the Capitol in Washington, D.C., it was denied acceptance there because of the damage. But incendiary blemishes and all, it was still a work that could elicit admiration, and for about a decade Leutze displayed it at major German art exhibitions. The wounded painting won the Große Goldene Medaille (Great Gold Medal) of the Große Berliner Ausstellung (Great

Exhibition of Berlin) and soon became even more widely known after an engraving was made by Paul Girardet. The canvas found a permanent home when the Kunstverein, a private art society founded in 1823 in the city of Bremen in northwest Germany for the purpose of promoting art, purchased it from the artist in 1863 for 900 Taler Gold and displayed it in its gallery; the Kunstverein had constructed its own museum, the Kunsthalle Bremen, in 1849, the same year Leutze commenced his efforts to memorialize Washington's crossing on canvas.

But Leutze's original depiction of the dramatic voyage to victory in the American Revolutionary War seemed to have a date with destiny, and its second destructive encounter was fatal. After dark on September 4, 1942, and continuing through the early hours of the next morning, Allied planes (probably from the British Royal Air Force) flew over Bremen on a bombing run. The phosphorus bombs that were dropped on the Kunsthalle Bremen scorched rooms L, M, N, O, P, and Q in the second-floor gallery. To protect the paintings during air raids, museum workers had sequestered in a shelter all of them except Leutze's canvas hanging in room L, which could not be removed because it was too large. Not only did the Kunsthalle Bremen sustain structural damage in the attack, but Leutze's *Washington Crossing the Delaware* was obliterated. Although the later version was already an artistic icon, ironically the artist's original rendition of the spirit of democracy was blown up on Nazi soil by intrepid freedom fighters.

The painting *Washington Crossing the Delaware* that became known to posterity is a second version, a scion of the original. Some artists who have the misfortune of seeing an unfinished piece of their work disfigured might abandon the quest to bring it to fruition and instead make a fresh start with something new. But Leutze evidently felt his work had a special purpose. Like Washington's soldiers, who refused to let anything, not even a nor'easter, cause them to abandon their mission, Leutze, undismayed, immediately began the arduous task of recreating his painting. At more than

twelve feet high by over twenty-one feet wide, this canvas was no small endeavor!

The second version swiftly became a part of American culture and has long been a symbol of fighting for an honorable cause in the face of great odds— not just in America, but everywhere. The rebel leader's ramrod pose, his men's unswerving faith and devotion to duty, the flag pointing to the heavens as if the mission is a divine calling—bravery, strength, and determination radiate from its surface. And the world has been inspired by this stirring emblem of patriotism because the painter had a vision and refused to let anything, not even fire, stop him from putting that vision on canvas.

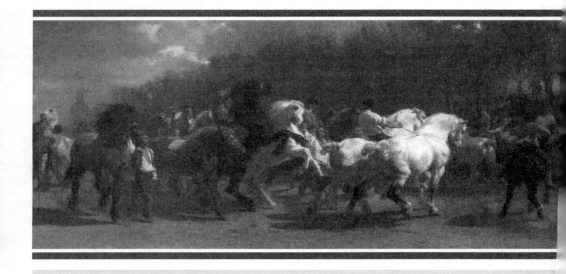

The Horse Fair

(1853–55)

Rosa Bonheur

⌖

To what lengths will an artist go to paint a picture? Michelangelo famously perched on a scaffold to paint the ceiling of the Sistine Chapel. Hans Holbein the Younger crossed the English Channel several times to render portraits of prospective brides for Henry VIII. Théodore Géricault rented an atelier near a morgue and hospital so he could study cadavers and amputated limbs. To paint her most famous work, *The Horse Fair,* the nineteenth-century French artist Rosa Bonheur took a decidedly unconventional approach.

Rosa Bonheur lived in the patriarchal Victorian era, in which a woman who trespassed outside the traditional feminine boundaries invited the scorn of society. In her world, women were expected to adhere to the canons of proper female behavior. Dress codes were clearly defined. Wives were instructed on how to submit themselves to their husbands' carnal desires. And French art institutes were closed to women.

But Bonheur ignored the conventions, and through her talent and determination—not to mention her audaciousness—became one of the most celebrated female artists of her day.

Rosa was the eldest child of Raymond and Sophie Bonheur. Raymond was a painter, and Sophie was an orphan who had been raised in a wealthy

family. In the early 1830s her father became an adherent of the Saint-Simonian faith, a scientific-Utopian reform movement that embraced feminist principles, and for a time so immersed himself in it that he even took up residence with his fellow adherents at a retreat.

Sophie's death when Rosa was eleven hit the family hard. As Raymond's consuming teaching duties as an artist did not leave him time to properly care for his four young children, he felt it was necessary to make arrangements for them to stay temporarily in the care of other families. Over the next several years the young Bonheurs were shuttled between other homes and boarding schools.

At one point Rosa incurred the wrath of the matron of the house by frequently skipping school to wander off to the Bois de Boulogne to watch the horses being walked. Rosa's father sent her to learn the trade of a seamstress, but the girl found herself ill suited for the sewing lessons and chores and would slip into another area of the home where the sewing teacher's husband had a lathe and she could spin its wheel. When Rosa grew older her father put her in a private girls' boarding school, but by her own admission, her tomboyish behavior earned the antipathy of her classmates, and her unruly conduct ultimately resulted in her dismissal from the school. She returned to her father's home where, free at last to indulge her own interests and encouraged by her father, her determination to succeed as an artist took solid form. To learn from the eminent masters, she copied paintings at the Louvre, for which she earned income. But it was the art featuring animals that most inspired her, and she sought four-legged creatures outdoors to paint. Bonheur's passion for depicting animals was deep. She painted, among other creatures, cows, horses, rabbits, bulls, and sheep; she kept animals in her studio; she dissected animals to study their anatomy. She displayed at the Salon and exhibited her animal pictures in Rouen and Paris and won medals.

Rosa's desire to master the craft of animal painting took her in the mid-1840s to the unpleasant world of Parisian slaughterhouses to study anatomy.

The rivers of blood, foul smells, and terrified squeals of doomed animals would surely have discouraged other ambitious women, but Bonheur resolved to put up with it. As if this were not enough, she found she had to suffer the vulgar remarks of uncouth men who did not take kindly to females in their midst, even a boyish-looking woman like Bonheur. As a profile in *London World* put it in 1880, "As an animal painter she had to go wholly out of the beaten track to find her subjects, sometimes to the great stables of Paris, sometimes to the abattoirs. The brutes were exceedingly well behaved; but the superior beings in charge of them, the slaughtermen and horseboys, did not always imitate their example." Eventually one of the workmen took pity on her and assumed the role of her protector, which forced the other men to treat her with more respect so she could devote herself without distraction to studying and sketching the animals and honing her artistic skills.

Eventually, Bonheur chose as a subject the Paris horse fair, an open-air extravaganza on the Boulevard de l'Hôpital. She knew she would receive unpleasant attention as a woman conducting her artistic studies at the fair—hard stares, nasty remarks, ribald gestures—and feared they would interfere with her attention to her work. If she disguised herself as a member of the opposite sex, she reckoned, she could apply herself more diligently.

In mid-nineteenth-century Paris, men's and women's public attire were properly distinct: Men wore trousers and shirts; women were clothed in long skirts, bodices, and bonnets. Local law prohibited women from wearing pants in public except for medical reasons. Following proper procedure, Bonheur applied for and was granted permission from the prefecture of police to dress as a man in public for a limited time.

In her masculine garb, Bonheur generally visited the horse market a few times each week. A diminutive woman of about thirty with short hair parted like a man's, wearing pants, a blouse, and boots, she would undoubtedly have been taken for a boy in his teens among the sea of attendees. Sketchbook in hand, Bonheur went about her business without

attracting the disparaging attention she might have expected had she been in women's dress.

Bonheur's painting, completed in 1853, quickly won acclaim in Europe and America. *The Horse Fair* is a dazzlingly fast-paced, spirited look at a nineteenth-century horse market. A group of massive Percherons cavorts before a crowd of spectators. Two spirited horses in the center, one black, one white, rear defiantly. The fair comes alive as we almost hear the thunder of the great horses' hooves and their brassy neighing mixed with the handlers' raucous shouts. Bonheur's depiction of the Percherons, whose ancestors carried medieval knights into battle, is spectacular: brawny muscles ripple under their glossy hides, their powerful legs and long necks astonishingly fluid and graceful for such huge creatures.

The Horse Fair grabbed the public fancy. It was a sensation at the 1853 Salon, then was exhibited in some French cities and in London, and finally toured the United States before being sold to a British publisher and dealer in 1855.

With the success of *The Horse Fair,* Bonheur's fame spread. Her works were in demand, and she prospered financially. Before the decade was out, she moved from the metropolis of Paris to a château in the hamlet of By near Fontainebleau. Dressing in men's clothes and keeping her hair closely cropped was for her no longer just a professional strategy; it became part of her lifestyle. Here is an account from the August 25, 1878, edition of the *New York Times* by a visitor to Bonheur's country retreat when the artist was in her midfifties:

I had never seen Rosa Bonheur but Mme. ———— insisted on driving me down, as any friend of hers was sure of a welcome from the artist. The country was charming, and as we approached the gates I noticed a working man in a blouse, with short, thick, gray hair, eagerly on the lookout for the carriage. My friend shook hands with him with effusion, and I noticed that this curious *ouvrier* wore brilliants at the cuffs and

collar of his shirt. I was beginning to meditate on the eccentricity of an artist's household, when the working man turned to me with the frank and charming manner of Rosa Bonheur herself, and welcomed me to the pleasantest of visits in the pleasantest of country houses!

Rosa Bonheur had male friends, but she never married or had children. She seems to have viewed men with a degree of contempt, reportedly making derogatory remarks about them on numerous occasions. One friend, the landscape painter Joseph Verdier, recalled that soon after he was married, he went out riding with Bonheur. The pair happened to encounter one of Verdier's acquaintances, who jested that it was perhaps not prudent of his new bride to let him ride off with Bonheur. The artist commented dryly, "If you only knew how little I care for your sex, you wouldn't get such queer ideas into your head. The fact is, in the way of males, I like only the bulls I paint."

Rosa Bonheur found her companionship in other women. Her first great love was Nathalie Micas, whom her father had taught when Nathalie was in her youth. After Micas died, Bonheur was heartbroken, but she eventually found another partner, a young American named Anna Klumpke.

Rosa Bonheur died in 1899 at the age of seventy-seven. The French artist left behind a legacy of magnificent animal paintings including *Ploughing in the Nivernais, Muleteers Crossing the Pyrenees, Cows and Sheep in a Hollow Road, Doe and Fawn in a Thicket,* and *Hay Making in the Auvergne,* but of course she is best known for *The Horse Fair.* Painting works that captured the public imagination, she was in her personal life bold and aggressive, an uncompromising feminist in a period when she had few compatriots.

Rosa Bonheur famously donned male garb in Paris in the mid–nineteenth century to paint her great equine work of art. But the true story of *The Horse Fair*—and indeed of her life—was not that Rosa Bonheur had to pretend to be a man, but that she refused to hide who she was as a woman.

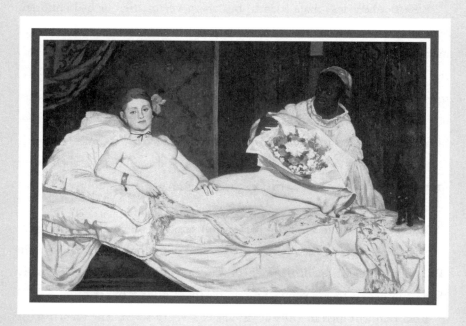

Olympia

(1863)

Édouard Manet

※

It is in the nature of artists to express themselves on canvas without regard for the consequences of their vision. Artists are free spirits, and if they break conventions, that is something the public has to deal with: Art supersedes public mores. But of course such artistic audacity does not come without a cost, because when a work of art does not conform to public morality, a scandal may result that could jeopardize the artist's career.

FOR A FRENCH artist in the mid–nineteenth century, exhibiting at the Salon was vital for career success. The annual exhibition of new paintings, the Salon was the grand showcase of art in France, and people flocked to it. The Salon facilitated sales of paintings and commissions, and with galleries and independent exhibitions rare at the time, it was vital to a painter's livelihood and career.

A screening jury determined whether a painting would be accepted for exhibition at the Salon. Skilled artists, the jury's members belonged to the French Academy, and their preference was generally for the academic form of painting. Artists who didn't conform to their tastes were usually rejected.

Many a tender creative ego was deflated by such a rebuff; even suicide was not unheard-of.

In 1865 Édouard Manet submitted two entries for the Salon, *Christ Mocked by the Soldiers* and *Olympia,* and both, surprisingly, were accepted. He had, after all, created a furor two years before with his *Luncheon on the Grass (Déjeuner sur l'herbe).* That painting had been rejected by the Salon and was exhibited instead in the Salon des Refusés, a sort of counter-Salon established by Napoleon III to showcase works too unorthodox for the Academy. It featured a naked young woman sitting on the ground next to two fully clothed reclining men, looking directly out at the viewer. For Parisians, a picnic was a favorite leisure activity to while away the hours with friends and family. The intrusion of a naked woman into this innocent setting was lewd, vulgar, and suggestive.

For all the commotion it caused, *Déjeuner sur l'herbe*—perhaps the first modern art scandal—was a minor disturbance compared to the rumpus raised by *Olympia,* which Manet had essentially completed in 1863. This painting also starred a naked woman—the same woman, in fact, who had modeled for *Déjeuner sur l'herbe.*

Manet probably suspected that *Olympia* would cause some commotion, like his friend Baudelaire's collection of poems *Les fleurs du mal* (*Flowers of Evil*), which was deemed immoral when it was published in 1857. But art, Manet felt, was a powerful force, and its creators had to suffer the consequences of their works. As Baudelaire told him after a previous rejection from the Salon, an artist must be true to himself.

In *Olympia* a young woman reclines naked on a bed. Her legs are crossed at the ankles, and her left hand rests on her upper left thigh. She is wearing earrings, a thin black choker around her neck, a gold bracelet on her right arm, and a red orchid in her pulled-back hair; a high-heeled slipper dangles from her left foot. Her haughty gaze meets the viewer straight on. Standing behind her, a black woman offers her a bouquet of flowers, while a black cat, its back arched high, eyes open wide, stands at the foot of the bed.

The reaction to *Olympia* was sheer horror.

As in *Déjeuner sur l'herbe,* Manet's subject was no idealized female, no goddess, angel, or nymph. Olympia was an emphatically contemporary woman, a courtesan in her boudoir, confronting the viewer without shame. The white sheets on the bed are rumpled, obviously from recent use. The bouquet of flowers is presumably an offering from a client who waits in an outer room. The black cat appears hostile, ready to spring into action against an intruder. Indeed, the viewer, who is in the room with Olympia, is cast unwillingly in the role of a client about to avail himself of her services.

How offensive this was to the bourgeoisie and aristocrats!

With the new broad boulevards made by Georges Eugène Haussmann, who modernized Paris by razing old streets and slums, prostitution in the city had proliferated. But there were important class distinctions: The common man might do business with the streetwalker, while only the middle and upper classes could generally afford the elegant courtesan. These clients were often married men, and while their extramarital relationships were socially acceptable, they were not spoken about or publicly flaunted.

A painter simply didn't exhibit pornography, no matter how artistic, in the Salon, or even in the Salon des Refusés. Manet's painting, with its appalling subject and equally appalling technical aberrations—its lack of depth and sharp contrasts between light and dark—was an affront to respectable French society.

Olympia sent the art world into spasms. Soon, word got around about the shocking painting, and people flocked to see it. The public outrage was so great that large crowds not only reacted with laughter and disparaging remarks but wanted to physically attack the painting as well. It was moved to the farthest room and hung above a door out of reach. Still, flocks of people came to gawk at it for the entire time the hall was open.

The painting was derided as a "female monkey," "the epitome of ugliness," "a gamy courtesan." Although *Olympia* was not without its supporters—Manet's friends Émile Zola and Baudelaire prominently among

them—critics from the Paris newspapers in May and June had a field day eviscerating Manet's work. The painter Gustave Courbet called *Olympia* "the queen of spades after her bath," and the writer Théophile Gautier scolded, "There is no point of view from which *Olympia* can be understood, even if you look at it the way it is, a skinny woman lying on a bed. The flesh tones are dirty, the modeling nonexistent." *Olympia* was even lampooned in vulgar and comical illustrations that appeared in print. "Now you're as famous as Garibaldi," Manet's friend Edgar Degas told him.

Curiously, no one at the time seemed to realize that Manet's *Olympia* closely resembled Titian's *Venus of Urbino*. This was no accident; Manet had copied the painting during his 1853 visit to Florence. But this homage would hardly have mattered; instead of exalting a goddess, Manet's work elevated an ordinary concubine. With the added devices of tension and implicit risk, it implicated married men with mistresses, who interpreted it as a direct assault.

Manet craved fame but not infamy. He wrote to his friend Baudelaire, "I wish you were here with me. Insults are pouring down on me like hail. All this shouting is painful, and clearly someone must be in the wrong."

Baudelaire, in Brussels, ill and devastated by his own failures, found the strength to write back. "Do you think you are the first person to be placed in such a situation?" he said. "Have you more genius than Chateaubriand and Wagner? And yet, they were mocked all right. They did not die of it."

But the public frenzy was overwhelming to Manet. On the street, people would look at him as if he were an outlaw or spit obscenities at him. He was so castigated in the papers that he had to stop reading them. The fury, while ubiquitous, was hypocritical, since in Paris prostitutes, streetwalkers, and mistresses were commonplace; frequently they were treated better than their clients' wives. "The attacks of which I have been the object have broken the spring of life in me," he wrote to Proust. "People don't understand what it feels like to be constantly insulted."

Weary of all the contempt, abuse, and ridicule, Manet left for Spain in late June. Over the summer he refreshed himself and drew inspiration from the paintings of Velázquez and El Greco, but he found the food intolerable and left abruptly to return home.

Back in Paris, Manet resumed his painting and his usual routines. The artist frequented the Café Guerbois near his art supply shop, on the Grande-rue des Bastignolles, where he would meet friends. Word of his visits to the café spread among the artist community, and his little circle was soon swelled by a crowd of young rebels of the art world. By virtue of the uproar over *Olympia,* Manet had become something of a cause célèbre for these artists, many of whom had experienced the crushing disappointment of being rejected by the Salon. They were mostly painters, among them Monet, Degas, Pissarro, and Renoir, whose fame as Impressionists was yet to come. Manet was their elder statesman, a role model and hero. They rallied around him and looked up to him, for he had earned the scorn and wrath of the Salon and the bourgeoisie, and had once been relegated to the Salon des Refusés.

Manet continued to paint, and in 1872, after the Franco-Prussian War, he offered *Olympia* for sale, asking twenty thousand francs. No one came forward to buy it, so he held on to it. In 1882 he received much praise for his *Bar at the Folies-Bergère* when it was exhibited at the Salon. Over the years many of his submissions were rejected, but he continued to believe in the Salon, even though he was urged by his Impressionist friends to exhibit at independent showcases as they were now doing.

By this time illness was taking a toll. Manet's health was in serious decline; he was being ravished by a progressive degeneration of the nervous system, locomotor ataxia, a late form of syphilis. His condition worsened to the point where he could hardly walk, and then he became so feeble he could not get out of bed. When Claude Monet and other close friends visited him, they had to choke back tears.

A short time later, on April 30, 1883, Édouard Manet died at the age of fifty-one. His funeral at the Passy Cemetery drew a large crowd, including

many of his Impressionist friends. Antonin Proust gave the oration, and he was a pallbearer along with Claude Monet, Émile Zola, Alfred Stevens, Philippe Burty, and Théodore Duret. "He was greater than we thought," said Degas after his funeral.

Although Manet had inherited a great deal of money from his father, he had managed it poorly. Some years after his death, his widow, Suzanne, greatly in need of money, decided to sell *Olympia.* Word reached Claude Monet, who was afraid it would be purchased by a foreigner and taken out of France. "Not only did he play an important individual part, he was also the representative of a great and fruitful evolution," wrote Monet of his deceased friend. "It thus appears impossible to us that such a work does not belong in our national collections, that the master is denied entrance where his pupils have already been admitted."

Monet said he would meet the original asking price for *Olympia,* and many in the Guerbois group, some of whom Manet had helped when they were destitute, lent their financial support. Monet came up 585 francs short in his public subscription drive to raise twentythousand francs, but Suzanne accepted the amount anyway. The painting was then offered to the state. The state accepted, but since Manet hadn't been dead for ten years it couldn't go to the Louvre, the state's most important and prestigious art museum. Instead it went to the Luxembourg Museum, where it stayed until November 1907, when Georges Clemenceau—an old acquaintance of Manet's and the subject of a couple of his portraits—became the French premier and ordered *Olympia* into the Louvre.

Years later *Olympia* was transferred to the Jeu de Paume museum, which became the depository for many Impressionist and post-Impressionist paintings, and then later to its present home, the Musée d'Orsay, a redesigned railway station that opened in 1986 to house art from the second half of the nineteenth century.

Manet was a rebel, underappreciated in his lifetime, as many artists are, but not afraid to confront the establishment. A transitional figure, he was

the hero of a group whose members came to lead the movement known as Impressionism. While he learned from and idolized the great masterpieces, he broke with the traditions of academic painting, portraying contemporary events and subjects with a candidness and realism that was scandalous for its time.

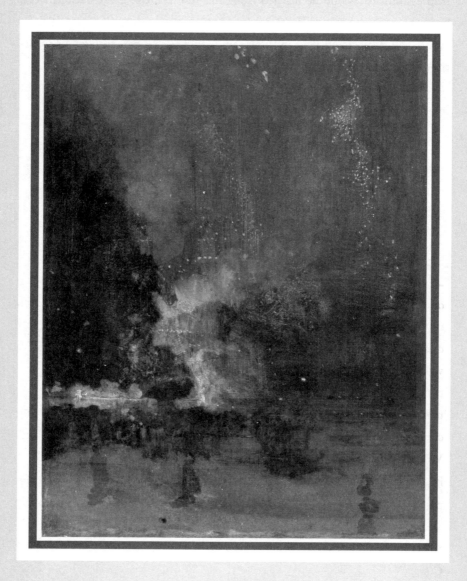

✳

Nocturne in Black and Gold:
The Falling Rocket

(1875)

James Abbott McNeill Whistler

Art and criticism go hand in hand, but when the two are strongly at odds, legal issues may arise. Should the critic have the right to free expression of opinion? Should a painter be protected from mockery that could degrade the value of the artist's work and harm the artist's career? In a written review, at what point does the critic cross the boundary from permissible language to libel? These are difficult questions that require an understanding of particular circumstances, which can be varied and complicated. For insight, let us turn to the 1870s, the middle of the Victorian Age, when a showdown took place in an English court of law between the titan of British art critics and a rising American expatriate painter, in what might be called the art trial of the century.

IN 1877, THE Grosvenor Gallery opened in London. It was founded by Sir Coutts Lindsay, who wanted to establish in the city, whose art scene he considered staid and unadventurous, a truly modern and progressive showcase for talented artists.

The mission of the Grosvenor was simple: It would exhibit selected pictures in a beautiful environment in the most advantageous manner,

paying diligent attention to the hanging, spacing, and arrangement of paintings so their full potential could be appreciated. It would also publicize the pictures to maximize their chances for success. Lindsay intended to rectify complaints about the current art showcases in the city, including those about their infelicitous, overcrowded displays and their rejection of promising artists. He was determined that the new gallery meet the needs of both fresh and established artists in the most effective ways.

Housed in a newly erected building on New Bond Street, a fashionable thoroughfare, the grand Victorian art palace contained galleries for paintings, watercolors, and sculptures; a library and dining area; and various other sumptuously decorated and furnished rooms. Exhibition was by invitation only. The Grosvenor Gallery's debut Summer Exhibition ran for three months beginning on May 1. In the Grosvenor's commodious first-floor West Gallery, the show featured paintings by such artists as Edward Burne-Jones, Ferdinand Heilbuth, James Tissot, and George Frederick Watts.

James Abbott McNeill Whistler was another artist who exhibited at the gallery's debut. Born in Lowell, Massachusetts, in 1834, he had studied art as a boy, moved with his family to Russia where his father was employed as an engineer, attended West Point, and when he was twenty-one went off to Paris to pursue a career in art before finally settling in London a few years later.

By the 1870s, Whistler had embraced the burgeoning Aesthetic movement with its "art for art's sake" philosophy and had produced a series of moonlit landscapes and water pictures that he called "nocturnes," rendered in the Japanese style that the painter admired. At the Grosvenor Summer Exhibition, Whistler exhibited eight paintings: *Nocturne in Black and Gold: The Falling Rocket; Nocturne in Blue and Silver; Nocturne in Blue and Gold; Nocturne in Blue and Silver: Old Battersea Bridge; Harmony in Amber and Black; Arrangement in Brown; Arrangement in Black No. III: Irving as Philip II of Spain;* and *Arrangement in Grey and Black No. II: Portrait of Thomas Carlyle.* All were displayed in the elegant West Gallery with its crimson silk damask

and velvet-covered high walls, except for the Carlyle portrait, which was entered late into the exhibit by Whistler and assigned space in another area of the gallery.

Amid great fanfare, the Summer Exhibition attracted large crowds anxious to see the new gallery and the paintings by the chosen artists. Among the thousands of visitors to the Grosvenor Gallery at its debut during those warm London months was the eminent art critic John Ruskin.

IF THERE WAS a pantheon of British art connoisseurs in the third quarter of the nineteenth century, John Ruskin was its high priest. New artists whom he extolled often rose to prominence; those whose deficiencies he pointed out tended to fade from view.

The author of the celebrated multivolume series *Modern Painters* was an indefatigable writer, researcher, and analyst of art and had risen to become the Slade Professor of Art at Oxford. Ruskin, a painter himself of some talent who believed that art had a moral or utilitarian purpose, had earned a reputation as a sage and was extolled for advancing the fine arts of the day.

Ruskin was astonishingly prolific, writing on a vast range of subjects including, besides art, botany, philosophy, social science, political science, religion, geography, animals, and sundry other topics. He promoted social reform and worked to support culture and education. He disseminated his thoughts, experiences, observations, and philosophies to the general public in monthly numbered letters he called *Fors Clavigera* ("Fortune Bearing a Key") that were intended for the edification of the English working class. On leave from his Oxford duties, soon after visiting the Grosvenor, Ruskin addressed its recent opening in his July number.

Ruskin acknowledged that the Grosvenor had been founded "in the true desire to help the artists and better the art of this country," and therefore, he declared, he hoped for its success. But he found both the interior decor and the arrangement of the paintings objectionable, critiquing them at some

length. Then Ruskin addressed one of the painters whose work was exhibited:

> For Mr. Whistler's own sake, no less than for the protection of the purchaser, Sir Coutts Lindsay ought not to have admitted works into the gallery in which the ill-educated conceit of the artist so nearly approached the aspect of wilful imposture. I have seen, and heard, much of Cockney impudence before now; but never expected to hear a coxcomb ask two hundred guineas for flinging a pot of paint in the public's face.

Although the critic seemed to be expressing his irritation at Whistler's exhibited works in general, the last phrase was an apparent reference to the painter's *Nocturne in Black and Gold: The Falling Rocket,* as it was the only work of Whistler exhibited at the Grosvenor that was for sale.

JAMES MCNEILL WHISTLER was at a professional social club with his friend George Henry Boughton, a fellow painter, when he learned of Ruskin's attack in *Fors Clavigera.* Whistler was used to criticism of his work, having over the years been laughed at and derided by both critics and the public, but he also had a fighting spirit. This time, he felt, the rancor directed at him was different. Ruskin had called him a "coxcomb," a term Whistler was not familiar with, but he knew it couldn't be flattering. Looking it up later, he found that it referred to "the licensed jester who wore a cap and bells with a cock's comb in it, who went about making jests for the amusement of his master and public." Yes, the critic was arrogant; his words cut like a surgeon's blade. The famous John Ruskin had condemned once too often. Ruskin was revered as a prophet of art, a critic whose opinions reigned as gospel, but maybe, just maybe King Solomon could be toppled from his pedestal—by the alleged impostor, no less. In his

conversation with Boughton, Whistler made it clear he would pursue justice for what he considered Ruskin's libelous remarks.

WHISTLER'S NOCTURNES, AS far as Ruskin was concerned, did not demonstrate fine craftsmanship. They were completed hastily, he said, and then offered for sale as "art" at steep prices to an unsuspecting public. But many impartial observers conceded that his words were unduly harsh. He had, after all, defended J. M. W. Turner when that painter's works had been disparaged. Why then did Ruskin direct such invective at Whistler? Why had he denigrated Coutts Lindsay? Why, in his *Fors* July number, had he resorted to name-calling? His petulant vehemence seemed to indicate a troubled state of mind.

IN THE MID—NINETEENTH century the art circles of France and England, the two countries in which Whistler pursued his career after he left America, were populated by such painters as Gustave Courbet, John Everett Millais, Dante Gabriel Rossetti, Edgar Degas, Henri Fantin-Latour, and Alphonse Legros. From the time Whistler had arrived in Paris to study in the studio of Charles Gleyre, he had felt his way through it all. He had successes, but he had also had paintings rejected by both the Salon and the Academy, and he had exhibited in the Salon des Refusés. He became interested in Japanese art; he had an exhibition of his paintings; he attracted respect as a colorist; he did etchings. All sorts of influences swirled around him: movements, styles, ideologies, subject matters, theories, and methods. Painters banded together to advance the ideals of their chosen style. There was Realism, Aestheticism, Pre-Raphaelitism, Impressionism, Symbolism— a host of styles to sample and experiment with. Eventually he chose his own path, his own independent style. He made art that broke rules and scorned tradition, art that the average person had difficulty understanding. And while there were those who truly appreciated his work, many saw nothing in it with which to be impressed and branded him a pretender.

WHAT WAS THE state of Ruskin's mind when he penned his harsh words against Whistler in *Fors Clavigera*? What emotional baggage might have prompted such a venomous attack? Surely it is the job of the critic to be more discerning than ordinary people, and to be witty if not acerbic in expression to make a point, but could there be behind a critic's professional facade personal problems that aggravate the severity of judgment? John Ruskin's professional success was not to be denied, but there seemed to be an inverse relationship between his professional accomplishments and his personal happiness. Romance had painfully eluded him, and he lived with stress, loneliness, unfulfilled hope, and disappointment. The illustrious scholar may have scored high in academics, but in the field of love his engagements were disastrous.

Miss Rose La Touche was three decades the junior of John Ruskin. She had been his pupil when she was a girl, and as she blossomed into young womanhood he fell in love with her. He had proposed marriage, and she requested three years to make up her mind. Throughout, Ruskin—who in 1848 had married the daughter of his parents' longtime friends, only to have her annul the marriage six years later—was ever hopeful. Rose, who was a devoutly pious evangelical, found Ruskin's religious convictions insufficiently strong, and in the end she declined his proposal. Then Rose, who had been sickly as a child, began to deteriorate, and as Ruskin stood by helplessly, she died in 1875 at the age of twenty-six.

Rose's premature death was just the latest emotional setback for Ruskin, who at this time was in his midfifties. This heartbreaking event, and the strain of long years of her indecisiveness, was yet another knife in his heart. When Ruskin was a young man, another object of affection had left him in great pain. If Whistler held up John Ruskin as a callous critic who did not know the injury of ridicule, he was sorely mistaken, for it was a torment he knew well.

Ruskin was seventeen when he was first smitten. The object of his affection was fifteen-year-old Adèle-Clotilde Domecq, the beautiful blonde

daughter of his father's business partner from France who visited his house with three of her sisters one winter while her father called on his British clients. Ruskin fell rapturously for Adèle. He tried to woo her with poetry and prose, but, as he later wrote, she "laughed over it in rippling ecstasies of derision, of which I bore the pain bravely, for the sake of seeing her thoroughly amused." When Adèle returned to France, Ruskin pined with loneliness, and he again set down his longings in heartfelt poetry. Fearful of her mocking reaction, he could not bring himself to send the verses to her, but he did dispatch "a French letter seven quarto pages long descriptive of the desolations and solitudes of Herne Hill since her departure," only to receive back a letter from one of her younger sisters saying Adèle had read the letter and had "laughed immensely at the French."

For each disappointment, there was renewed hope, however, and for four years Ruskin's heart had swelled with the anticipation that Adèle might one day be his, until he found out one day that a marriage proposal for Adèle had come from a handsome and wealthy young Frenchman, and that negotiations had commenced. In his forlornness, he responded by writing a long, poignant poem he titled "Farewell."

Then late one evening Ruskin felt a strange sensation in his throat. He coughed and brought up blood. Alarmed, his mother rushed him to a doctor, who declared him to be quite ill. The lovesick young Lothario withdrew from Oxford, and his parents took him to the Continent to recuperate. Yes, mockery Ruskin knew, ridicule he endured, and suffering he was dealt.

A DISPUTE IS often rooted in deep animosities, and a single stroke can bring the contention to a head. Ruskin's animadversions may be symptomatic of such ill will between the critic and the painter, for although strangers to each other, the two were opposites in both ideology and personality.

Ruskin had once written, "I have given up ten years of my life to the single purpose of enabling myself to judge rightly of art"; Whistler believed that

only an artist was competent to be a critic. Ruskin abhorred the encroachment of commercial growth; Whistler embraced it in his work. Ruskin owned a Titian, studied Botticelli, and savored traditional art; Whistler painted "arrangements" and "harmonies" and cultivated his own path. Ruskin was intrigued by nature; Whistler eschewed it. Ruskin found beauty in sunset splendors, Whistler in the evening mist. To Ruskin, art had a practical purpose; for Whistler, it was "art for art's sake." Moralism, naturalism, aestheticism—each viewed art through a different lens.

As to their contrasting characters, Ruskin was a gentleman commoner; Whistler a bohemian. Ruskin was of a serious nature; wit flashed from Whistler. Ruskin flourished in wealth; Whistler wallowed in financial insecurity. Ruskin remained a devout practitioner of the religion of his childhood; Whistler had given up on his. Ruskin stayed true to his homeland; Whistler had fled the country of his birth. Ruskin's reputation was iconic; Whistler's controversial. Perhaps their one common bond was that the flower of genius had germinated in the mind of each. But that may have been their undoing as well as their commonality.

The legal showdown was thus inevitable. Sir Coutts Lindsay set up, as Messrs. Gilbert and Sullivan would later parody it, the bout with his "greenery-yallery Grosvenor Gallery," in which the impresario's selection of iconoclastic painters almost invited someone of Ruskin's ilk to step in amid the fanfare and cause a ruckus. Lindsay, not immune himself from the critic's barbs, set the trap, and Ruskin grabbed the bait. It only remained for the conflict to present itself in the formal arena of a court of law.

———

RUSKIN RELISHED THE opportunity to confront the painter in court. The critic, essayist, and social reformer, immersed in his erudite world of architecture, Venetian stones, Botticelli, the Pre-Raphaelites, and Turner, was always looking for a new forum to disseminate his views on art. Dissension was always a possibility, but once he espoused a view he clung to it tenaciously.

Ruskin hoped his upcoming court battle with Whistler would garner publicity and receive widespread attention. "It's mere nuts and nectar to me, the notion of having to answer for myself in court," he wrote to his friend, the painter Edward Burne-Jones, "and the whole thing will enable me to assert some principles of art economy which I've never got into the public's head, by writing, but may get sent over all the world vividly in a newspaper report or two."

THE CREMORNE GARDENS in Chelsea was a festive leisure park with an enormous dancing platform, pavilions, theaters, and banquet halls, landscaped with tall trees and grottoes. With its music and parties, food and drink, and special amusements such as balloon launches, it was a place of gaiety and excitement where young men and women socialized. It sat on the banks of the Thames, and visitors sometimes arrived by boat, debarking at one of the nearby piers. This little resort in Chelsea, where Whistler was a resident, offered a welcome change from the concrete of London.

Whistler's *Nocturne in Black and Gold: The Falling Rocket,* the subject of the painter's upcoming lawsuit, was his rendition of a fireworks display, inspired by one at the Cremorne Gardens. In his own nontraditional style, he had painted parallel columns of flying golden embers and puffs of glowing smoke against a darkened landscape, striving to recreate a sense of the dazzling visual spectacle. To some, the painting was a remarkable achievement with its own intrinsic beauty, but others would not even call it a serious work of art; to them it was just an ugly pastiche of splotches and specks smeared on a canvas by the hand of a dauber of dubious talent. Whistler's "nocturne" was a term he defined as an arrangement of color, shape, and line.

SOME TIME AFTER Whistler filed his lawsuit, the venerable Professor Ruskin became delirious. He was afflicted with "brain fever" (probably typhus), the first of several such attacks. He had had every intention of testifying in his

defense in Whistler's libel suit, scheduled for the autumn of 1878, but now it was not clear whether the incapacitated sage would be able to appear.

IN HIS PURSUIT of redress, Whistler devoted much time to helping his counsel prepare their briefs. The counsel extracted all the ammunition it could from the vexed artist and avidly went to work to prove their case. They dug deep into Ruskin's tirade: His attack against Whistler was personal and lacked valid criticism of the artist's work; his language was coarse. An artist's fortunes precariously hinge on the critic's opinion, and thus the latter has a responsibility to be fair-minded. When the critic abuses that power, he commits an egregious offense. John Ruskin's influence in the art world was so strong that his condemnation of Whistler had a seriously negative effect on the artist's career. The financial loss to Whistler was evident. Since Ruskin had published his vituperative critique, the painter had had difficulty selling his works, and now his financial future was in jeopardy. The counsel of the injured party spared no effort to make the case that a terrible wrong had been committed.

A CROWD ASSEMBLED in a chamber of the Exchequer Court in Westminster on November 25, 1878. A special jury had been chosen to sit for the case now before the bench, the libel suit of James Whistler against John Ruskin.

"Imposture," "impudence," "coxcomb," "flinging a pot of paint in the public's face"—Ruskin's brief harangue in print, a couple of sentences and a handful of disapproving words, was now to be tested in a court of law. To Ruskin, aged fifty-nine, and his supporters, the libel action was a ludicrous and wasteful exercise. For Whistler, forty-four years old, it was an opportunity to fight for justice.

The eminent art critic could not, alas, be present for the trial. Although he had by now recovered from the brain fever, his health was still fragile, and his doctor had forbidden him to testify. The presence of Ruskin, the

Olympus of art criticism, would be sorely missed. Obviously the critic himself could best address his own defense, and the plaintiff's side was anxious to grill him on the witness stand. It would have been a battle that both sides could have savored, but ill health had intervened, and the defendant was forced to pick his witnesses.

The opposing sides in the trial faced off. The counsel for Whistler were sergeant-at-law John Humffreys Parry and William Petheram. Ruskin was represented by Attorney General Sir John Holker and Charles Synge Christopher Bowen. The justice of the high court was Baron Huddleston.

There was drama and excitement just going into the trial. Some potential witnesses were hesitant about testifying, as they were friends of both the plaintiff and the defendant and did not wish to take sides; or, as influential members of the art community, they did not want to tarnish their reputations, and it would not be known until right before the trial began who would give evidence. Whistler in particular had expected the art community of London to rally behind him in this cause célèbre for maligned artists, but he did not receive the support he expected.

Whistler was examined by his counsel and cross-examined by the defendant's counsel. On examination by Mr. Petheram, he provided biographical details, and on the cross-examination by Sir John Holker spoke about his nocturnes. If an official transcript of the proceedings was made, it apparently does not survive, but in his *Gentle Art of Making Enemies,* Whistler recounts some of the testimony. Here is the artist's account of a portion of the exchange between himself and the attorney general pertaining to Whistler's *Nocturne in Black and Gold: The Falling Rocket*:

"Now, Mr. Whistler. Can you tell me how long it took you to knock off that *nocturne?*"

". . . I beg your pardon?" (*Laughter.*)

"Oh! I am afraid that I am using a term that applies rather perhaps to my own work. I should have said, 'How long did it take

you to paint that picture?' "

"Oh, no! permit me, I am too greatly flattered to think that you apply, to work of mine, any term that you are in the habit of using with reference to your own. Let us say then how long did I take to—'knock off,' I think that is it—to knock off that nocturne. Well, as well as I remember, about a day."

"Only a day?"

"Well, I won't be quite positive; I may have still put a few more touches to it the next day if the painting were not dry. I had better say then, that I was two days at work on it."

"Oh, two days! The labor of two days, then, is that for which you ask two hundred guineas?"

"No;—I ask it for the knowledge of a lifetime." (*Applause.*)

"You have been told that your pictures exhibit some eccentricities?"

"Yes, often." (*Laughter.*)

"You send them to the galleries to incite the admiration of the public?"

"That would be such vast absurdity on my part, that I don't think I could." (*Laughter.*)

"You know that many critics entirely disagree with your views as to these pictures?"

"It would be beyond me to agree with the critics."

"You don't approve of criticism then?"

"I should not disapprove in any way of technical criticism by a man whose life is passed in the practice of the science which he criticizes; but for the opinion of a man whose life is not so passed, I would have as little regard as you would, if he expressed an opinion on law."

"You expect to be criticized?"

"Yes, certainly. And I do not expect to be affected by it until it

becomes a case of this kind. It is not only when criticism is inimical that I object to it, but also when it is incompetent. I hold that none but an artist can be a competent critic."

The grilling of the plaintiff continued. Whistler was asked if he placed his pictures on a garden wall or a clothesline to dry, and why he called one of his pictures an "arrangement in black." Here is more of Whistler's account of the proceedings:

"What was the subject of the nocturne in blue and silver belonging to Mr. Grahame?"

"A moonlight effect on the river near old Battersea Bridge."

"What has become of the nocturne in black and gold?"

"I believe it is before you." (*Laughter.*)

The picture called the nocturne in blue and silver was now produced in Court.

"That is Mr. Grahame's picture. It represents Battersea Bridge by the moonlight."

Baron Huddleston: "Which part of the picture is the bridge?" (*Laughter.*)

His Lordship earnestly rebuked those who laughed. And witness explained to his Lordship the composition of the picture.

. . . The Court then adjourned. During the interval the jury visited the Probate Court to view the pictures which had been collected in the Westminster Palace Hotel.

After the Court had re-assembled the "Nocturne in Black and Gold" was again produced, and Mr. Whistler was further cross-examined by the attorney-general: "The picture represents a distant view of Cremorne with a falling rocket and other fireworks. It occupied two days, and is a finished picture. The black monogram on the frame was placed in its position with reference to the proper

decorative balance of the whole."

"You have made the study of Art your study of a lifetime. Now, do you think that anybody looking at that picture might fairly come to the conclusion that it had no peculiar beauty?"

"I have strong evidence that Mr. Ruskin did come to that conclusion."

"Do you think it fair that Mr. Ruskin should come to that conclusion?"

"What might be fair to Mr. Ruskin I cannot answer."

"Then you mean, Mr. Whistler, that the initiated in technical matters might have no difficulty in understanding your work. But do you think now that you could make *me* see the beauty of that picture?"

The witness then paused, and examining attentively the Attorney-General's face and looking at the picture alternatively, said, after apparently giving the subject much thought, while the Court waited in silence for his answer:

"No! Do you know I fear it would be as hopeless as for the musician to pour his notes into the ear of a deaf man." (*Laughter.*)

"I offer the picture, which I have conscientiously painted, as being worth two hundred guineas. I have known unbiased people express the opinion that it represents fireworks in a night-scene. I would not complain of any person who might simply take a different view."

The Court then adjourned.

There was much more to come in the courtroom where art criticism was on trial. The attorney general asserted that even if Ruskin's comments were austere, they could not be reasonably objected to. What was to become of art, he wanted to know, if there were no critics? He declared that if Whistler were not prepared for ridicule, he should never have publicly exhibited his

pictures, and that if a critic thought a picture was crude, he had a right to say so without risking legal action.

Artist Albert Moore defended Whistler in his examination by Parry, then was cross-examined by the attorney general. Other witnesses testified for Whistler, including the dramatist William Gorman Wills and the critic William Michael Rossetti. Artists Edward Burne-Jones and William Powell Frith and the dramatist Tom Taylor gave evidence for Ruskin. There were examinations and cross-examinations. Ruskin's counsel tried to establish that Whistler's *Falling Rocket* was not a serious work of art, even offering into evidence at one point a mid-sixteenth-century Titian portrait owned by Ruskin to exemplify true art. When a nocturne was brought into evidence before the jurors, the counselors on opposite sides got into a debate over which was the right side up.

The expert witnesses commented on *The Falling Rocket*'s composition, color, form, and other details, opined as to whether it should be considered a work of art, and gave their estimate of its value. Whistler attempted to educate the court about the difference between abstraction and realism: The nocturne should be viewed as an "artistic arrangement," not as a "view" of Cremorne, for "if it were called a view . . . it would certainly bring about nothing but disappointment on the part of the beholders." Legal counsel launched attacks, barbs flew back, counsel remained unruffled and continued their legal maneuverings. Statements were routinely followed by either laughter or applause. Witnesses paused in their testimony to reflect on their answers while the court waited anxiously for their responses. It was at once theatrical, serious, and mesmerizing.

The trial continued until the next day, capturing widespread attention in England as the counsel of its esteemed native son locked horns with the American expatriate. Counsel for defendant and counsel for plaintiff took parting shots at each other, and then the jury retired to consider its verdict.

It was the moment of truth for both parties. Whistler had sued for a thousand pounds and sorely needed the money, as he was deeply in debt. For

the wealthy Ruskin, financial recompense was immaterial. The professor was a man of conviction, steadfast in his beliefs, and fearsome in his desire to express them. This was a case about the right to criticize, with pride and his station in English society bundled into it.

After a short deliberation, the jury came down in favor of the plaintiff.

The award? One farthing for Mr. Whistler.

WHISTLER HAD TECHNICALLY won his libel suit, but the award was an insult and given clearly to make a point. The judge denied Whistler costs; each party had to pay his share of the expenses.

Although Ruskin could have personally assumed the charges, his friends at the Fine Art Society were of the opinion that because he had genuinely given so much of himself over the years to the advancement of art, he should not have to personally dispense the 386 pounds to defend himself, and they successfully took up a public subscription on his behalf. But the financial assistance did not assuage the defeated critic. The decision of the court so angered him that he resigned his Oxford art professorship. "The result of the Whistler trial leaves me no further option," he declared to the dean of Christ Church. "I cannot hold a Chair from which I have no power of expressing judgment without being taxed for it by British Law." A bruised ego, however, wasn't the worst of Ruskin's problems. Brain fever was soon to attack him again.

For the work that was at the center of the libel dispute, a painting that took not just one or two days to "knock off" but was "the labor of a lifetime," Whistler endured the insult of an award in his favor for the grand sum of one farthing. There was talk of funds being collected on the impoverished painter's behalf, but this effort was not pursued, and eventually the legal fees proved too onerous. Five months after the trial, Whistler declared bankruptcy.

Despite the controversies regarding his artistic ability, his oeuvre of paintings—especially the portrait of his mother (*Arrangement in Gray and*

pictures, and that if a critic thought a picture was crude, he had a right to say so without risking legal action.

Artist Albert Moore defended Whistler in his examination by Parry, then was cross-examined by the attorney general. Other witnesses testified for Whistler, including the dramatist William Gorman Wills and the critic William Michael Rossetti. Artists Edward Burne-Jones and William Powell Frith and the dramatist Tom Taylor gave evidence for Ruskin. There were examinations and cross-examinations. Ruskin's counsel tried to establish that Whistler's *Falling Rocket* was not a serious work of art, even offering into evidence at one point a mid-sixteenth-century Titian portrait owned by Ruskin to exemplify true art. When a nocturne was brought into evidence before the jurors, the counselors on opposite sides got into a debate over which was the right side up.

The expert witnesses commented on *The Falling Rocket's* composition, color, form, and other details, opined as to whether it should be considered a work of art, and gave their estimate of its value. Whistler attempted to educate the court about the difference between abstraction and realism: The nocturne should be viewed as an "artistic arrangement," not as a "view" of Cremorne, for "if it were called a view . . . it would certainly bring about nothing but disappointment on the part of the beholders." Legal counsel launched attacks, barbs flew back, counsel remained unruffled and continued their legal maneuverings. Statements were routinely followed by either laughter or applause. Witnesses paused in their testimony to reflect on their answers while the court waited anxiously for their responses. It was at once theatrical, serious, and mesmerizing.

The trial continued until the next day, capturing widespread attention in England as the counsel of its esteemed native son locked horns with the American expatriate. Counsel for defendant and counsel for plaintiff took parting shots at each other, and then the jury retired to consider its verdict.

It was the moment of truth for both parties. Whistler had sued for a thousand pounds and sorely needed the money, as he was deeply in debt. For

the wealthy Ruskin, financial recompense was immaterial. The professor was a man of conviction, steadfast in his beliefs, and fearsome in his desire to express them. This was a case about the right to criticize, with pride and his station in English society bundled into it.

After a short deliberation, the jury came down in favor of the plaintiff.

The award? One farthing for Mr. Whistler.

WHISTLER HAD TECHNICALLY won his libel suit, but the award was an insult and given clearly to make a point. The judge denied Whistler costs; each party had to pay his share of the expenses.

Although Ruskin could have personally assumed the charges, his friends at the Fine Art Society were of the opinion that because he had genuinely given so much of himself over the years to the advancement of art, he should not have to personally dispense the 386 pounds to defend himself, and they successfully took up a public subscription on his behalf. But the financial assistance did not assuage the defeated critic. The decision of the court so angered him that he resigned his Oxford art professorship. "The result of the Whistler trial leaves me no further option," he declared to the dean of Christ Church. "I cannot hold a Chair from which I have no power of expressing judgment without being taxed for it by British Law." A bruised ego, however, wasn't the worst of Ruskin's problems. Brain fever was soon to attack him again.

For the work that was at the center of the libel dispute, a painting that took not just one or two days to "knock off" but was "the labor of a lifetime," Whistler endured the insult of an award in his favor for the grand sum of one farthing. There was talk of funds being collected on the impoverished painter's behalf, but this effort was not pursued, and eventually the legal fees proved too onerous. Five months after the trial, Whistler declared bankruptcy.

Despite the controversies regarding his artistic ability, his oeuvre of paintings—especially the portrait of his mother (*Arrangement in Gray and*

Black: Portrait of the Painter's Mother)—eventually gained for Whistler the immortality he coveted. With Ruskin's prodigious output of acclaimed scholarly works, his fame was already sealed. But what was one to make of the results of the libel case? Whistler's was a victory in name only; Ruskin's loss of a farthing was less than nominal.

In the course of two days, the London art world was turned upside down, with a sensational legal battle pitting an esteemed critic against a struggling painter, a Goliath against a David. But in the end the verdict did not satisfy either party, and the paint, it seemed, was flung in both their faces.

A Convalescent

(C. 1878)

James Tissot

❖

Like astrology or the Tarot or other methods of augury, art can sometimes be eerily prescient. A painting may at the time of its creation tell a seemingly casual story with an innocuous theme; yet that story may in retrospect prophetically suggest the future course of the artist's life. At one point during his troubled career, the nineteenth-century French painter James Tissot unwittingly predicted on canvas the strange circumstances that were to befall him many years later.

IT WAS SPRING in England, the season of rebirth. Outside, the earth vibrated with the promise of new life, while inside a quiet London parlor there was hope of a different kind, of calling spirits from beyond the grave.

It was dark in the room. The doors were locked, and a feeling of tension hung heavily in the air. The participants were gathered around the medium, who was seated in an easy chair from which he would deliver his incantations. Seated next to him was a broken man, now bursting with eager anticipation.

William Eglinton, the medium, was already internationally famous at the age of twenty-seven. He had held séances in several European countries,

had conducted sittings for investigators and professors at distinguished universities, and had visited America, India, and Italy in the course of his work. Well aware of the controversy surrounding his unlikely career, he had on occasion held private sittings for skeptics and people of high standing.

On this spring night in London, a hush fell in the room. The séance was about to begin. Three women and a man were also present. They were friends both of Mr. Eglinton, the medium, and of the devastated man, a personage of the art world, James Tissot.

The eminent French painter was born Jacques-Joseph Tissot; he had decided to anglicize his given name after meeting American painter James Abbott McNeil Whistler in the late 1850s.

It was through an article in a French newspaper that Tissot had learned of Mr. Eglinton. He had read a marvelous description by Florence Marryat, the actress and novelist, of an Eglinton séance—presumably the one in which she had summoned a daughter who had tragically died in infancy ten years previously. Tissot was intrigued by the phenomenon. He met with Mr. Eglinton during one of the latter's visits to Paris and inquired whether he might further investigate this curious phenomenon.

Spiritualists—especially one of Mr. Eglinton's stature—did not ordinarily admit novices and dabblers to materialization séances, for through their capricious interruptions they were liable to inhibit the delicate proceedings, but the medium granted Tissot the opportunity to attend a materialization. The artist was duly impressed by what he learned. As nineteenth-century spiritualist author John. S. Farmer later wrote, "This he did with the most satisfactory results, obtaining clear and irrefregable evidence as to the identity of the spirits communicating with him through Mr. Eglinton's mediumship, both in connection with psychography [automatic writing] and materialisation."

Tissot converted to spiritualism and ventured to England to undergo his own investigation of this otherworldly phenomenon. The man who had innocently inquired into matters of the hereafter was in emotional pain of

the most difficult sort. Two and a half years previously the great love of his life had passed on and created a deep chasm of loneliness in his life. His mind ached with memories of a beautiful woman whose life had been sadly cut short. The hole in his heart begged to be filled with any form of contact with her, as improbable as that might seem. He wanted to invoke her spirit.

She had had fine, soft features, she was wholly adorable, and she was a fallen woman. Kathleen Kelly was seventeen when she boarded a boat that would carry her all the way to India and an arranged marriage to a military surgeon she had never met. But the marriage was of short duration. Her conscience soon got the better of her, and she confessed to her new husband that on the voyage to her wedding, she had met a man and could not fight the loving feelings that had overcome her. Worse, her feelings for that man endured even after she had tied the knot with her contracted spouse. Aghast, he immediately agreed to a divorce, and later that year Kathleen returned to England to give birth to an illegitimate child. A little over four years later, she gave birth to a second son, also out of wedlock.

At this time Kathleen was living at St. John's Wood in London, which happened to be the area where James Tissot lived. By chance they met, and she and her two fatherless children soon moved in with the handsome, mustachioed Tissot.

By the time Kathleen came into his life, James Tissot was a celebrated painter who had exhibited at the Paris Salon and the Royal Academy. At this point in his professional career, his specialty was scenes of contemporary life, in which he often featured beautiful women. So rigid were the morals of the day that his 1876 painting titled *The Thames* was regarded as obscene because it featured one man and two women—of apparent low virtue—reclining fully dressed on a boat. His paintings were so lifelike, executed with such technical virtuosity, that they drew the scorn of critics. In 1877, the eminent art critic John Ruskin wrote that Tissot's paintings were "unhappily, mere coloured photographs of vulgar society."

Tissot began using Kathleen as a model for his paintings around 1876. She could appear sophisticated, as in *Mme Newton à l'ombrelle*, or casual, as in *The Picnic*. Around 1878, not long after the death of his beloved brother, Marcel-Affricani, just a year older than himself, Tissot featured Kathleen in his work *A Convalescent*.

It is a simple, charming street scene that shows an old man in a luxurious three-wheeled bath chair, bundled with blankets and holding the steering column in one hand, being pushed from behind by a young man, with Kathleen, dressed in a long fur coat with her hands in a muff, by his side. As in virtually all the paintings of Tissot's in which Kathleen appears, her beauty is radiant, and she has an air of elegance and innocence. The love with which Tissot painted her is evident.

Kathleen had left James in the full bloom of her young womanhood in 1882, when she was just twenty-eight years old, ripped from his loving arms by the dreadful disease of tuberculosis. Devastated by the untimely loss of the sweet, beautiful Irish lass who had stolen his heart, on the day of her funeral he could not tear himself away from her as she lay in her coffin, staying by her side for hours, praying, his heart pulsing in pain.

AS THE SÉANCE participants waited in expectant silence, a sudden change came over the face of Mr. Eglinton. Gradually out of the darkness emerged two figures. They were hazy and indistinct at first, but the witnesses could perceive that one form was male, the other female. As the apparitions began to take shape, the medium's face grew heavier.

Gazing at the two spirits standing together, Tissot was overcome by emotion. A light, carried by the male figure, shed its glow on the face of the female. Tissot stared hard. Yes, this was the woman he had known and loved and painted fondly for half a dozen years. Breathlessly, he asked her to kiss him. The woman came forward and gently put her lips to his. The other participants watched in fascination as she kissed him a second time, and then once more. The tender scene lasted only a few precious minutes,

then there was another last kiss, and a warm handclasp. Tissot's eyes were fixed on the two figures as they disappeared in the same mysterious manner in which they had materialized.

Ever since Kathleen's death, Tissot had been in an emotionally enfeebled state, wounded in heart and soul. Living in the home that had served as the nest for the two of them became too painful, and he had moved on to Paris, where he had tried to resume a normal life. But even after reacquainting himself with old sites and haunts and people he knew, creating new works in pastel, and promoting his art to new audiences, there remained a deep open wound that even the balms of Paris could not soothe. With the summoning of Kathleen's spirit in London, the painter's broken spirit underwent a rejuvenation.

Uncannily, Tissot's earlier painting may have been a prescient metaphor for the unlikely event that had just come to pass. When the spirits were called, he was ill with grief, a dispirited soul whose broken heart was in desperate need of mending. But now that Kathleen had come to him, he was revitalized. Older now than when he had been with her, he could move on again with the drive of a younger man. The energy of youth propelled him, the wisdom of age steered him, and there was peace of mind now that he knew Kathleen would always be by his side. It was just what he had painted back in 1878, in a work he prophetically called *A Convalescent*.

Le mariage de convenance

(1883)

William Quiller Orchardson

⌖

Questions sometimes arise about whether a painting is autobiographical. Take, for instance, the painting *Le mariage de convenance* by the Victorian artist William Quiller Orchardson, which shows a discontented young wife seated across the dinner table from her older husband. Orchardson himself was married to a much younger woman. Was Orchardson's painting a case of art imitating life?

AROUND THE MID-1860s, after having had several studios in London over the previous few years, the Scottish-born artist William Quiller Orchardson took an atelier in Kensington in the county of Middlesex in southeast England. For a time he resided with his friend and fellow Scottish painter James Archer at the Archer family home in Phillimore Gardens. Around 1867, Archer introduced Orchardson, whose pictures were now bringing him acclaim, to a neighbor, Charles Moxon, who bought one of his paintings. The two men became friends, and Moxon's young daughter caught the attention of Orchardson, who was approaching his mid-thirties. She was "little Nellie Moxon, a small, shy, dark-haired schoolgirl of about thirteen, with a habit of twiddling her innumerable buttons."

Orchardson was something of a ladies' man, but he never behaved flirtatiously toward Nellie. "They were simply great friends, a middle-aged man and a young girl, almost a child," Orchardson's daughter wrote later, "so that their engagement caused much surprise." On April 6, 1873, about a half dozen years after they had met, Ellen Moxon ("Nellie" was her childhood nickname) and Orchardson were married at the Parish Church in Kensington. Orchardson was thirty-nine, Moxon was twenty years younger.

At the time of their marriage, William Quiller Orchardson had achieved an artistic reputation for his historical genre pictures. But he would later take up a different theme in a pair of paintings: the union of two people for the advantages each could offer the other; a marriage, perhaps, without love, a marriage possibly even without happiness—a marriage of convenience.

The marriage of convenience was an established, familiar arrangement with sundry permutations, one of which had earlier been immortalized by William Hogarth in his mid-eighteenth-century *Marriage à-la-Mode* series, in which he satirized the contrived unions favored by upper society, exposing the greed, corruption, and lasciviousness with which they were permeated.

Orchardson's painterly meditations on the marriage of convenience highlighted age and economic disparity: a young woman marrying an older man for his wealth, he wedding her for her unspoiled beauty. For some women the arranged marriage was a route of escape from the restrictions imposed on single women by a patriarchal Victorian society. But while such a union might seemingly be at once the young lady's passport to the good life and the millionaire's ticket to conjugal nirvana, such a paradise was not without emotional precipices from which its protagonists might tumble.

Through a marriage of convenience, a young woman could extricate herself from a straitened situation (or from dependence on her father, if he was affluent) and achieve social status and freedom from financial concerns, raising children in a secure and comfortable environment, leading a life of leisure surrounded by servants and governesses. But she might not be physically attracted to her older husband; he might lack the physical and

emotional energy of a younger man; she might have less in common with him than a younger man and thus find herself bereft of true companionship; he might be unwilling or unable to produce children. And all the while, of course, she would be expected to be a perfect wife.

To make matters worse, for many years in the Victorian age, under English common law a married woman had no individual identity of her own. The law did not recognize her as a person, deeming her and her husband one individual, with the husband in possession and control of her property and wealth.

But if a woman who was not from a well-to-do family did not marry, what were her options? Employment opportunities for women were severely limited; she might be forced to take menial work in a factory or mine. Nannies and governesses, two of the few respectable positions to which intelligent single women might aspire, were often treated as second-class citizens. If all else failed, a woman could end up selling her body and live a life of degradation and disease.

Marrying for money might not have bought happiness, but it certainly beat the alternatives.

So did the marriage-of-convenience theme that Orchardson painted mirror the state of marital affairs in the Orchardson household? Would this Victorian painter ironically achieve great success for portraying a social inequity to which he himself was a party? Would Mrs. Orchardson become as unhappy as the woman in her husband's portrait and seek to leave him? Would she become a "bird in a gilded cage," and would she try to escape?

ORCHARDSON WAS BORN in Edinburgh, Scotland. When he was a young teenager, he enrolled in the Trustees' Academy and not long after began showing his work at the Royal Scottish Academy.

Brimming with talent and ambition, in the early 1860s, Orchardson went to London to make his fortune. From 1865 until 1874, Orchardson exhibited paintings of Shakespearean scenes, and in the late 1870s he began

painting episodes from the careers of famous figures of history, as well as psychological dramas from middle- and upper-class ménages.

While other Victorian painters delved into topics such as the fallen woman or the hapless spinster, Orchardson, in his melodramatic domestic scenes, showed that the higher strata of society were not immune from romantic and economic complications, quandaries, adversities, and misfortunes. Orchardson's paintings of social scenes were often bold and provocative, typically taking place in grand, elegant Victorian rooms.

Orchardson's *Le mariage de convenance* was much acclaimed during his lifetime. The scene in its basic context is universal, a married couple seated at the dinner table. But this is no ordinary tableau of domestic tranquility. The young wife sits opposite her husband at one end of a long table, the distance as great as the gap in years between them, not to mention the emotions that separate them. The wife sulks in her chair, her head hanging forward and resting on her left palm as she stares sullenly at the floor. The husband, a much older man with a walrus mustache, gazes with consternation at his bored wife across the expansive table, perceiving her discontent and fearing she might leave him.

The marriage of convenience, the union between one who glows with golden youth and one whose luster is waning but whose pockets are filled with gold, is a timeless theme, one that was taken up musically across the ocean as the Victorian era was fading. With a maudlin lyric by Arthur J. Lamb and a sweet, infectious, archetypical Tin Pan Alley melody by Harry Von Tilzer, "A Bird in a Gilded Cage" became one of the biggest popular song hits in America in the year 1900:

> *She's only a bird in a gilded cage,*
> *A beautiful sight to see,*
> *You may think she's happy and free from care,*
> *She's not, though she seems to be.*
> *'Tis sad when you think of her wasted life,*

For Youth cannot mate with Age,
And her beauty was sold
For an old man's gold,
She's a bird in a gilded cage.

Orchardson followed up his own artistic social commentary with *Mariage de Convenance—After!* depicting the sad results of the May-December marriage. The older husband is now alone, sitting between a cold hearth and the long dining table, on which a single place is set; behind him hangs a portrait of his beautiful, and now estranged, wife.

So did Orchardson, himself a partner in a May-December marriage, paint *Le mariage de convenance* as a reflection of his own marital state? Apparently not. According to Orchardson's daughter, Hilda Orchardson Gray, the marriage of William Quiller Orchardson and his much younger, very attractive wife, Ellen, "was a true-love match, and they remained true lovers until the end of their lives and beyond, they hoped."

But why would a very happily married man paint a scene of marital discontent? One might expect that an artist in a wretched marriage would yearningly paint a scene of marital bliss; but the reverse is more difficult to understand. Did it reveal Orchardson's deepest fears? Was it a sort of talisman to ward off disaster? Or could it have been an expression of Schadenfreude that his own marriage had far transcended mere convenience, whereas those of many other older men had not?

By the last decade or so of his life, Orchardson—who died in 1910, three years after he was knighted—seemed to have accumulated enough wealth to live quite comfortably. In the mid-1890s he and Ellen were living in a house in which his studio, with its high ceiling, stately walls, and elegant furniture, rivaled some of the exquisite parlors in the upper-class households he painted; it was described as "palatial."

However, Gray writes, "When he grew old and ill my Mother managed all the business affairs, and to her lasting honour be it told, never allowed

her husband to suspect even that she would be very poor at his death; so great was her desire that his last days should be full of peace and happiness."

With his *Le mariage de convenance,* William Quiller Orchardson painted what was, for him, a cheerless fantasy, not a realistic reflection of his own fortunate marriage. At the end of her husband's life, Ellen Moxon Orchardson likewise painted an artful deception. By hiding from him her own dire prospects for financial security after he passed on, Lady Orchardson, in her way, created a canvas of the highest artistic quality, for it depicted imagery of faithful devotion, an expansive palette of affection, and a composition of loving commitment. The picture she presented to her husband was fervent, eloquent, and spirited. If art is bringing joy to others, she practiced art in its highest form. She showed that the art of love, in sacrificing one's own convenience for the comfort, well-being, and happiness of one's beloved, creates the ultimate canvas. And we can only assume that, as with all true art, the narrative ended in redemption.

In 1912, Ellen, Lady Orchardson, according to an article in the *New York Times,* was granted a civil pension of four hundred dollars "in consideration of her inadequate means of support."

At the Moulin Rouge

1892–95

Henri Marie Raymond de Toulouse-Lautrec

⋊⋉

Artists make a variety of personal statements in their paintings, expressing their views on politics, particular events, religious beliefs, morals, and culture. But might they also use their work to illustrate their personal feelings about their own relationship to society? For insight, let us turn to the poignant approach taken by a French artist.

HENRI DE TOULOUSE-LAUTREC was not happy with the way he looked, but he had no choice but to make the best of it. He was less than five feet tall, and his face was adjudged hideous. With this physical appearance Lautrec confronted an unkind society, and found himself the target of insulting remarks from thoughtless gawkers.

Henri Marie Raymond de Toulouse-Lautrec-Montfa had seemed destined for a life of privilege. On November 24, 1864, in the southwestern French city of Albi, he was born into one of the aristocratic families of France.

Despite their patrician backgrounds, Henri's parents, Count Alphonse de Toulouse-Lautrec-Montfa and Adèle Tapié de Céleyran, were not a good match. Alphonse was a rabid outdoorsman who was temperamental,

haughty, impulsive, undisciplined, and decidedly eccentric in his behavior. Adele was his polar opposite: serious, pious, cautious, ethical, responsible.

To keep their fortunes and titles in the family and not mix in inferior blood, the practice among aristocrats was to intermarry. For the last several generations, there had been many alliances between the Toulouse-Lautrec and Tapié de Céleyran families. Henri's parents were first cousins, his grandmothers sisters. His paternal aunt married his maternal uncle.

Count Alphonse basically did as he pleased and was often away for long periods on hunting trips or other excursions. Adèle raised Henri mostly by herself, always providing unconditional love, support, and affection; Henri's childhood was pleasant, and the absence of his father didn't seem detrimental. With family ties running strong, mother and son often spent extended visits at relatives' châteaus. The boy enjoyed his large circle of playmate-cousins as he made the rounds of their country homes, and he was particularly fond of animals. Henri's mother thought her small son frail, however, and decided to keep the boy out of school and have him receive his early education at home.

When he was nine years old Henri began formal schooling in Paris. He was a good student, but health problems caused him to miss months of classes, and in January 1875 his mother pulled him out of school once and for all. Deeply concerned about his diminutive size and severe leg pains, she sent him to a therapist who promised to strengthen his legs and make him grow.

Henri didn't seem to respond positively to the therapy, and after a year his devoted mother attempted another approach, taking him on a round of spa visits. But as Henri became an adolescent, when other children his age were shooting up like weeds and his height remained relatively unchanged, her efforts began to be colored by desperation.

To the chagrin of Henri's father, the avid outdoorsman and hunter who no doubt wanted his aristocratic heir to follow in his footsteps, young Henri didn't seem headed for the sporting life. Lautrec père tried to motivate his son with his own prescription for vigor in his inscription on the flyleaf of a

book on falconry that he presented the bedridden boy when he was eleven years old: "Remember, my son, that life in the open air and in the light of the sun is the only healthy life; everything which is deprived of liberty deteriorates and dies quickly."

For all the drastic actions taken to make Henri grow, when that goal began to appear futile, the situation suddenly became even more bleak. At the age of fourteen, Henri was at the family home in Albi when he slipped on a poorly waxed floor and fractured his left thigh. After an initial period of recuperation, the boy's mother took him to convalesce in resorts at Nice and Barèges, where she hoped the therapeutic waters of the spas would help heal his legs. But about fourteen months after the first fall, Henri and his mother were walking near Barèges when the boy stumbled into a ditch and broke his right leg.

After this second mishap, Henri's legs stopped growing entirely, and he was permanently dependent on a cane to walk. From the waist up, however, his body matured. His parents told him—and were perhaps led to believe themselves, at least at the time—that Henri's stunted growth was due to his falls. Henri may never have known that he probably suffered from a rare congenital disease called pyknodysostosis, which is fairly common in the children of close relatives. The condition is associated with dwarfism; its victims have fragile, brittle bones that break easily—and Henri was, in fact, a dwarf.

Birth defects due to intermarriage were a mark of shame among aristocratic families. Handicapped progeny were described as delicate or frail, never defective. "I am small, but I am not a dwarf," Henri insisted to a friend as a young man.

During the convalescence beginning with his first fall, Henri began to develop a serious interest in painting. He had a natural talent for art; he had been drawing and sketching in his exercise books since he was a child. But while his father and other relatives dabbled in art, it was not deemed a respectable professional endeavor for an aristocrat. Yet he loved to paint; it

gave him a much-needed feeling of worth, and he was determined to pursue it. His father arranged for him to take art lessons with a family friend, a deaf-mute from Bordeaux named René Princeteau, who painted animals and sporting scenes.

Under Princeteau's tutelage, Henri's burgeoning talent was nourished and encouraged. After a short time, however, Princeteau thought Henri had made such progress that he should study with a more advanced teacher. Henri first entered the Paris studio of the academic painter Léon Bonnat, and then, along with a number of his fellow pupils from Bonnat's studio, that of another academic painter, Fernand Cormon.

Paris was a great haven for artists, musicians, writers, and poets, an exciting city for a person on the cusp of adulthood. But despite Henri's background of aristocracy and wealth, his grotesque physical appearance put him at a disadvantage. Elfin in stature, he had a wide nose, bright red fleshy lips, a thick tongue, heavy eyebrows, a coarse black beard and mustache, sloping shoulders, short arms, and stubby hands. He spoke with a lisp, walked with a limp (using a cane), and wore pince-nez. In a letter to his mother in 1885 he referred to himself as "this horrible, abject creature." But Henri did have one nice physical feature, his brown eyes, and he made the best of it. As Yvette Guilbert, a celebrated female performer, later remarked about her first meeting with the young man, she was initially taken aback by his ugly face. But then she said about his eyes, "I looked at them for some time, and suddenly Lautrec, noticing my glance, took off his glasses. He was well aware that his eyes were his only attractive features and generously unveiled them for my inspection."

In Paris as a young, independent man who had led both a difficult and a stifled life, Lautrec found a sense of liberation. He had always been devoted to his adoring, if not overbearing, mother, but around the mid-1880s, when he was twenty, he made a break, leaving the family home to live with friends in Montmartre. This was a district with a long history of decadence; gambling, prostitution, carousing, crime, and murder were commonplace.

Montmartre was set on a hill overlooking Paris, and it was beginning to supplant the Latin Quarter as the city's main artistic locale. Here, people led bohemian lives, free to do as they wished. Dance halls, cabarets, bars, and restaurants dotted the avenues, and the night life was full and active—a far cry from the regimen of Lautrec's aristocratic, highly conservative family.

Henri moved around a bit before settling at a studio close to the district's cemetery. It was from this Montmartre habitat that Lautrec drew inspiration for his pictures. Among his many subjects were circus people, dancers, and streetwalkers. In his work he did not in any way exhort, lecture, or offer moral discourse, but rather brought this world to appealing life.

Lautrec became a fixture at almost all the Montmartre establishments. One of his early favorites was the Élysée-Montmartre, a lively, glamorous dance hall where an austere "dancing inspector" was employed to admonish bold women who kicked too high, revealing nothing under their petticoats but bare flesh. Lautrec artistically recorded its scenes like a diligent reporter. The dance hall enjoyed great popularity, but there were always new and more trendy establishments opening in the district's partylike atmosphere, and the Élysée-Montmartre began to decline when a dance hall at the base of Montmartre opened on October 5, 1889. It would become famous for the striking fake red windmill above its entrance that glittered resplendently in the night, and it was a place with which Lautrec as an artist would be inextricably linked. It was called the Moulin Rouge.

AT NIGHT THE Moulin Rouge, whose name means "red mill," came alive with bright lights, jaunty music, plentiful alcohol, colorful characters, and pretty women. It was wildly popular, drawing everyone, from Parisians and Montmartre artists and writers, to tourists who simply couldn't leave the city without visiting the famed nightspot, to those looking for love. The women dressed in colorful outfits with fancy hats and long black gloves and the men in dapper suits with top hats and walking canes, and it was so

crowded that it was hard for people to move without bumping into one another.

The ballroom was enormous, with mirrored walls and a high ceiling, and was brightly lit with gas lamps. In the bandstand was a huge orchestra. At the proper time, the hall's dancers would rush in, their skirts held high, to begin a quadrille.

At the ends of the large ballroom were stages where people could observe the scene on the dance floor. Spectators crowded these platforms watching the dancers can-can and do their splits. In one section were tables of hopeful women waiting for men to buy them drinks and then pay for the physical pleasure of their company. During the evening there were many kinds of entertainment, including singers and novelty acts, but late at night the greatest professional dancers of Montmartre took to the floor and provided a dazzling show unique to the city.

Lautrec brought this wildness and gaiety to life on canvas and paper. Seated at a table or on a bar stool, night after night Lautrec sketched the scenes in the dance hall. The artist befriended the hall's famous performers, immortalizing them in paintings, posters, lithographs, and drawings. There was Jane Avril, the demure quadrilliste, the only dancer allowed to wear colored underwear; La Goulue, the audacious star of the *naturalist quadrille,* who danced on the tables; Valentin le Désossé, La Goulue's tall, thin, rubbery dancing partner, nicknamed "the disjointed"; Yvette Guilbert, the shapely red-haired consummate dance-hall singer; Le Pétomane, a novelty performer who could produce a variety of sounds and songs from his posterior; and many others.

Among the scenes of the Moulin Rouge Lautrec painted or made lithographs of, often featuring or showing its performers or people he knew, were *La Goulue Entering the Moulin Rouge; Moulin Rouge—La Goulue; The Englishman at the Moulin Rouge; At the Moulin Rouge: The Waltzing Couple; Jane Avril Leaving the Moulin Rouge; The Dance at the Moulin Rouge; The Clowness at the Moulin Rouge;* and *In the Moulin Rouge: The Beginning of the Quadrille.*

But it was in Lautrec's later painting *At the Moulin Rouge* that the artist may have offered a glimpse into his soul. He painted it around the middle of the 1890s, a few years after many of the stars who thrilled the audiences at the famed dance hall had left, his interest in the Montmartre scene had waned, and the Moulin Rouge itself had undergone many changes. The painting of his friends and himself was a personal image from his glory days at Montmartre, and it represented that world as he intimately remembered it. Lautrec did not display *At the Moulin Rouge,* nor did he sign it.

Count Henri de Toulouse-Lautrec had rejected the world his parents wanted for him for an environment whose values were vastly different from those of his background. He knew his extremely conservative family disapproved of his "other" life, which was not a very well-kept secret. When he unleashed himself in the world of Montmartre, with its sordid class of music-hall performers, prostitutes, and shady operators, with its dance halls and bars and brothels, he sought both refuge and freedom. Here he made friends, his artwork flourished, and he felt comfortable. He had found his own milieu.

In his new world Henri's grotesque appearance was inconsequential; his close friends focused on his benign soul and not his outward appearance. To strangers, however, he was still a grossly misshapen dwarf and was often the target of disparaging remarks. Although he found acceptance among his artistic colleagues and the denizens of Montmartre, he plunged deeply into alcoholism. After a fit of delirium tremens, some friends convinced him to go to a sanatorium in Neuilly. But by this time, unwittingly or not, he had made a bold statement about himself in his painting *At the Moulin Rouge.*

The scene, which takes place behind a balustrade and slightly below the viewer, is not one of the animated dances of the Moulin Rouge but a view of patrons and performers in casual repose, including some of those who composed Lautrec's circle. Seated at a table are poet Édouard Dujardin; La Macarona, a Spanish dancer known for her "effrontery"; photographer Paul Sescau; wine merchant Maurice Gilbert; and the red-haired performer Jane

Avril, her head in her hands, her face invisible. Standing behind the table to the left are Dr. Gabriel Tapié de Céleyran, the artist's tall cousin and steady social companion, and Lautrec, inconspicuously but manifestly present. To the right, La Goulue (Louise Weber), the Moulin Rouge's quadrille leader, her hands on her hair, primps before a mirrored wall as La Môme Fromage, her lesbian companion, looks on. In the right foreground, May Milton, an English dancer and Avril's lover, thrusts her face, glowing strangely green under the lights, partially into the picture, as if gaping at the spectators behind the balustrade.

By placing himself in the scene, Lautrec declared that he was part of the Montmarte netherworld. He does not stand off to the side like Goya in his *Charles IV and His Family* or Velázquez in his *Las Meninas,* but near the center, an arriviste in the thick of the spectacle. As longtime denizens sit at a table, the deformed, libidinous artist, alcoholic frequenter of brothels and friend of wastrels, is in motion, presumably finding his way through it all. Whether or not he belonged to this unconventional milieu as much as he would have liked, his placement of himself in it is a cry of defiance on behalf of all whose differences from the norm relegate them to the fringes of the social order. While some unfortunate people afflicted with physical deformities withdraw to the gloomy, solitary existence of a hermit, Lautrec did not let his unsightly appearance stop him from living the life he wanted. Although sensitive about his looks, he developed his natural talents and pursued a professional path. And despite, or perhaps because of, his physical affliction, he immersed himself in a social milieu that was at once colorful and decadent, vibrant and morally shocking, a world at stark odds with his aristocratic and archconservative upbringing, but one in which he flourished artistically. And in one particular painting, he not only depicted the environment he had come to love, but made a powerful personal statement of independence.

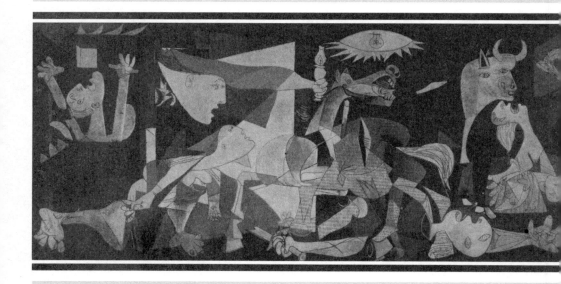

Guernica

(1937)

Pablo Picasso

✠

A painting may sometimes be a powerful political tool. An artist who is sufficiently outraged may be driven to express that emotion on canvas, and the resulting work may become not only a penetrating political statement for its historical period, but the manifesto of a particular cause for all times.

IT WAS A breezy, rainy spring day in Paris, the eleventh of May, 1937.

At 7 Rue des Grands-Augustins, on the second floor, daylight filtered through the tall columns of the windowpanes, brightening the room in which a huge canvas rested on the tile floor. The serene quiet of the studio was in stark contrast to the artist's homeland a few hundred miles away, where a torn country was swirling irrevocably into a cyclone of violence. A civil war was cleaving Spain as a powerful insurgent force led by General Francisco Franco tried to overthrow the liberal Republican government—which had won the election in February of the preceding year—and institute broad totalitarian rule.

With Franco's troops thrashing their way through the country, the beleaguered Spanish Republican government was fighting off a revolution at the same time it was trying to ready itself for representation at the

upcoming Paris World's Fair, which it saw as a golden opportunity to demonstrate its legitimacy and resolve to the world and to portray the terrible suffering inflicted on its people by the encroaching rebels.

At the time, Paris was a haven for anti-Fascist Spanish writers, poets, and painters. Several months earlier, one of the architects of the Spanish pavilion for the World's Fair, Jose Luis Sert, attempted to enlist the support of these influential people. As he would later write:

This was a moment in which things looked pretty grim for the cause of Republican Spain. And certainly many Spanish intellectuals in Paris were very concerned about what they could do and what kind of reaction would be appropriate. The Spanish Pavilion—which was the first and only national pavilion that Republican Spain ever had in a World Fair—drew together all the resources of the great artists and great Spanish luminaries who were in Spain. So the idea of approaching Picasso to contribute to this project seemed like a very reasonable one, since he certainly was one of the most well known Spanish artists in Paris at that particular moment.

Picasso! His surname alone was synonymous with artistic genius. Universally acclaimed for his astounding originality, technical virtuosity, and remarkable versatility, his substantial oeuvre included such brilliant works as *The Blind Man's Meal; The Old Guitarist; The Actor; Woman with a Fan; Acrobat on a Ball; Les Demoiselles d'Avignon; Two Seated Women; Three Musicians;* and *Girl Before a Mirror.* The outlines of the professional metamorphosis of Pablo Ruiz Picasso, born fifty-five years earlier in the Andalusian seaport of Malaga in southern Spain, were so well known that his creative stages—Blue Period, Rose Period, Negro Period, Cubism, Analytical Cubism, Synthetic Cubism, and Surrealism—were already legendary.

To show where his sympathies lay, Picasso accepted the commission of the Republican government, which, in another feat of political expediency,

had already made the expatriate artist the curator of Madrid's highly prestigious Prado Museum. He understood it to be incumbent upon him to produce some sort of artistic anthem for political freedom, one that would potentially galvanize democracies everywhere to take a stand against the crushing enemy of Spain's legally elected regime.

Following his commission in January, Picasso determined to find an atelier that would fit his needs, a space large enough to produce a painting that would fill a pavilion wall at the World's Fair. He found one with the help of his lover, Dora Maar, a young photographer and painter, who knew of a vacancy in her parents' neighborhood. Picasso quickly rented the space, two upper floors of a pre–French Revolution building near Notre Dame. He converted its largest rooms into studios, and with its labyrinth of apartments and other rooms, spiraling staircases, and cobblestone courtyard, the giant loft was conducive to both the working and living needs of the artist.

The edifice on the Rue des Grands-Augustins even had a bit of lore to it. Within its walls, as Picasso would later say, lurked "historical and literary ghosts." The dukes of Savoy had reportedly lived there long ago; and more recently the actor Jean-Louis Barrault and the anti-Fascist poet and philosopher Georges Bataille had adapted the large rooms for professional purposes. The sinister, winding stairways had been immortalized by Balzac in *Le Chef-d'oeuvre inconnu,* his tale of an obsessed painter.

But while the Spanish Civil War raged on, Picasso's work on his commission stagnated. He busied himself instead with other projects as his mind sought the appropriate artistic expression. Months passed, and he still could not quite formulate the statement he wanted to make, but the outrageous misdeeds committed in his native country—churches torched, nuns raped, civilians randomly murdered, people attacked in their homes, political prisoners slaughtered—made him melancholy. His beloved mother's heartfelt letter about the nearby convent that was set ablaze and the acrid air that caused her eyes to continually burn with tears saddened him deeply, too.

But just as political instability in Spain had been fermenting for years—

the division between left-wing elements (anarchists, syndicalists, and socialists) and right-wing elements (the military, the Catholic Church, and aristocratic landowners) resulted in continual uprisings, strikes, and other forms of chaos—Picasso's art, too, had increasingly been reflecting themes of violence. Over the last two years he had produced etchings of bulls physically attacking or destroying figures representing righteousness and honor, although in some cases he depicted the powerful animals as innocent or merely frisky, leaving the viewer to resolve the ambiguity. One famous etching was called *Minotauromachie,* in which a fearsome horned creature approaches a little girl holding a bouquet of flowers in her right hand. A candle in her left hand is reflected in the creature's glowing eyes. Signaling the artist's anxieties are a half-naked dead woman on a horse below the minotaur's outstretched hoof, a man escaping on a ladder while observing the action below, and two women watching from the window.

Early in 1937, at a barn in a town near Versailles called Le Tremblay-sur-Mauldre, Picasso made a series of engravings to publicize the sufferings of the people of his country. This pictorial tale illustrated the anguish caused by the abhorred Spanish rebel leader, whom the artist drew as a repugnant monster. Titled *Dream and Lie of Franco,* the work was disseminated in the form of a two-page booklet in which the engravings appeared like a cartoon strip.

From winter to spring, Picasso made little progress on his project for the Paris World's Fair. Some thought that Picasso, his immense talent and international fame notwithstanding, was a peculiar choice to produce a work intended, at least by the Spanish Republic, to portray to the world a bitter internecine battle that was plunging a country into terrible distress. Picasso was known for his advocacy of the Cubist idea that the true nature of objects could be revealed only by visually taking them apart and reassembling them as abstract forms. Those who wanted a clear and forthright statement from the artist about the horrors of war in Spain feared that whatever he produced would not be understood or appreciated by the masses.

Picasso's procrastination ended abruptly with the shocking news that flashed around the world at the end of April 1937. It came out of Guernica, a little town in north-central Spain in the Basque provinces, known as the location where the Biscayne Assembly would proudly meet under an oak tree, a treasured symbol of their people's freedom.

April 26 was an ordinary market day in the ancient Basque capital. But around four-thirty in the afternoon, when the streets were crowded with peasants and townsfolk, a fleet of hostile warplanes roared in over the town. As church bells signaled the people to run for cover, Junker 52 and Heinkel bombers and fighters unleashed a torrent of bombs and grenades.

There was no escape from the determined, murderous attackers. As people ran to the fields, the Heinkel fighters swooped down low to pick them off with machine guns. In consecutive waves until the sun mercifully set, bombers and fighters followed one another relentlessly and methodically carpet-bombing the town from one end to the next, destroying homes, farmhouses, buildings, and the railroad station, leaving hundreds dead on the streets and hundreds more buried under the flaming rubble. When all was done, nearly 1,700 people, one-third of the town's population, had been slain, and 889 were wounded.

The destruction, it turned out, had not been wrought by Nationalist Spain, whose air power was undeveloped, but was rather the work of the Luftwaffe's highly trained Condor Legion. The German invaders had come at Franco's invitation to show Republican Spain just how strong and deadly his military machine could be. It was also a chance for Nazi Germany to give its combat pilots air-raid experience, as well as to instill fear in free nations of what German air power could do to their own cities.

Indeed, nothing was to be gained from a military standpoint by ravaging the town. But as the capital of its region and with the Basque people's strong spirit of independence, Guernica, which had not previously been damaged by the civil war, was a symbolic threat to imperious Nationalist Spain.

The decimation of Guernica summoned in Picasso the inspiration for the theme that had so far eluded him. A day or two after the town's destruction, he was driven to fury by the terrible photos in the papers and the ghastly tales he heard from visitors. He began to make preparatory sketches and paintings almost immediately, still without a concrete idea of what his final product would be, but compelled by his pain to begin the work using the various elements that were forming in his mind.

It was not Picasso's intent to record the event by painting realistic images of the death and destruction, but rather to freely suggest the shock and raw power of what had happened in a way that would evoke a horrified reaction in the viewer. Several days later, on May 11, Picasso was ready to begin his response to the Guernica atrocity on canvas for the world to see.

In his commodious studio now stood a screen that stretched twenty-five feet, eight inches across and rose eleven feet, six inches high. As big as the room was, it could not comfortably accommodate the mammoth canvas; the top had to be bent backward, and Picasso would need a ladder to paint the upper region.

Over many weeks, in white, black, and gray tones, Picasso filled his canvas with an array of characters and emotions. A woman, head flung back to the sky, mouth open in a silent wail, cradles her lifeless child. A horned bull with staring eyes stands menacingly surveying the scene. In the mural the bull seems be the monstrous enemy, Franco and Fascism, the cause of all the distress in the picture, but in preparatory drawings the bull appeared rather to be the people of Spain on the lookout for the attackers. An eviscerated horse, a central figure in the painting, is screaming, its nostrils flaring. It could be the sundered nation of Spain, or General Franco. Over the horse is the sun, but the lightbulb inside it might be a subtle reference to the "artificial" light of the news media that has made the world aware of the event. Beneath the horse lie the supine remains of a warrior, the fingers of his left hand spread apart, palm heavily grooved, a broken dagger in his clenched right hand. Another woman crouches in fear, her breasts visible, head craned

Picasso's procrastination ended abruptly with the shocking news that flashed around the world at the end of April 1937. It came out of Guernica, a little town in north-central Spain in the Basque provinces, known as the location where the Biscayne Assembly would proudly meet under an oak tree, a treasured symbol of their people's freedom.

April 26 was an ordinary market day in the ancient Basque capital. But around four-thirty in the afternoon, when the streets were crowded with peasants and townsfolk, a fleet of hostile warplanes roared in over the town. As church bells signaled the people to run for cover, Junker 52 and Heinkel bombers and fighters unleashed a torrent of bombs and grenades.

There was no escape from the determined, murderous attackers. As people ran to the fields, the Heinkel fighters swooped down low to pick them off with machine guns. In consecutive waves until the sun mercifully set, bombers and fighters followed one another relentlessly and methodically carpet-bombing the town from one end to the next, destroying homes, farmhouses, buildings, and the railroad station, leaving hundreds dead on the streets and hundreds more buried under the flaming rubble. When all was done, nearly 1,700 people, one-third of the town's population, had been slain, and 889 were wounded.

The destruction, it turned out, had not been wrought by Nationalist Spain, whose air power was undeveloped, but was rather the work of the Luftwaffe's highly trained Condor Legion. The German invaders had come at Franco's invitation to show Republican Spain just how strong and deadly his military machine could be. It was also a chance for Nazi Germany to give its combat pilots air-raid experience, as well as to instill fear in free nations of what German air power could do to their own cities.

Indeed, nothing was to be gained from a military standpoint by ravaging the town. But as the capital of its region and with the Basque people's strong spirit of independence, Guernica, which had not previously been damaged by the civil war, was a symbolic threat to imperious Nationalist Spain.

The decimation of Guernica summoned in Picasso the inspiration for the theme that had so far eluded him. A day or two after the town's destruction, he was driven to fury by the terrible photos in the papers and the ghastly tales he heard from visitors. He began to make preparatory sketches and paintings almost immediately, still without a concrete idea of what his final product would be, but compelled by his pain to begin the work using the various elements that were forming in his mind.

It was not Picasso's intent to record the event by painting realistic images of the death and destruction, but rather to freely suggest the shock and raw power of what had happened in a way that would evoke a horrified reaction in the viewer. Several days later, on May 11, Picasso was ready to begin his response to the Guernica atrocity on canvas for the world to see.

In his commodious studio now stood a screen that stretched twenty-five feet, eight inches across and rose eleven feet, six inches high. As big as the room was, it could not comfortably accommodate the mammoth canvas; the top had to be bent backward, and Picasso would need a ladder to paint the upper region.

Over many weeks, in white, black, and gray tones, Picasso filled his canvas with an array of characters and emotions. A woman, head flung back to the sky, mouth open in a silent wail, cradles her lifeless child. A horned bull with staring eyes stands menacingly surveying the scene. In the mural the bull seems be the monstrous enemy, Franco and Fascism, the cause of all the distress in the picture, but in preparatory drawings the bull appeared rather to be the people of Spain on the lookout for the attackers. An eviscerated horse, a central figure in the painting, is screaming, its nostrils flaring. It could be the sundered nation of Spain, or General Franco. Over the horse is the sun, but the lightbulb inside it might be a subtle reference to the "artificial" light of the news media that has made the world aware of the event. Beneath the horse lie the supine remains of a warrior, the fingers of his left hand spread apart, palm heavily grooved, a broken dagger in his clenched right hand. Another woman crouches in fear, her breasts visible, head craned

up, her left foot stretched back. Above her are two other women, one holding a lantern in her outstretched arm, the other leaning out the window of a burning house, her clothes aflame, her arms reaching for the sky.

As he was creating the mural, certain occurrences provoked Picasso to issue a statement. First, there were rumors circulating in America that Picasso was a supporter of the rebel General Franco. Second, there had been a demonstration at the University of Salamanca in which General Millan Astray had pointed a gun at the writer Miguel de Unamuno, made disparaging remarks about intelligence, and praised death. And there was also the assassination of the poet and dramatist García Lorca in Grenada. In May, Picasso wrote:

The Spanish struggle is the fight of reaction against the people, against freedom. My whole life as an artist has been nothing more than a continuous struggle against reaction, and the death of art. . . . In the picture on which I am now working and which I shall call *Guernica*, I clearly express my abhorrence of the military caste which is now sinking Spain into an ocean of misery and death.

The Paris World's Fair, its theme a celebration of modern technology, ran from May through November 1937 and was attended by thirty-four million people. The Spanish Pavilion opened several weeks late, on July 12, missing much of the fanfare that attended the gala opening. Unlike the exhibits of the other countries, those of the Spanish Pavilion were not focused on technology; rather, they portrayed the Republicans' fight for independence, the horrors of the civil war, and the suffering of the homeland.

Due to financial limitations, the Spanish Pavilion was modest compared to its immediate neighbors, the Nazi Germany pavilion beside it and the Soviet Union pavilion behind it. An elongated sculpture made by Albert Sanchez Perez stood outside. It bore a hopeful inscription: "The Spanish people have a path, it leads to a star." Across from the entrance on the first floor was sculptor

Alexander Calder's Mercury Fountain, and behind it, occupying a wall directly facing arriving visitors, was the pavilion's main attraction, *Guernica,* Picasso's response to the horrific bombing of the Basque town. It was accompanied by a poem written by Paul Eluard. The ironically titled "Victory of Guernica" declared that the human spirit of a caring, freedom-loving people can overcome the worst of horrors and prevail. Other features in the pavilion included Joan Miró's defiant painting *The Reaper,* collages of daily life in Spain during the war, and, in the auditorium, films about the war.

Not unexpectedly, reactions to Picasso's *Guernica* were mixed. Many visitors to the Spanish Pavilion examined the painting and tried to match its images with its alleged antiwar intent. The Soviets, who supported the Spanish Republican government, were confused about whether it was a call to arms.

Critics both praised and condemned the painting, usually according to their political leanings, left or right respectively. But even some of the artist's left-wing compatriot admirers, such as the writer Juan Larrea, denounced it. Its supporters felt the painting superbly expressed the evils of Franco's Fascist regime and the war it spawned. Some said it was just another version of Goya's *Third of May,* while others praised it for being more universal. To his critics Picasso stated, "I paint this way because it's a result of my thought. I have worked for years to obtain this result.... I can't use an ordinary manner just to have the satisfaction of being understood."

After the Paris fair *Guernica* traveled around Europe, as Picasso wanted it exhibited as a demonstration of his antiwar sentiments. Its itinerary included Norway, London, Leeds, and Liverpool.

In 1939 a Picasso retrospective was held at the Museum of Modern Art in New York City, to which the artist lent *Guernica.* With Europe now besieged by the Nazis, who proscribed Picasso, it was thought the painting would be safer in America, and it was kept at the museum as a temporary loan. But even after World War II ended, *Guernica's* home remained,

temporarily at least, at New York's MoMA. It did leave the United States for exhibitions in different cities in Europe and South America, but pursuant to Picasso's wishes, it was kept out of Spain: Until Spain embraced democracy, it could not have *Guernica*.

As William Rubin, the director of the Department of Painting and Sculpture at the Museum of Modern Art in New York City, would later write in a letter published in the *New York Times:*

> Picasso made crystal-clear on a number of occasions through the years . . . that "Guernica" should be sent to Spain only when a genuine Spanish republic has been restored. This is the understanding which we at the Museum of Modern Art had always had with Picasso, and continue to have with his widow, Jacqueline. This is the only formulation of Picasso's wishes with respect to "Guernica" which was ever confirmed to the museum by Picasso's lawyers.

The Spanish Civil War, in which over a million people died, ended in March 1939 after the surrender of Madrid. The Nationalists took control of the country, and Franco became Spain's ruler. England, France, and America all soon recognized the new Spanish government.

Picasso did not live to see *Guernica* exhibited on Spanish soil. The master artist died in 1973, with Franco still in power.

Franco, who turned Spain into a right-wing dictatorship, died on November 25, 1975. He had chosen Juan Carlos, grandson of Alfonso XIII, the Spanish king who was deposed in 1931, to be the successor of his regime. With Carlos leading the country, the Spanish monarchy was restored, but instead of continuing a fascist state as he had been trained, Carlos made some early reforms and eventually instituted a democratic government. Such actions set the stage for Picasso's great antiwar work to be sent to his homeland at the request of the Spanish government.

On October 25, 1981, the hundredth anniversary of Picasso's birth, *Guernica* arrived in the artist's homeland. It was temporarily housed at the Cason del Buen Retiro, a part of the Prado Museum, while a new museum of modern art was being built. In 1992 the Reina Sofía National Museum Art Centre in Madrid was completed, becoming the permanent home of Picasso's masterpiece.

As the historical record shows, man's inhumanity to man seems to be a recurring theme of human nature. Raids, beatings, pillagings, rapes, assaults, torture, senseless slaughter—all are part of the grim inventory of human mistreatment. Sadly, they will probably continue. After one terrible day in 1937 when bombs rained mercilessly from the sky onto a peaceful little town in Spain, taking the lives of hundreds of defenseless civilians, Pablo Picasso in his Parisian atelier was roused to paint his protest. His piece is a timeless and universal statement that cries out not just against the bombing of Guernica but against all atrocities perpetrated upon innocent people anywhere. As a bold outcry against inhumanity, *Guernica* is also a symbol that the human instinct to eliminate suffering is more powerful than the desire to inflict it, that terror can be defeated, and that peace, freedom, and liberty will ultimately prevail.

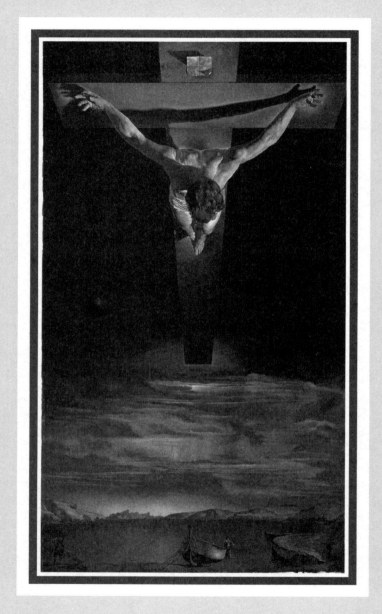

Christ of Saint John of the Cross

(1951)

Salvador Dalí

⊞

Great paintings are cultural treasures, celebrated not only for their beauty or other intrinsic qualities but for the everlasting joy they bestow upon humanity. But what about works of art that meet with controversy and criticism? How will they be embraced by future generations? Are they cause for celebration, too?

TOM HONEYMAN WAS on a routine trip to London. As was the habit of the congenial Scottish art connoisseur, he stopped by the Lefevre Gallery to chat up old friends and see what was new in the art world. The gallery was holding a new Dalí exhibition; Honeyman had followed the artist's career with interest, so he looked forward to seeing what the brilliant, eccentric painter had been up to.

Fifteen years earlier, in 1936, the sixty-year-old Honeyman had attended Dalí's previous exhibition in London, spending a month examining the artist's phantasmagoria. Dalí was a fascinating surrealist painter whose art made people think. Imbued with Freudian influences, his dreamlike paintings, in true surrealist fashion, were at once provocative, disturbing, grotesque, shocking, humorous, haunting, and abstruse. A viewer could

always expect to be surprised and challenged by a Dalí painting. Honeyman was interested in learning how Dalí's creative and symbolic approaches had evolved.

The new Lefevre exhibition attracted a large crowd to see the twelve oil paintings and twenty-nine watercolors, pastels, and drawings. Honeyman noticed, however, that one painting seemed to draw more attention than any of the others. Curious, Honeyman jostled his way through the knot of people to have a look.

He stood transfixed before the giant canvas. It was *Christ of Saint John of the Cross.*

Dalí's painting of the crucifixion was unlike any other Honeyman had ever seen. Christ's head bore no crown of thorns; no nails impaled his limbs; no blood streamed from his body. This was not a crucifixion of suffering or despair. The featureless cross, seen from above, hovered in midair, dizzyingly suspended over the landscape below. The face of Christ, so often depicted as wracked with anguish, was not to be seen; the head was bent forward so only a mop of wavy copper-colored hair was visible. Above the downturned head, the muscles of the back of the neck and shoulders were lushly sculpted by light falling from above and to the right, the arms stretched back like wings. The body was not the traditional mangled figure but an exquisite specimen of the male form. The foreshortened legs, ending in gracefully crossed feet, completed the technically dazzling human triangle, the lowered head appearing as a dark circle above the triangle's downward-pointing apex.

Where was the pain? Where were the sorrow and anguish? This aerial Christ was suffused with a celestial beauty, and the orange clouds that floated above the fisherman and boat by the sapphire lake at the bottom of the painting gave it a sense of transcendent peace.

Tearing his gaze from this astounding work, Honeyman had to withdraw from the crowd. He needed to be alone to contemplate his response to this startling religious vision.

He was astonished that Dalí's *Christ of Saint John of the Cross* had had such an unsettling effect on him; he had served as a physician in the Royal Army in World War I and was not easily ruffled. After some reflection, however, this experienced art observer began to second-guess his reaction. Had Dalí purposefully employed some trick to manipulate the viewer?

Crucifixions, of course, had long been a staple of art. Filippo Brunelleschi, Rogier van der Weyden, Fra Angelico, Andrea Mantegna, Michelangelo Buonarroti, Giovanni Bellini, Lucas Cranach the Elder, Tintoretto, Joseph Koenig, Pablo Picasso, and Marc Chagall were among the legions of artists who had painted crucifixions, but Dalí's had affected Honeyman like few other works of art.

After collecting himself, he went back to look at the strange canvas again. For all his years of poring over works of art, he remained perplexed. What was Dalí trying to accomplish?

Tom Honeyman headed back to Glasgow with Dalí's *Christ of Saint John of the Cross* very much on his mind. As soon as he got back, he picked up the phone to make a call.

IN 1950 SALVADOR DALÍ, the Spanish-born painter of *The Great Masturbator, The Lugubrious Game,* and *The Persistence of Memory,* had what he called a "cosmic dream." The surrealist artist, who used trancelike techniques to bring to the surface images from his subconscious, made a drawing of what he saw in his reverie, showing a light-colored triangular figure with a dark circle at its center, daggerlike objects radiating from the dark circle. This image, he wrote, "represents the nucleus of an atom." To Dalí, this nucleus had a metaphysical implication: He considered it to be "the very unity of the universe, the Christ."

Dalí was to find more meaning in his dream. The French Carmelite scholar Father Bruno de Jésus-Marie referred Dalí to an old drawing that was reproduced in a book he had written. Father Bruno had sent a photographer to take a picture of the drawing at the monastery at Ávila,

Spain, where it had been preserved for hundreds of years. He thought it might mean something to the painter. It had allegedly been drawn by the revered sixteenth-century Christian mystic saint, John of the Cross.

SAINT JOHN OF the Cross had a vision while praying at the church of the Monastery of the Incarnation in Ávila, Spain.

It was a time of danger for the friar, who had helped Saint Teresa establish the Discalced Carmelite monasteries and at the same time spiritually elevated himself to the life of a mystic.

In 1535, when she was twenty years old, Teresa had entered the monastery to become a nun. But the Carmelite nuns there had relaxed their religious rule, and Teresa soon felt called by God to help the nuns return to the asceticism of their order at the time of its founding. Teresa then founded a new convent in Ávila in 1562. But in October 1571, her superiors compelled her to return to the Monastery of the Incarnation as a prioress. She asked John of the Cross, a member of the men's Carmelite order since 1563 and a reformer like herself, to come to the monastery as a confessor.

Saint John had dedicated himself to a life of divine love, striving to bring his soul into an intimate union with God, in the belief that God would be generous to those who surrendered perfectly to Him.

Oral tradition relates the circumstances of the ecstasy of Saint John of the Cross. As he prayed before the altar in the church of the monastery, before him appeared the image of the crucified Christ. But it was unlike any crucifixion scene known in the sixteenth century. It was as if John were looking down at Christ on the cross, which rose obliquely into the air, and seeing him in profile from the left side. Christ was suspended from the beams, his arms thrust backward, nails driven through his hands. His head was slumped downward, and his legs were bent.

THE VENERABLE SISTER lay on the bed, the grip of death upon her. She knew she was dying, but her devotion to God surpassed any other emotion.

For many years she had carried something close to her heart that gave her strength.

On her deathbed, the old woman asked for food. But when it was brought to her, she declined to eat it and instead offered it as a last sacrifice to God for His love. She told her confessor that in making this offering, she felt the warmth of Christ in her heart.

Ana María de Jesus had carried by her heart a piece of paper, small and worn, for forty years, guarding it as if it were a holy relic. A favorite of Saint John of the Cross, the nun had received the slip of paper from the mystic; on it was a drawing he had made many years earlier following a religious ecstasy. It pictured Christ on the cross. Such a drawing would not have been uncommon, but this one, made in the fever of divine rapture, was different. According to oral tradition, this was what Ana María de Jesus kept with her to the end.

After her death, Saint John of the Cross's drawing of the crucifixion was preserved at the Monastery of the Incarnation in Ávila, Spain.

SALVADOR DALÍ WAS profoundly affected by the mystic's drawing. Shortly afterward, the artist had his own vision of Christ on the cross, suspended in the air above the bay of Port Lligat, the small fishing village in Spain where he had a home. Dalí felt he had been granted the vision on condition that he depict it on canvas. He heard voices call out his name and declare, "You must paint this Christ."

Dalí immediately went to work. According to a letter he wrote setting out the process of the painting's design, he had intended to insert the traditional details of the crucifixion, such as Christ's thorny wreath, but substituting red carnations for blood, with jasmine flowers streaming from the wound in Christ's side. Then a subsequent dream, when he was almost finished with the painting, altered his plans. In this reverie, he saw Christ bare of all the crucifixion accoutrements, leaving only "the metaphysical beauty of Christ–God." Dalí added that he was determined to eschew the

manner in which modern painters rendered Christ, interpreting him "in the expressionistic and contortionist sense, thus obtaining emotion through ugliness," and that his goal was for his Christ to be "as beautiful as the God that He is."

After seeing the drawing of Saint John of the Cross, Dalí made another drawing, this time of a light triangle and a dark circle, about which he wrote, "[It] aesthetically summarized all my previous experiments, and I conceived my Christ in this triangle."

In Dalí's painting, at what angle is Christ on the cross to the landscape below? Is he parallel to the ground, lying underneath the cross? Is he rising at an acute angle? Perpendicularly? Dalí seems to have employed an optical illusion. Curiously, if Saint John of the Cross's crucifixion drawing is turned to the side, Christ is seen suspended underneath the cross as the cross ascends at a slight angle into the air.

In the late fall of 1951, Salvador Dalí finished his crucifixion painting. Shortly after he applied the last brushstrokes, the canvas was packed in a mammoth container to be sent off for its public debut. The famous painter arrived in London with his wife, Gala, four days before the December 5, 1951, opening of his exhibition at the Lefevre Gallery.

ARRIVING BACK IN Glasgow after attending Dalí's London exhibition, Tom Honeyman, who was the director of art galleries for the city of Glasgow, called Jack Kelly, the city treasurer. Excited about Dalí's painting, Honeyman hoped the city might buy for one of its galleries a study sketch Dalí had made for his new work. The asking price for the sketch was an affordable 250 pounds.

Honeyman had assumed there was no chance of the city buying the painting itself, which was priced at twelve thousand pounds. But Kelly, caught by Honeyman's enthusiasm, mused aloud that the city might be interested not just in the drawing, but in its remarkable implementation on canvas. It had been sixty years since Glasgow had made such a bold art

acquisition, when in 1891 it had purchased James Abbott McNeill Whistler's *Portrait of Thomas Carlyle* for the then-not-unsubstantial price of one thousand pounds. Whistler's painting was included in the infamous 1877 Grosvenor Gallery exhibition of the painter's works, which the art critic John Ruskin had publicly mocked, and the Corporation of Glasgow was heavily criticized for purchasing the portrait. Yet it had proved to be an important acquisition for the city. So why not again?

If a feasible price could be arranged for Dalí's revolutionary crucifixion painting, the men figured, perhaps the city could purchase it. But the city had to act quickly. The painting was scheduled to go on tour to other European cities, and, with word of the masterful work spreading, competition with other potential purchasers might drive the price out of Glasgow's reach.

Honeyman was thrilled at the prospect of the work's finding a permanent home in one of the galleries he supervised. He had seen firsthand the magnetic effect it had on people; he himself had found it difficult to walk away from the painting.

Arrangements were promptly made for the painting to be brought to Glasgow so the Art Galleries Committee could examine it rigorously and ponder the various aspects of the proposed acquisition: the painting's artistic merit, its potential to grow in value over the years, the anticipated reaction of the public.

The painting was viewed in Glasgow only for a day. In that short space of time, residents of the city were invited to have a look and voice their opinions. Many were positive. Also in its favor, surplus exhibition funds were found to be available for the purchase, so no public monies would be required to make a respectable offer.

Although there was some dissension, the city fathers approved the purchase. Honeyman contacted Dalí's agent, whom he had known for many years, and pitched his offer at the highest price the city could afford. The agent, who liked the idea of the painting's going to Glasgow, helped the

negotiation along. Dalí, perhaps pleased that his work would be in a public museum, agreed to a lower price than the painting might have fetched elsewhere. In the end, Dalí sold *Christ of Saint John of the Cross* to Glasgow for eighty-two hundred pounds. Newspapers reported the sale on January 25, 1952.

And once the deed was done, controversy immediately arose.

Magazine and newspaper art critics wrote disapproving articles about the acquisition. Local citizens sent vituperative letters to the newspapers. Some two hundred students at the Glasgow School of Art signed a petition to the Glasgow Corporation alleging the purchase was a "shameful waste of money" and that the funds would have been better used to support local art pupils. Members of the Royal Academy, the association for Britain's foremost painters, disparaged the purchase as well. The criticisms were varied: A painting by Dalí was not worth that kind of money; the artist had handled the subject matter in an indelicate way; the painting involved "trickery"; if a museum was going to acquire a Dalí, it should be one of his surrealist works; the money would have been more wisely spent on a painting by another artist; and on and on.

Honeyman and the city authorities expected negative reactions, but not the bitterness of the attacks. Dalí himself spoke up to defend his work, acknowledging that people found the painting unsettling because of the unorthodox perspective of its composition. But, as he wrote in a letter, he felt there could be no religious objection to it, since it was based on the ecstatic vision of an acknowledged saint, John of the Cross.

Dalí was soon off for a lecture tour of the United States focusing on his newly discovered interest in what he called "nuclear mysticism"—a mixture of physics and metaphysics—and his painting had a new home. It has continued to inspire visceral reaction, both positive and negative, over the years (in 1961 and 1982 it was physically attacked by museum visitors), but it immediately captured the public imagination and continues to be relished

by the masses. In 2005 it ranked at the top of a poll by the *Glasgow Herald* (with almost 30 percent of the votes) as Scotland's favorite painting.

"From all the controversy," Honeyman presciently wrote not long after the painting was acquired in 1952, "it should be clear that Glasgow has purchased an art event." Indeed, Honeyman, in his spirited defense of the acquisition of Salvador Dalí's *Christ of Saint John of the Cross,* may have summed up the everlasting allure of art: Every great painting, each in its own individual way, is an "art event" to be celebrated for the benefit of posterity.

LOCATIONS OF PAINTINGS

Mona Lisa: Louvre Museum, Paris, France.

Christina of Denmark, Duchess of Milan: The National Gallery, London, England.

Eleonora of Toledo with Her Son Giovanni de' Medici: Uffizi Gallery, Florence, Italy.

Mars and Venus United by Love: The Metropolitan Museum of Art, New York, New York.

David with the Head of Goliath: Galleria Borghese, Rome, Italy.

The Anatomy Lesson of Dr. Nicolaes Tulp: Mauritshuis, The Hague, The Netherlands.

The Night Watch: Rijksmuseum, Amsterdam, The Netherlands.**Benjamin Franklin:** The White House, Washington, D.C.

The Tribuna of the Uffizi: The Royal Collection, London, England.

The Honorable Mrs. Graham: National Gallery of Scotland, Edinburgh, Scotland.

Watson and the Shark: National Gallery of Art, Washington, D.C.

The Skater: National Gallery of Art, Washington, D.C.

George Washington (Athenaeum Head): Museum of Fine Arts, Boston, Massachusetts.

Charles IV and His Family: National Museum of the Prado, Madrid, Spain.

Lady Maitland: The Metropolitan Museum of Art, New York, New York.

Slave Ship: Museum of Fine Arts, Boston.

The Outcast: Royal Academy of Arts, London, England.

Washington Crossing the Delaware: The Metropolitan Museum of Art, New York, New York.

The Horse Fair: The Metropolitan Museum of Art, New York, New York.

Olympia: Musée d'Orsay, Paris, France.

Nocturne in Black and Gold: The Falling Rocket: The Detroit Institute of Arts, Detroit, Michigan.

A Convalescent: Manchester Art Gallery, Manchester, England.

Le mariage de convenance: Kelvingrove Art Gallery and Museum, Glasgow, Scotland.

At the Moulin Rouge: The Art Institute of Chicago, Chicago, Illinois.

Guernica: Reina Sofía National Museum Art Centre, Madrid, Spain.

Christ of Saint John of the Cross: Kelvingrove Art Gallery and Museum, Glasgow, Scotland.

Other versions of these paintings by the same artists may be housed at other locations.

NOTES AND BIBLIOGRAPHY

Mona Lisa

Quotations of Vasari are from the cited Vasari books and from Burroughs. For a detailed account of the 1911 theft of *Mona Lisa,* see Reit and McMullen, which were some of my main sources; contemporary *New York Times* articles also were useful.

2 In the early: Bramly, 398; Payne, 270.

2 The artist Leonardo: *On the Occasion* (Foreword).

3 "portrait of a": Vallentin, 514; Bramly, 399.

3 Lisa Gherardini: www.louvre.fr.

7 "painted from life": Payne, 273; Zubov, 514.

7 It has been: Bramly, 399.

10 As time passed: Reit, 17.

11 At five o'clock: *New York Times,* August, 23, 1911.

13 So flagrant: Mailer, 319; McMullen, 203–204.

14 "Leonard" bolted the: Reit, 138.

17 According to the: *New York Times,* January 25, 1914.

Bibliography

Atalay, Bülent. *Math and the Mona Lisa: The Art and Science of Leonardo da Vinci.* Washington, D.C.: Smithsonian Books, 2004.

Bramly, Serge. Translated by Siân Reynolds. *Leonard: Discovering the Life of Leonardo da Vinci.* New York: Edward Burlingame Books/HarperCollins, 1991.

Burroughs, Betty, ed. and abridger. *Vasari's Lives of the Artists.* Simon & Schuster, New York, 1946.

McMullen, Roy. *Mona Lisa: The Picture and the Myth.* Boston: Houghton Mifflin, 1975.

Mailer, Norman. *Portrait of Picasso as a Young Man: An Interpretive Biography.* New York: Atlantic Monthly Press, 1995.

On the Occasion of the Exhibition of the Mona Lisa by Leonardo da Vinci Lent to the President of the United States and the American People by the Government of the French Republic, 1963. (Foreword by John Walker; text adapted from *Hommage à Léonard de Vinci,* Louvre, Paris, 1952.)

Payne, Robert. *Leonardo.* Garden City, N.Y.: Doubleday, 1978.

Reit, Seymour V. *The Day They Stole the Mona Lisa.* New York: Summit Books, 1981.

Rummel, G. Albert. *Mona Lisa, The Million Dollar Painting, Why It is Famous and Great: An Appreciation.* Cincinnati: W. S. Dixon, 1923.

Vasari, Giorgio. *The Lives of the Painters, Sculptors and Architects,* Vol. Two. London: J. M. Dent, 1927.

————. *These Splendid Painters.* New York: J. H. Sears, 1926.

Vallentin, Antonina. Translated by E. W. Dickes. *Leonardo da Vinci: The Tragic Pursuit of Perfection.* New York: Viking, 1938.

Zubov, V. P. Translated by David H. Kraus. *Leonardo da Vinci.* Cambridge, Mass.: Harvard University Press, 1968.

Christina of Denmark, Duchess of Milan

Unless otherwise specified, all quotations in this chapter are from Chamberlain, 114–136 (Chamberlain's quotations are from the *Calendars of Letters and Papers* from the reign of Henry VIII, and are in their original English form).

36 "as the golden sun": Williams, 171.

36 "to nourish love": Hackett, 331.

Bibliography

Chamberlain, Arthur B. *Hans Holbein the Younger, Vol. II*. London: George Allen, 1913.

Hackett, Francis. *Henry the Eighth*. New York: Liveright, 1945.

Lacey, Robert. *The Life and Times of Henry VIII*. New York: Praeger, 1974.

Langdon, Helen. *Holbein*. New York: Dutton, 1976.

Rowlands, John. *Holbein: The Paintings of Hans Holbein the Younger*. Boston: David R. Godine, 1985.

Williams, Neville. *Henry VIII and His Court*. New York: Macmillan, 1971.

Eleonora of Toledo with Her Son Giovanni de'Medici

For an excellent account of the royal wedding of Cosimo and Eleonora, see Minor and Mitchell. See Arnold for details on Eleonora's burial gown and Eisenblicher for essays on various aspects of Eleonora's life; for information on Eleonora's burial garb, see especially the essay in Eisenblicher by Westerman Bulgarella.

45 "The body was": Young, 288–289.

Bibliography

Arnold, Janet. *Patterns of Fashion*. London: Macmillan, 1985.

Eisenblicher, Konrad, ed. *The Cultural World of Eleonora di Toledo, Duchess of Florence and Siena*. Hants, England: Ashgate, 2004.

Minor, Andrew C., and Bonner Mitchell. *A Renaissance Entertainment: Festivities for the Marriage of Cosimo I, Duke of Florence, in 1539*. Columbia: University of Missouri Press, 1968.

Young, Colonel G. F. *The Medici,* Vol. II. New York: Dutton, 1909.

Mars and Venus United by Love

50 According to the X-ray: Burroughs, 93–94.

52 "When the artist": Burroughs, 96.

52 "buffoons, drunkards": www.edu/art/gettyguide.

Bibliography

Burroughs, Alan. *Art Criticism from a Laboratory.* Boston: Little, Brown, 1938.

McClafferty, Carla Killough. *The Head Bone's Connected to the Neck Bone: The Weird, Wacky, and Wonderful X-Ray.* New York: Farrar, Straus and Giroux, 2001.

http://www.getty.edu/art/gettyguide/artMakerDetails?maker=592&page=1

David with the Head of Goliath

Hibbard contains English translations of short contemporary and older biographies of Caravaggio.

56 but according to: Milner.

Bibliography

Berenson, Bernard. *Caravaggio: His Incongruity and His Fame.* London: Chapman & Hall, 1953.

Hibbard, Howard. *Caravaggio.* New York: Harper & Row, 1983.

Langdon, Helen. *Caravaggio: A Life.* New York: Farrar, Straus and Giroux, 1998.

Milner, Catherine. "Red-Blooded Caravaggio Killed Rival in Bungled Castration Attempt." *Telegraph,* February 6, 2002.

Robb, Peter. *M: The Man Who Became Caravaggio.* New York: John Macrae/Henry Holt, 2000.

Turner, Jane, ed. *The Dictionary of Art,* Vol. 5. New York: Grove/Oxford University Press, 1996.

The Anatomy Lesson of Dr. Nicolaes Tulp

Hecksher provides an excellent account of this painting and seventeenth-century anatomical demonstrations.

66 "Evildoers who, while living": Heckscher, 99.

67 His violation: Broos, 208.

Bibliography

Bailey, Anthony. *Rembrandt's House*. Boston: Houghton Mifflin, 1978.

Broos, B., et al. *Portraits in the Mauritshuis: 1430–1790*. The Hague: Zwolle/Waanders, 2004.

Hind, Arthur M. *Rembrandt*. Cambridge, Mass.: Harvard University Press, 1932.

Heckscher, William S. *Rembrandt's Anatomy Lesson of Dr. Nicholaas Tulp*. New York: New York University Press, 1958.

Kiers Judikje, and Fieke Tissink. *The Golden Age of Dutch Art*. London: Thames and Hudson, 2000.

Marx, Claude Roger. *Rembrandt*. New York: Universe Books, 1960.

Mee, Charles, Jr. *Rembrandt's Portrait: A Biography*. New York: Simon & Schuster, 1988.

Murray, John J. *Amsterdam in the Age of Rembrandt*. Norman: University of Oklahoma Press, 1967.

Nash, J. M. *The Age of Rembrandt and Vermeer: Dutch Painting in the Seventeenth Century*. New York: Holt, Rhinehart and Winston, 1972.

Rosenberg, Jakob. *Rembrandt*. Cambridge, Mass.: Harvard University Press, 1948.

The Night Watch

For a comprehensive history of this painting, see Havenkamp-Begemann.

74 The first destructive: *New York Times,* January 14, 1911, and January 15, 1911.

74 The second act: *New York Times,* September 9, 1975.

74 Fifteen years later, *New York Times,* April 7, 1990.

75 The painting was erroneously: Havenkamp-Begemann, 7.

Bibliography

Haverkamp-Begemann, E. *Rembrandt: The Night Watch*. Princeton, New Jersey: Princeton University Press, 1982.

Benjamin Franklin

80 "proved a good": Franklin, 69.

81 "Yours is at": Hart, 412.

84 "General Howe has not": Stimpson, 69.

85 "I found your house": Historical Society of Pennsylvania facsimile of Franklin's letter.

87 "Our English enemies": Hart, 412.

89 "The fortune of war": Hart, 415–416.

Bibliography

American Philosophical Society Meeting Notes of April 20, 1906. Philadelphia: American Philosophical Society, 1906.

Franklin, Benjamin. *The Autobiography of Benjamin Franklin*. Edited by Charles W. Eliot, part of Harvard Classics anthology, Vol. I. New York: P. F. Collier & Son, 1909.

Hart, Charles Henry. "The Wilson Portrait of Franklin; Earl Grey's Gift to the Nation." *The Pennsylvania Magazine of History and Biography*, Vol. XXX. Philadelphia: The Historical Society of Pennsylvania, 1906, 409–416.

"Proceedings of the American Philosophical Society," Vol. 100, No. 4, 1956.

The Record of the Celebration of the Two Hundredth Anniversary of the Birth of Benjamin Franklin, Under the Auspices of the American Philosophical Society Held at Philadelphia for Promoting Useful Knowledge, April the Seventeenth to April the Twentieth, A.D. Nineteen Hundred and Six, Vol. I. Philadelphia: The American Philosophical Society, 1906, xv–xix.

Sellers, Charles Coleman. *Benjamin Franklin in Portraiture*. New Haven, Conn.: Yale University Press, 1962.

Stimpson, George. *A Book About American History*. New York: Harper & Brothers, 1950.

The Tribuna of the Uffizi

The story of this chapter is based on Volume One of Mrs. Papendiek's journals, 82–89. Millar, another source, is an excellent work for learning about this painting.

94 He had been tapped: Smith, 53.

Bibliography

Millar, Oliver. *Zoffany and his Tribuna*. London: The Paul Mellon Foundation for British Art 1966/Routledge & Kegan Paul, 1967.

Papendiek, Mrs. Edited by Mrs. Vernon Delves Broughton. *Court and Private Life in the Time of Queen Charlotte: Being the Journals of Mrs. Papendiek, Assistant Keeper of the Wardrobe and Reader to Her Majesty,* Vol. I. London: Richard Bentley & Son, 1887.

Smith, Bernard. *European Vision and the South Pacific* (second edition). New Haven, Conn.: Yale University Press, 1985.

The Honorable Mrs. Graham

Maxtone Graham was my main source for this chapter; it is a wonderful book, interspersing letters from the Cathcarts and others in chronological order with insightful commentary by the author. While it is out of print and may be difficult to obtain, it is a book I would recommend to anyone wishing to learn more about Mary Graham and her circle. A contemporary book lavished with color illustrations that I would recommend is Belsey. Drummond was another important source. See Aspinall-Oglander and Brett-James for biographies of Thomas Graham.

103 "a daring old man": Drummond, 17.

104 in the summer of: Aspinall-Oglander, 6.

105 "Jane has married": Brett-James, title page.

107 "matchless pair": Drummond, 34.

114 "His mind and": Cockburn, 149–150.

Bibliography

Aspinall-Oglander, Cecil. *Freshly Remembered: The Story of Thomas Graham, Lord Lynedoch*. London: Hogarth, 1956.

Belsey, Hugh. *Gainsborough's Beautiful Mrs. Graham*. Edinburgh: National Gallery of Scotland, 2003.

Brett-James, Antony. *General Graham Lord Lynedoch*. New York: St. Martin's, 1959.

Cockburn, Henry. *Journal of Henry Cockburn, Being a Continuation of the Memorials of His Time, 1831–1854*, Vol. I, Edinburgh: Edmonston and Douglas, 1874.

Drummond, P. R. *Perthshire in Bygone Days: One Hundred Biographical Essays*. London: W. B. Whittingham, 1879.

Maxtone Graham, E. *The Beautiful Mrs. Graham and the Cathcart Circle*. Boston: Houghton Mifflin, 1928.

Smailes, Helen. "Gainsborough's Beautiful Mrs. Graham (Mary Catchart of Schaw Park, Alloa)." *Forth Naturalist and Historian*, Vol. 26, 2003, 93–96.

Williamson, Geoffrey. *The Ingenious Mr. Gainsborough, Thomas Gainsborough: A Biographical Study*. New York: St. Martin's Press, 1972.

Watson and the Shark

The opening account of the shark attack on Watson is based on a report in an issue of the *Morning Chronicle, and the London Advertiser* in April 1778, as reproduced in Miles. All Ethan Allen quotes are from Allen.

119 The sailors rushed: Webster, 4.

120 "Such is the wretched": Webster, 13.

121 Watson had been born: Miles, 55; Webster, 3.

125 The bodies of: Prown, 272.

126 "a boy attacked": Frankenstein, 138.

126 In early 1779: Prown, 275.

127 After Watson died: Webster, 13.

127 "There are those": Isham, 26.

Bibliography

Allen, Ethan. *A Narrative of Colonel Ethan Allen's Captivity Written by Himself.* Burlington: H. Johnston, 1838.

Frankenstein, Alfred, and the Editors of Time-Life Books. *The World of Copley 1738– 1815.* New York: Time-Life Books, 1970.

Isham, Samuel. *The History of American Painting.* New York: Macmillan, 1905.

Miles, Ellen G.: *American Paintings of the Eighteenth Century.* Washington, D.C.: National Gallery of Art; New York: Oxford University Press, 1995.

Prown, Jules David. *John Singleton Copley in England 1774–1815.* Cambridge, Mass.: Harvard University Press, 1966.

Webster, J. Clarence. *Sir Brook Watson: Friend of the Loyalists, First Agent of New Brunswick in London.* Sackville, New Brunswick, Canada: Reprinted from the Argosy, Mount Allison University, 1924.

The Skater

My account of Stuart and Grant's skating adventure is based on Dunlap, 218, and Mason, 15.

130 Stuart had exhibited: Whitley, 17, 24.

131 "suddenly lifted": Whitley, 31.

Bibliography

Dunlap, William. *A History of the Rise and Progress of The Arts of Design in the United States, Vol. One.* Boston, C. E. Goodspeed & Co., 1918.

Mason, George C. *The Life and Works of Gilbert Stuart.* New York: Charles Scribner's Son, 1879.

Miles, Ellen G. *American Paintings of the Eighteenth Century.* Washington, D.C.: National Gallery of Art; New York: Oxford University Press, 1995.

George Washington (Athenaeum Head)

Mason and Dunlap provide contemporary accounts of this painting and were my main sources.

135 "looked more like": Dunlap, 209.

135 "he had eaten": Dunlap, 209.

136 "No human being": Mason, 26.

137 "the most superb-looking": Mason, 120.

137 Washington suffered: Rachlin, 151.

138 "Mr. Stuart": Mason, 117.

138 "It would be": Dunlap, 233.

139 "There seems to be": Mason, 118.

139 Dunlap noted: Dunlap, 231.

140 From 1928: Data from the Bureau of Engraving and Printing of the U.S. Department of the Treasury.

Bibliography

Dunlap, William. *A History of the Rise and Progress of The Arts of Design in the United States, Vol. One.* Boston, C. E. Goodspeed & Co., 1918.

Mason, George C. *The Life and Works of Gilbert Stuart.* New York: Charles Scribner's Son, 1879.

Mount, Charles Merrill. *Gilbert Stuart: A Biography.* New York: W. W. Norton, 1964.

Rachlin, Harvey. *Lucy's Bones, Sacred Stones, and Einstein's Brain.* New York: Henry Holt, 1996.

Whitley, William T. *Gilbert Stuart.* Cambridge, Mass.: Harvard University Press, 1932,

Charles IV and His Family

Bibliography

Baticle, Jeannine. *Goya: Painter of Terrible Splendor.* New York: Harry N. Abrams, 1994.

Harris, Enriqueta. *Goya.* London: Phaidon, 1969.

Licht, Fred. *Goya: The Origins of Modern Temper in Art.* New York: Universe, 1979.

Mühlberger, Richard. *What Makes a Goya?* New York: The Metropolitan Museum of Art/Viking, 1994.

Lady Maitland

The account of Napoleon observing Lady Maitland's portrait that was hanging in his cabin on the *Bellerophon* (as well as all of his dialogue) comes from Maitland.

150 had triumphantly captured: *The Dictionary of National Biography*, 1257.

151 "Who is that": Maitland, 71–72.

153 "The Emperor Napoleon": Ibid., 28.

153 "any ship of war": Ibid., 31.

154 "A victim to": Bourrienne, Vol. 14.

155 "Capitaine": Maitland, 188.

155 "Lord Keith": Ibid., 134–135.

156 "He would surely": "A Midshipman," 212.

156 "We had never": Ibid., 212.

157 "a horrid gloom": Ibid., 253.

157 "a daughter of": Ibid., 247.

157 "charming little woman": Ibid., 247.

158 died at sea: *Dictionary of National Biography*, 828.

158 fine French wine: "A Midshipman of the *Bellephoon*," 247.

158 "I have been": Maitland, 72.

Bibliography

Andrew, William Raeburn. *Life of Sir Henry Raeburn, R.A.; With Portraits and Appendix*. London: W. H. Allen, 1886.

Bourrienne, Louis Antoine Fauvelet de. Edited by Ramsay Weston Phipps. *Memoirs of Napoleon Bonaparte*, Vol. 14. New York: Charles Scribner's Sons, 1891.

The Dictionary of National Biography. London: Oxford University Press, n.d.

Greig, James. *Sir Henry Raeburn, R.A. His Life and Works; With a Catalog of His Pictures*. London: "The Connoisseur" (Otto Limited), 1911.

Maitland, Captain F. L., C.B. *Narrative of the Surrender of Buonaparte and of His Residence on Board H.M.S.* Bellerophon; *With a Detail of the Principal Events That Occurred in That Ship, Between the 24th of May and the 8th of August, 1815*. London: Henry Colburn, 1826.

"A Midshipman of the *Bellerophon*." *Memoirs of an Aristocrat, and Reminiscences of the Emperor Napoleon*. London: Whittaker & Co., 1838.

Slave Ship

Several sources cite Clarkson's account of the *Zong* jettison and Thomson's poem "Summer" from *The Seasons* as the inspiration for Turner's *Slave Ship*. The *Zong* incident, including the number of slaves thrown overboard, and the subsequent court trial come mainly from Clarkson (Vol. I, 95–98) and Stuart (29–31); Falconbridge from Buxton, 124–129.

161 The family was: Ruskin, *The Works of John Ruskin,* Vol. 35.

162 "the entire direction": Ibid, 29.

162 essay in *Blackwood's Magazine*: Wingate, 48.

163 "It is a sunset": Ruskin, *Modern Painters*, Vol. II, 161.

163 His father, knowing well: Ruskin, *The Works of John Ruskin,* Vol. 35, 318–319.

164 "I had it at": Ibid, 319.

164 "The pleasure of": Ibid.

165 "immediately fastened together": Buxton, 124.

168 "the aerial tumult": Thomson, 64.

168 "lured by the": Ibid., 65.

168 "Behold! he rushing": Ibid., 65.

170 "so thoroughly corrupt": Stuart, 31.

170 too painful to live with: Ruskin, *The Works of John Ruskin,* Vol. 3, lv.

170 "I think the noblest": Ruskin, *Modern Painters,* Vol. 2, 161.

171 "I believe, if": Ibid., 162.

Bibliography

Beaufort, Madeleine Fidell, and Jeanne K. Welcher. "Some Views of Art Buying in New York in the 1870s and 1880s." *The Oxford Art Journal* 5:1, 1982, 48–55.

Buxton, Thomas Fowell. *The African Slave Trade and Its Remedy*. London: Frank Cass & Co., 1967.

Conant, Helen S. "Joseph Mallord William Turner." *Harper's New Monthly Magazine,* Vol. LVI, February 1878, 381–400.

Cook, E. T., *The Life of Ruskin,* Vols. I and II. London: George Allen & Co., 1911.

Cook, E. T., and Alexander Wedderburn, eds. *The Works of John Ruskin* (Library Edition). London: George Allen, 1903.

Clarkson, Thomas. *The History of the Rise, Progress, and Accomplishment of the Abolition of the African Slave-Trade by the British Parliament, In Two Volumes.* London: Longman, Hurst, Rees, and Orme, 1808; reprinted by Frank Cass & Co., London, 1968.

Gage, John. *J.M.W. Turner "A Wonderful Range of Mind."* New Haven, Conn.: Yale University Press, 1987.

Hermann, Luke. *Turner: Paintings, Watercolors, Prints & Drawings.* Boston: New York Graphic Society, 1975.

Hirsh, Diana, and the Editors of Time-Life Books. *The World of Turner, 1775–1851.* New York: Time-Life Books, 1969.

Joll, Evelyn, Martin Butlin, and Luke Hermann. *The Oxford Companion to J.M.W. Turner.* Oxford, England: Oxford University Press, 2001.

Klingberg, Frank J. *The Anti-Slavery Movement in England: A Study in English Humanitarianism.* Hamden, Conn.: Archon Books, 1968.

Lindsay, Jack. *J.M.W. Turner: His Life and Work: A Critical Biography.* Greenwich, Conn.: New York Graphic Society, 1966.

———. *Turner: The Man and His Art.* New York: Franklin Watts, 1985.

McCoubrey, John. "Turner's *Slave Ship*: Abolition, Ruskin, and Reception." *Words & Image,* Vol. 14, No. 4, October–December 1998, 319–353.

Mathieson, William Law. *Great Britain and the Slave Trade 1839–1865.* New York, Octagon Books, 1967.

Miers, Suzanne. *Britain and the Ending of the Slave Trade.* New York: Africana Publishing Company, 1975.

Porter, Dale H. *The Abolition of the Slave Trade in England, 1784–1807.* Hamden, Conn.: Archon Books, 1970.

Ruskin, John. *Modern Painters* (in Five Volumes). Boston: Dana Estes, n.d.

———. *Fors Clavigera: Letters to the Workmen and Labourers of Great Britain,* Vol. IV. Chicago: Belford, Clarke & Company, n.d.

———. *Fors Clavigera: Letters to the Workmen and Labourers of Great Britain,* Vol. III. Boston: Colonial Press, 1900.

————. *The Works of John Ruskin,* Vols. 1–39 (Library Edition). Edited by E. T. Cook and Alexander Wedderburn. London: George Allen, 1903–1912.

Sandhu, Sukhdev, and David Dabydeen. *Slavery, Abolition and Emancipation: Writings in the British Romantic Period, Volume I, Black Writers.* London: Pickering & Chatto, 1999.

Sherrard, O. A. *Freedom from Fear: The Slave and his Emancipation.* Westport, Conn.: Greenwood Press, 1973.

Stuart, Charles. *A Memoir of Granville Sharp, To Which Is Added Sharp's "Law of Obedience," and an Extract From His Law of Retribution.* Westport, Conn.: Negro Universities Press, 1970 (reprint of 1836 edition).

Thomson, James. Edited by James Sambrook. *The Seasons and The Castle of Indolence.* Oxford: Clarendon Press, 1972.

Walker, Andrew. "From Private Sermon to Public Masterpiece: J.M.W. Turner's *The Slave Ship* in Boston, 1876–1899." *Journal of the Museum of Fine Arts, Boston,* Vol. 6, 1994, 5–13.

Walker, John. *Joseph Mallord William Turner.* New York: Harry N. Abrams, 1976.

Weelen, Guy. *J.M.W. Turner.* New York: Alpine Fine Arts Collection, 1982.

Williams, Gomer. *History of the Liverpool Privateers and Letters of Marque With an Account of the Liverpool Slave Trade.* London: William Heinemann, 1897.

Wingate, Ashmore. *Life of John Ruskin.* London: The Walter Scott Publishing Co., 1910.

Woodward, John. *A Picture History of British Painting.* London: Vista Books, 1962.

The Outcast

Redgrave's discussion with Lord Northwick is based on the painter's diary, F. M. Redgrave, 226–227. My main sources for the Lady Hamilton–Horatio Nelson story were Lofts, Popock, Hibbert, and Fraser.

174 "longed to fight": Redgrave, 43.

179 The queen snubbed: Fraser, 144; Hibbert, 90.

182 Likely that did not: Lofts, 97, Fraser, 249.

185 Even when Horatia: Lofts, 185; Hibbert, 404.

Bibliography

Fraser, Flora. *Emma, Lady Hamilton*. New York: Alfred A. Knopf, 1987.

Hibbert, Christopher. *Nelson: A Personal History*. Reading, Mass.: Addison-Wesley, 1994.

Lofts, Norah. *Emma Hamilton*. New York: Coward, McCann & Goeghegan, 1978.

Popock, Tom. *Nelson and His World*. New York: The Viking Press, 1968.

Redgrave, F. M. *Richard Redgrave, C. B., R.A., A Memoir, Compiled From His Diary*. London: Cassell & Company, 1891.

Washington Crossing the Delaware

189 Crowds flocked: *New York Times,* November 1, 1851.

190 The admission fee: Ibid.

190 The *New York Times* declared: *New York Times,* November 3, 1851.

191 sunset-to-3:00 A.M.: Orientation exhibit script, Washington Crossing Historic Park.

192 In 1849: Groseclose, 38.

192 According to American landscape painter: Whittredge, 22.

193 By the autumn: Spassky, 17.

193 After making repairs: Waldman.

195 exhibited in the Capitol: *New York Times*, October 23, 1946.

195 for about a decade: Waldman.

195 engraving was made by: Ibid.

195 1863 for 900 Taler Gold: Ibid.

195–96 probably from the British: *New York Times*, October 23, 1946.

Bibliography

Grant, Richard. "Crossing the Delaware." *Newsday*, December 16, 2001.

Groseclose, Barbara S. *Emanuel Leutze, 1816–1868: Freedom Is the Only King*. Washington, D.C.: Smithsonian Institution Press, 1975.

Sheehan, George F. "Why Washington Stood Up in the Boat." *American Heritage,* December 1964, Vol. 16, Issue 1.

Spassky, Natalie. *American Paintings in the Metropolitan Museum of Art, Volume II.* The Metropolitan Museum of Art, in association with Princeton University Press, 1985.

Waldman, Emil. *Schicksal eines berühmten Historienbildes.* Washingtons Übergang über den Delaware in: *Bremer Nachrichten,* 28.1.1932.

Whittredge, Worthington. Edited by John I. H. Baur. *The Autobiography of Worthington Whittredge 1820–1910.* New York: Arno Press, 1969.

The Horse Fair

200 Rosa's father sent: Bois-Gallais, 18–19.

201 "As an animal painter": *London World* as quoted in *New York Times,* February 27, 1880.

202 Eventually one of the: Stanton, 22.

202 Local law prohibited: Klumpke, xxxi.

204 "If you only": Ibid., 366.

Bibliography

Ashton, Dore, and Denise Browne Hare. *Rosa Bonheur: A Life and a Legend.* New York: The Viking Press, 1981.

Klumpke, Anna. Translated by Gretchen van Slyke. *Rosa Bonuer: The Artist's (Auto)biography.* Ann Arbor: University of Michigan Press, 1997.

Bois-Gallais, F. Lepelle de. Translated by James Parry. *Biography of Mademoiselle Rosa Boheur.* London: E. Gambart, 1857.

Stanton, Theodore, ed. *Reminiscences of Rosa Bonheur.* New York: Hacker Books, 1976.

Olympia

Of Manet biographies, there is no shortage. All quotations in this chapter are part of the standard literature of Manet, often repeated in biographies of the artist and books on his paintings.

Bibliography

Adler, Kathleen. *Manet*. Topsfield, Mass.: Salem House/Phaidon Press, 1986.

Brombert, Beth Archer. *Edouard Manet: Rebel in a Frock Coat*. Boston: Little, Brown, 1996.

Friedrich, Otto. *Olympia: Paris in the Age of Manet*. New York: HarperCollins, 1992.

Harris, Nathaniel. *The Life and Works of Manet*. Great Britain: Parragon, 1994.

Néret, Gilles. *Édouard Manet, 1832–1883: The First of the Moderns*. Köln, Germany: Taschen, 2003.

Perruchot, Henri. Translated by Humphrey Hare. *Manet*. Cleveland: World Publishing, 1959.

Rey, Robert. *Manet*. New York: Crown, 1997.

Schneider, Pierre, and the Editors of Time-Life Books. *The World of Manet: 1832–1883*. New York: Time-Life Books, 1968.

Zeri, Federico, Marco Dolcetta, Paul Metcalfe, et al. *Le Déjeuner sur L'Herbe*. Richmond Hill, Ontario, Canada: NDE Pub., 1999.

Nocturne in Black and Gold: The Falling Rocket

220 "in the true desire": Ruskin, *Fors Clavigera*, 71.

220 "For Mr. Whistler's own sake": Ruskin, *Fors Clavigera*, 73.

221 at a professional social club: Pennell, *The Life of James McNeill Whistler*, I, 213.

221 "the licensed jester": Whistler, 13.

224 "laughed over it": Ruskin, *The Works of John Ruskin* (Præterita-I), Vol. 35, 180.

225 "a French letter": Ruskin, Ibid., 180.

225 "laughed immensely at": Ruskin, Ibid., 180.

225 "I have given up": Ruskin, *Modern Painters,* III.

227 "It's mere nuts": Cook, II, 428.

230 "Now, Mr. Whistler": Whistler, 4–11.

235 "if it were called": Whistler, 3.

236–37 "The result of": Cook, II, 430.

Bibliography

Cary, Elisabeth Luther. *The Works of James McNeill Whistler*. New York: Moffat, Yard and Company, 1907.

Casteras, Susan P., and Colleen Denney. *The Grosvenor Gallery: A Palace of Art in Victorian England*. New Haven, Conn.: Yale Center for British Art and Yale University Press, 1996.

Casteras, Susan P., and Alicia Craig Faxon. *Pre-Raphaelite Art in Its European Context*. Madison, N.J.: Fairleigh-Dickinson University Press, 1995.

Cook, E. T. *The Life of Ruskin*, Vols. I and II. London: George Allen & Co., 1911.

Denney, Colleen. *At the Temple of Art: The Grosvenor Gallery, 1877–1890*. Madison, N. J.: Fairleigh-Dickinson University Press, 2000.

Eddy, Arthur Jerome. *Recollections and Impressions of James A. McNeill Whistler*. Philadelphia: J. B. Lippincott, 1904.

Fordham, Edward Wilfrid, annotator. *Notable Cross-Examinations*. New York: The Macmillan Company, 1951.

Grosvenor Gallery Illustrated Catalogue, Winter Exhibition (1877–78). London: Librairie de L'Art and Chatto & Windus, 1877.

Harrison, Frederic. *John Ruskin*. London: Macmillan, 1925.

Laver, James. *Whistler*. New York: Cosmopolitan Book Corp., 1930.

Merrill, Linda. *A Pot of Paint: Aesthetics on Trial in Whistler v. Ruskin*. Washington, D.C.: Smithsonian Institution Press, 1992.

Newall, Christopher. *The Grosvenor Gallery Exhibitions: Change and Continuity in the Victorian Art World*. Cambridge: Cambridge University Press, 1995.

Pennell, E. R., and J. Pennell. *The Life of James McNeill Whistler*, Vols. I and II. Philadelphia: J. B. Lippincott, 1909.

———. *The Whistler Journal*. Philadelphia: J. B. Lippincott, 1921.

Ruskin, John. *Fors Clavigera: Letters to the Workmen and Labourers of Great Britain* (Vol. IV). Chicago: Belford, Clarke, n.d.

———. *Modern Painters*, Vol. III. London: J. M. Dent, 1906.

———. Edited by E. T. Cook and Alexander Wedderburn. *The Works of John Ruskin* (Library Edition), Vol. 35. London: George Allen, 1908.

Surtees, Virgina. *Coutts Lindsay, 1824–1913*. Norwich, England: Michael Russell, 1993.

Sutton, Denys. *Whistler*. London: Phaidon Press, 1966.

Way, T. R., and G. R. Dennis. *The Art of James McNeill Whistler: An Appreciation*. London: George Bell, 1903.

Whistler, J. A. MacNeill. *Whistler v. Ruskin: Art & Art Critics*. London: Chatto & Windus, 1878.

Whistler, James. *The Gentle Art of Making Enemies*. n.d.

Williams-Ellis, Amabel. *The Exquisite Tragedy: An Intimate Life of John Ruskin*. Garden City, N. Y.: Doubleday, Doran and Company, 1929.

A Convalescent

Tissot is one of my favorite artists, whose name I feel deserves a larger place in art history. An excellent biography of the artist, which was very helpful to me, is Wentworth's *James Tissot*. For accounts on nineteenth-century spiritualism, see Doyle and Farmer, which were my sources for the material on spiritualism in this chapter.

Bibliography

Doyle, Arthur Conan. *The History of Spiritualism,* Vol. II. New York: G. H. Doran, 1926.

Farmer, John Stephen. *'Twixt Two Worlds: A Narrative of the Life and Work of William Eglington*. London: Psychological Press, 1886.

Wentworth, Michael. *James Tissot*. New York: Oxford University Press, 1984.

Le mariage de convenance

The opening passage on the relationship between Orchardson and Ellen Moxon is based mainly on Gray, but even Gray was unsure of her father's date of birth, since he had always been vague about it. She gives his birth year as 1831, which means the artist would have been forty-two when he was married, or twenty-three years older than his bride (and not twenty, as stated in the chapter). For the ages of Orchardson and Moxon, I went by the official marriage certificate. As possible

further evidence that children or close relatives are often mistaken about important dates relating to family members, Hilda Orchardson Gray cites in her book a wedding day for her parents of April 8, 1873, two days after the date that appears on the marriage certificate.

248 "little Nellie Moxon": Gray, 68.

248 "They were simply": Gray: 74.

248 Orchardson was thirty-nine: General Register Office, UK, certified Copy of an Entry of Marriage.

248 *Marriage à-la-mode*: Armstrong, 39; Warner, 182; Web site of the National Gallery, London: www.nationalgallery.org.ok.

250 Brimming with: Armstrong, 15.

252 "was a true-love match": Gray, 76.

253 "palatial": Armstrong, 22.

253 "When he grew old": Gray, 110.

253 In 1912: *New York Times,* July 7, 1912.

Bibliography

Armstrong, Walter. *The Art of William Quiller Orchardson*. London: Seeley, 1895.

Gray, Hilda Orchardson. *The Life of Sir William Quiller Orchardson*. London: Hutchinson, 1930.

Little, James Stanley. *William Quiller Orchardson, R.A.: His Life and Works*. London: The Art Journal Office, 1897.

Warner, Malcolm. *The Victorians: British Painting 1837–1901*. New York: Harry N. Abrams, 1996.

At the Moulin Rouge

256 Henri's parents were: Denvir, 9; Castleman and Wittrock, 22.

257 "Remember, my son": Mack, 24.

258 "I am small": Huisman and Dortu, 48.

259 "I looked at": Mack, 198.

262 "the disjointed": Museum of Modern Art Tenth Loan Exhibition, 21.

Bibliography

Castleman, Riva, and Wolfgang Wittrock. *Henri de Toulouse-Lautrec: Images of the 1890s*. New York: Museum of Modern Art, 1985.

Denvir, Bernard. *Toulouse-Lautrec*. London: Thames and Hudson, 1991.

Frey, Julia. *Toulouse-Lautrec: A Life*. New York: Viking, 1994.

Heller, Rienhold. *Toulouse-Lautrec: The Soul of Montmartre*. Munich: Prestel, 1997.

Huisman, Philippe, and M. G. Dortu. *Lautrec by Lautrec*. New York: Viking, 1964.

Julien, Edouard. *Lautrec*. New York: Crown, 1991.

Lassaigne, Jacques. Translated by Stuart Gilbert. *Lautrec: Biographical and Critical Studies*. Geneva: Skira, 1953.

Mack, Gerstle. *Toulouse-Lautrec*. New York: Alfred A. Knopf, 1938.

Museum of Modern Art Tenth Loan Exhibition. *Lautrec Redon*. New York: Arno Press, 1931.

O'Connor, Patrick. *Nightlife of Paris: The Art of Toulouse-Lautrec*. New York: Universe, 1991.

Perruchot, Henri. Translated by Humphrey Hare. *T-Lautrec*. Cleveland: World, 1960.

Rich, Daniel Catton (introduction). *Henri de Toulouse-Lautrec "Au Moulin Rouge" in the Art Institute of Chicago*. London: Percy Lund Humphries, 1949.

Guernica

267 It was a breezy: *Bulletin Quotidien de Renseignements de l'Office National de la Météorologie*, Météo-France.

268 "This was a moment": www.pbs.org.

272 As church bells: *New York Times*, April 28, 1937.

275 "The Spanish struggle": Larrea.

277 "I paint this way": www.pbs.org.

277 "Picasso made crystal-clear": *New York Times*, Dec. 1, 1975.

Bibliography

Arnheim, Rudolf. *The Genesis of a Painting: Picasso's* Guernica. Berkeley: University of California Press, 1962.

Beardsley, John. *Pablo Picasso*. New York: Harry N. Abrams, 1991.

Cabanne, Pierre. Translated by Harold J. Salemson. *Pablo Picasso: His Life and Times*. New York: William Morrow, 1977.

Gilot, Françoise, and Carlton Lake. *Life with Picasso*. New York: McGraw-Hill, 1964.

Larrea, Juan. Guernica: *Pablo Picasso*. New York: Curt Valentin, 1947.

Lyttle, Richard B. *Pablo Picasso: The Man and Image*. New York: Atheneum, 1989.

MacDonald, Patricia A. *Pablo Picasso*. Englewood Cliffs, N.J.: Silver-Burdett, 1990.

Penrose, Ronald. *Picasso: His Life and Work*. New York: Harper & Brothers, 1958.

Christ of Saint John of the Cross

My main sources for some of the details in the opening of this chapter were Honeyman, Chapter 14, and *The Scottish Art Review*, Vol. IV, No. 2, Summer 1952. Details on Saint John of the Cross are from the Monastery of the Incarnation, Ávila, Spain.

281 Tom Honeyman was: Honeyman, 206.

282 the twelve oil paintings: *Dalí*, December 1951 program of The Lefevre Gallery, London.

283 he had served as a physician: Webster, 3.

284 "cosmic dream": *Scottish Art Review*, Vol. IV, No. 2, 1952, 28.

284 "represents the nucleus": Ibid., 28.

284 "the very unity": Ibid., 28.

287 "You must paint this Christ": *Scottish Art Review*, Vol. IV, No. 1, 1952, 5.

287 "the metaphysical beauty": *Scottish Art Review*, Vol. IV, No. 1, 1952, 5.

287 "in the expressionistic": Ibid., 5.

287 "as beautiful as": Ibid., 5.

287 "aesthetically summarized": *Scottish Art Review*, Vol. IV, No. 2, 1952, 28.

288 December 5, 1951: The Lefevre Gallery press release, 1951.

288 price of one thousand pounds: Way and Denis, 43.

290 for eighty-two hundred pounds: *Scottish Art Review,* Vol. IV, No. 2, 1952, 2.

290 "shameful waste": Dalí Information Sheet, November 2005, by Jean Walsh, Kelvingrove Art Gallery and Museum.

290 "trickery": *Scottish Art Review*, Vol. IV, 1958, 14.

291 In 2005 it ranked: *Glasgow Herald,* August 30, 2005.

291 "From all the controversy": *Scottish Art Review,* Vol. IV, No. 2, 1952, 30.

291 "art event": Ibid., 5.

Bibliography

Ades, Dawn. *Dalí.* New York: Thames and Hudson, 1995.

Dalí (exhibition program). London: The Lefevre Gallery, December 1951.

Honeyman, T. J. *Art and Audacity*. London: Collins, 1971.

Scottish Art Review, Vol. IV, No. 1, 1952.

Scottish Art Review, Vol. IV, No. 2, Summer 1952.

Way, T. R., and G. R. Denis. *The Art of James McNeill Whistler: An Appreciation.* London, George Bell and Sons, 1903.

Webster, Jack. *From Dalí to Burrel, The Tom Honeyman Story.* Edinburgh: B&W Publishing, 1997.

PICTURE CREDITS

※

Mona Lisa (Leonardo da Vinci): Erich Lessing/Art Resource, NY. *Christina of Denmark, Duchess of Milan* (Hans Holbein the Younger): © National Gallery, London. *Eleonora of Toledo with Her Son Giovanni de' Medici* (Agnolo Bronzino): Scala/Art Resource, NY. *Mars and Venus United by Love* (Paolo Veronese): All rights reserved, The Metropolitan Museum of Art, John Kennedy Fund, 1910 (10.189). *David with the Head of Goliath* (Michelangelo Merisi da Caravaggio): Scala/Art Resource, NY. *The Anatomy Lesson of Dr. Nicolaes Tulp* (Rembrandt Harmensz van Rijn): Royal Cabinet of Paintings, Mauritshuis, The Hague. *The Night Watch* (Rembrandt Harmensz van Rijn): © Rijksmuseum, Amsterdam. *Benjamin Franklin* (Benjamin Wilson): White House Historical Association (White House Collection) (981). *The Tribuna of the Uffizi* (Johan Zoffany): The Royal Collection © 2006, Her Majesty Queen Elizabeth II. *The Honorable Mrs. Graham* (Thomas Gainsborough): © National Gallery of Scotland. *Watson and the Shark* (John Singleton Copley): Ferdinand Lammot Belin Fund, Image © 2005 Board of Trustees, National Gallery of Art, Washington, D.C. *The Skater (Portrait of William Grant)* (Gilbert Stuart): Andrew W. Mellon Collection Image © 2005 Board of Trustees, National Gallery of Art, Washington, D.C. *George Washington* (Athenaeum Head): Gilbert Stuart, American, 1755–1828; *George Washington,* 1796; Oil on canvas; 121.28 x 93.98 cm. (47 ¾ x 37 in.); Museum of

INDEX

❖

Page numbers in *italics* refer to photographs of paintings.